鏡の國のアリニ

NATHALIE
BITTINGER

ANIME THROUGH THE LOOKING GLASS

TREASURES OF
JAPANESE ANIMATION

PRESTEL
MUNICH · LONDON · NEW YORK

鏡の國のアニメ

INTRODUCTION

Dragon Ball, Naruto, One Piece, etc. Readers and spectators from all over the world are fascinated by anime. Despite globalization and the cultural domination of the United States and Coca-Cola, Japanese anime has made its way into our homes, as we move away from animated cartoons on the long-established television channels toward Netflix, which drastically increased its catalog of *japanimation* at the height of the pandemic. The influence of manga, which offers a reservoir of stories for animated movies, is dizzying. English-based and even Franco-Belgian comic strips, such as *Tintin* and *Asterix,* have been successful for decades, but the new generation has adopted the rites of the original geeks: reading from right to left and a taste for typically Japanese storylines. Initially a subculture reserved for just a few aficionados, the imaginary world of the Land of the Rising Sun has since earned its privileged status and has spread to all media: paper, video games, television series, cinema, and merchandise.

Beyond these fashion trends, the world of anime is much more prolific, colorful, and tormented than the caricature of the 1980s, when Japanese animators produced *UFO Robo Grendizer, Candy,* and *Knights of the Zodiac* for children to watch after school. More so than *Fist of the North Star,* portrayed by French politician Ségolène Royal as a form of pornography of violence. Supposedly mindless products, capable of corrupting young souls raised on watching talking animals, pastel colors and Walt Disney's happily-ever-after fictions. Its detractors had not perceived the inventiveness of this art form that eagerly devoured all subjects. Far from appealing to only children, Japan has forged extremely high-quality animation for adults through its rich, unapologetically experimental, and sometimes offensive aesthetics. One after another, original creations followed, from *Akira* (1988) by Katsuhiro Ôtomo to *Your Name* (2016) by Makoto Shinkai, passing through the masterpieces of Studio Ghibli. These works are both pivotal and instrumental in the recognition of this film style in the West.

Free from the physical constraints of live-action movies, anime interweaves narrative layers while playing with the imaginary. A true visual feast, it is a laboratory of human experience and a kaleidoscope of the soul, multiplying the levels of reality. Its graphic debauchery, as well as its poetic purity, acutely seize the failings of society and materialize intangible emotions. Its creativity is boundless, from the apocalyptic tone that runs through its futuristic dystopias, such as in *Ghost in the Shell* (1995) by Mamoru Oshii, to the fantastic universes immortalized by Hayao Miyazaki, not to mention the elegiac realism of Isao Takahata and the spiritual threads that run through his work. These are registers that interweave to capture the metamorphoses of reality and the endless nuances of feelings. Rich in initiatory tales, Japanese animation is a wonderland, sometimes nightmarish, that takes the viewer to the other side of the mirror in order to better examine social, political, and environmental issues. A mirror that distorts—whether futuristic, poetic, or hyperrealistic—and never fails to sanctify the spirituality of nature through the grace of a traced line or a particular movement. A journey to the land of Japanese animation is, therefore, necessary to unfold its thematic wealth, its forceful narratives, and its aesthetic crossroads, where it displays its full emotional and reflective range.

CONTENTS

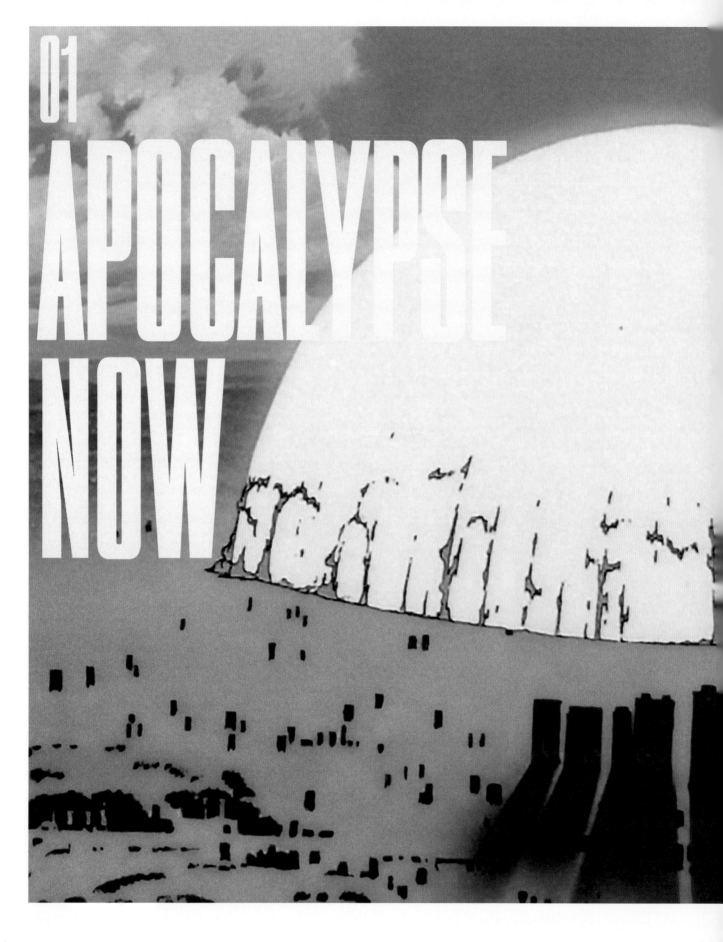

01

APOCALYPSE NOW

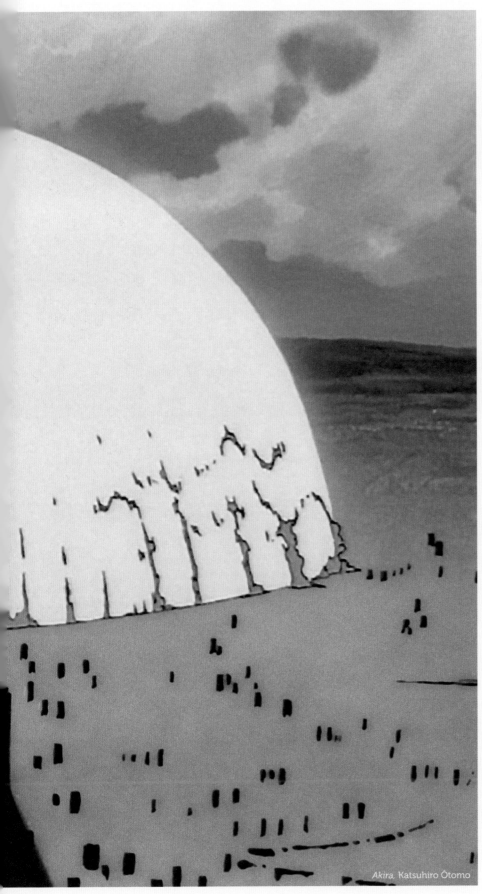

Akira, Katsuhiro Ōtomo

鏡の國のアニメ

Bodies have been shattered into a thousand pieces. The earth has become a desert hell. Futuristic cities have collapsed. Human or robotic bombs explode like fireworks. Clearly, Japanese animation fantasizes about the apocalypse. Its cartoonists have confronted this deep existential anguish head on, which then takes on varying mutant forms under their sharpened pencils.

This should not be surprising, given the history of the Land of the Rising Sun, from repeated earthquakes to the atomic bombs dropped on Hiroshima and Nagasaki by the Americans to impose Japan's unconditional surrender in August 1945. The explosion of the Fukushima nuclear power plant, just after the 2011 tsunami, was yet another reminder, much to the people's dismay. The archipelago is deeply aware of the fact that civilizations can be struck down by disaster at any time. *Memento mori.*

This is what anime's psychedelic, subversive, and even nihilistic animated cinema really hammers home. It never ceases to explore this humanity on the edge, in danger of losing its soul at the whim of technological or totalitarian delirium, devoured by its addiction to war or weakened by natural disasters—if humankind is not hacked by a virus or swallowed by the virtual worlds he has created.

ANIME GOES TO WAR

War is the beating heart of Japanese anime. Scanned from all angles, in its intimate and geopolitical stakes, war sees its shadow hovering over various genres: from historical reenactments to robot (or *mecha*, for "mechanics") and monster (*kaijū*) movies to heroic fantasy, fantastic, and postapocalyptic tales. A powerful narrative engine, such as Kaneda's red motorcycle in *Akira* (1988, Katsuhiro Ôtomo), it triggers the fierce fight of heroes ready to give their lives to save humanity. Because there are always new tyrants, clans, or armies to feed the manga tree, which is so often adapted to the screen.

Mortiferous and absurd, war is violently denounced as a self-destructive passion. The mangakas and filmmakers who revolutionized the art of drawing in the second half of the twentieth century are children of war. They belong to the "generation of ashes" who, at a young age, experienced the consequences of Japanese imperialism. They saw thousands of American bombs fall and walked through the dead bodies. Here is one key example: The future masters of animation of Studio Ghibli (founded in 1985), Hayao Miyazaki and Isao Takahata were four and ten years old respectively in 1945. With his little sister injured, Takahata had to run under the shells that destroyed his town of Okayama, as well as his house. Fortunately, he was reunited with his parents a few days later, avoiding the tragic fate of the orphans in his moving *Grave of the Fireflies* (1988), a kind of poetic metastasis of the madness of the time. From his first production, Takahata revolutionized the aesthetics of the Toei studio, which had been inspired by Disney since *The White Snake Enchantress* (1958). With the help of Yōichi Kotabe and Hayao Miyazaki, he broke the childish framework of cartoons with his cinematographic realism: modern *Horus, Prince of the Sun* (1968) depicted the struggle of a village against a monstrous invading wizard—a mythological plot about a community in peril, with troubled characters (such as the seductive Hilda), conceived as a metaphor for the Vietnam War.

These filmmakers have, therefore, experienced apocalyptic scenes in their bones. Destruction haunts their movies in realistic or fantastical forms. Many of them became fierce pacifists and transformed this traumatic experience into powerful visual narratives that question the fate of their country, thus becoming both executioner and victim. Some have explored the devastation wrought by militaristic Japan before it signed its 1947 Constitution, forced by the American occupiers, pledging to "renounce war forever." Others have offered a fictional grave to the anonymous dead. Filmmakers have also extrapolated futuristic wars, emphasizing how technology could potentially cause disaster and devastation. Their works incite audiences to never forget the absolute horror that culminated with the dropping of the nuclear bomb. Cartoons, with their total graphic freedom, had to come along to show us the ultimate unthinkable tragedy of radiation victims. War at its worst, and humanity in despair.

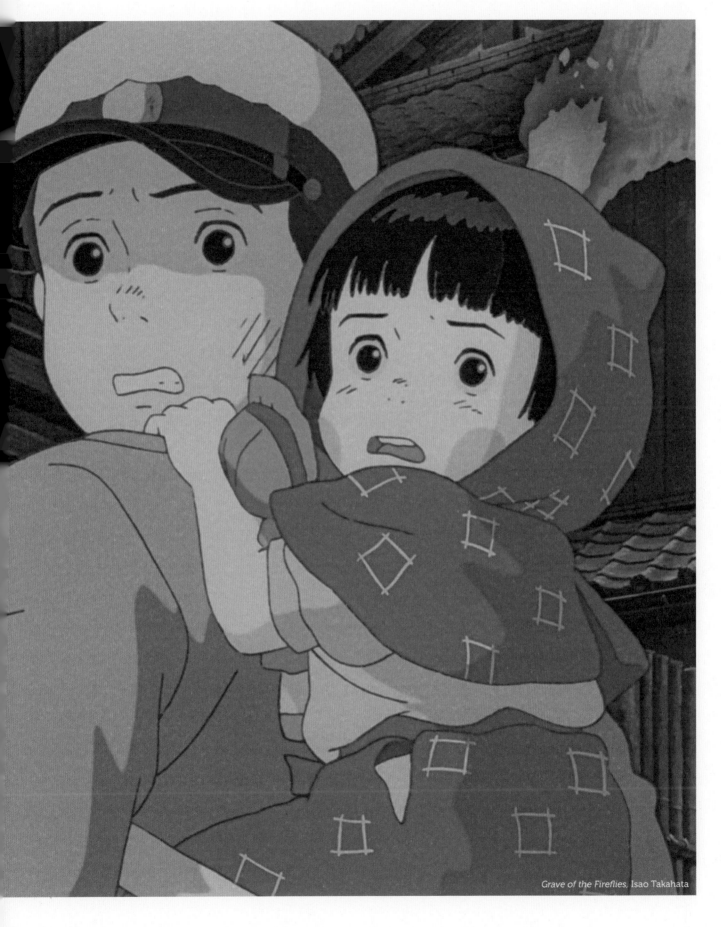

Grave of the Fireflies, Isao Takahata

THE PAINS OF HISTORY

This is how Japanese animation dared to face its country's history, such as the dramas of World War II. On April 16, 1988, Studio Ghibli screened *My Neighbor Totoro* and *Grave of the Fireflies,* back to back. On the one hand, Hayao Miyazaki brought wonderful forest spirits to life: the big plush Totoro and the Cat Bus serve as guides for two little girls in the lush green Japan of the 1950s. On the other hand, Isao Takahata made waves in the world of animation, showing the death of two starving war orphans. Setsuko, four years old, and her big brother Seita perish due to widespread indifference—one in front of the antiaircraft cave that serves as their "home" and the other in a train station, like an abandoned dog. Their mother died in the bombing of Kobe on June 5, 1945. In short, one room (cinema), two atmospheres. Even on the other side of the world, years later and thousands of miles away, viewers still remember the trauma of watching the movie. It was a far cry from the Sunday family cinema experience they were expecting.

Adapting a particularly raw semi-autobiographical short story by Akiyuki Nosaka (1967), Takahata brings collective tragedy to the heart of animation. Through his detailed drawings, he evokes the battlefields in ruins, rotting corpses, malnutrition, and bodies eaten away by vermin—consequences of a worldwide catastrophe. "Just because it's an animated film, it doesn't mean that one should spare the spectators, even the young ones," he commented (*Positif*, July–August 1996). He refuses to allow the public to look away from the atrocities of war. In the mid–1980s, he felt that a feeling of amnesia was taking over. He had his doubts as to whether the younger generation was even aware of the propaganda contained in *Momotaro's Divine Sea Warriors* (1945), the first Japanese animated feature movie, which was lost and then recovered in 1983. Directed by Mitsuyo Seo at the request of the Ministry of the

Imperial Navy, this film shamelessly captured the aura of a children's story from the Edo era (1603–1868). A small boy that looks like a samurai, Momotaro was a symbol of heroism and generosity, defeating ogres and saving the villagers. In 1945, he became the benevolent leader of a troop of animal soldiers dedicated entirely to the liberation of a Pacific island invaded by "white pirates," who eventually surrendered cowardly. Ironically, this ode to the glory of Japan was initially released in the midst of military defeat, in a ravaged, war-torn country.

Forty years later, *Grave of the Fireflies* is an invitation to pay tribute to the victims of war. That is why Seita and Setsuko are sometimes accompanied by their glowing ghosts. Breaks between the past and the present transport spectators into a spectral dimension. For therein lies the challenge: to revive these memories from beyond the grave through anime—those who return at the end of the film to contemplate contemporary skyscrapers. The children's terrible ordeal, underlined by a cruel realism, is fortunately enlightened by moments of grace sprouting from the rubble: the joy of a few sour candies, the taste of a bowl of rice after months of starvation, the light that glitters through a hole in an umbrella. The fireflies that dot this story are symbolic glimmers of hope in the night. Their ephemeral splendor evokes the poetic capacity of drawings to embrace everything—horrors as well as beauty.

A traumatic shadow over the twentieth century, World War II looms large over Japanese animation. Because it is immediately stylized, the drawing paradoxically creates a realism that hits home, offering a subtle balance between distance and immersion. And, to this end, Takahata has been the champion.

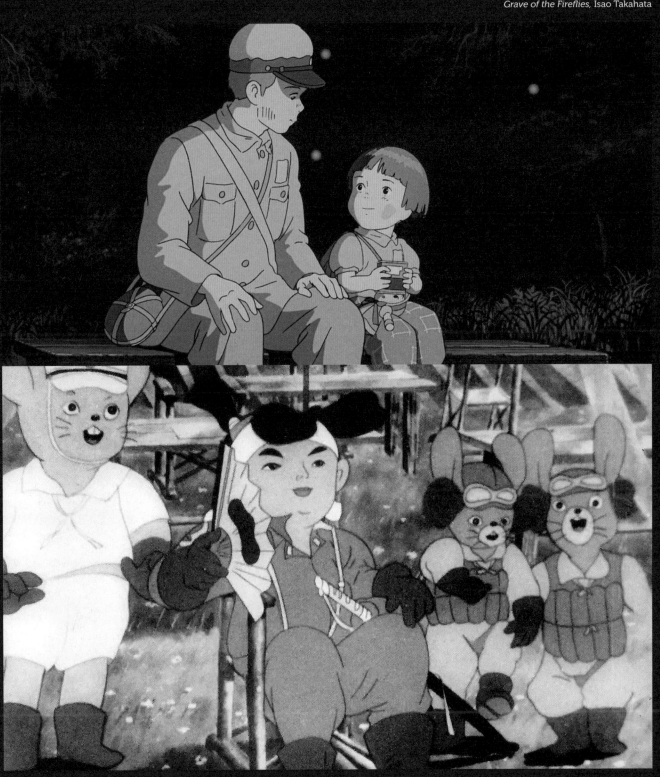

Grave of the Fireflies, Isao Takahata

Momotaro's Divine Sea Warriors, Mitsuyo Seo

BLACK RAIN

The fight against oblivion is at the heart of the more recent films that delve into the past. These biographical chronicles offer intimate insights, interweaving small and large stories.

Mizuho Nishikubo's *Giovanni's Island* (2013) celebrates the power of imagination to alleviate the blows of war. In September 1945, an island on which two young boys lived, in the Kuril Archipelago—and which Russia and Japan are still fighting over—was invaded by the Soviet army. This childhood paradise was plagued by violence, culminating in their deportation to a refugee camp in Russia. After a long voyage through the snow to see their imprisoned father, Kanta's death from hypothermia in the arms of his brother Junpei is reminiscent of *Grave of the Fireflies*. However, dreamlike breaks allow the children not to lose hope. As events unfold, they are propelled into the cosmic world of Kenji Miyazawa's novel *Night on the Galactic Railroad*. A philosophical compass in an unhinged world, the immensity of the galaxy often abruptly replaces cold reality. As Junpei observes upon his return to the island after fifty years of exile, the dead are now stars that shine their light on the living.

From Hiroshima to the military port of Kure, Sunao Katabuchi's *In This Corner of the World* (2017) patiently follows the daily life of a sensitive young wife with a passion for drawing. Once again, the gloomy reality of war is transfigured, little by little, thanks to Suzu's intuitive eye, which redraws the world as she sees it in her dreams. When a bomb takes her niece's life, as well as her own arm, she sees nothing but a black screen crossed by the evanescent forms of a distraught bird-missile, before imagining the girl sketched in a field of flowers. Above all, the director evokes in a roundabout manner, with great modesty, the "bombs of a new kind" that were dropped on Hiroshima. A large cloud rises ominously in the sky,

To prevent such a barbaric—unimaginable—act from ever repeating, some anime go even further with their shocking images. The malleability of drawing enables them to depict the explosion, the inferno, and the faces twisted in pain. Until it slips into horror. Renzo Kinoshita's short film *Pica Don* (*Atomic Bomb*, 1978) focuses on the calm before the storm on the morning of August 6, 1945, when everyone is quietly going about their business. When the bomb drops, the world freezes and fades into black and white. Carried away by the atomic blast, the bodies melt until they are nothing more than skeletons with bulging eyes, losing any human resemblance. The stylistic break in *Barefoot Gen* (1983) by Mori Masaki is equally hallucinatory. The film is adapted from the autobiographical manga with a strong political content by Keiji Nakazawa, who was among the Hiroshima survivors (or *hibakusha*, victims of intense discrimination). Although survival during wartime is exhausting, the life of Gen—a facetious child with round features (close to the style of Osamu Tezuka, the father of manga)—is made sweeter by the love of his family. But, at the moment of impact, there is a deluge of garish colors, screaming, and charred flesh. Men become zombies, the city falls apart. The mushroom cloud is a hellfire that sweeps away everything in its path before releasing its black rain of radioactive particles.

This imagery of bodies being liquefied by the nuclear explosion reappears in many works, particularly those that were castigated in the 1980s and 1990s for their violence (*Fist of the North Star*). Because showing the unrepresentable requires making radical graphic choices, which often draw from horror movies (zombie, cyberpunk, etc.).

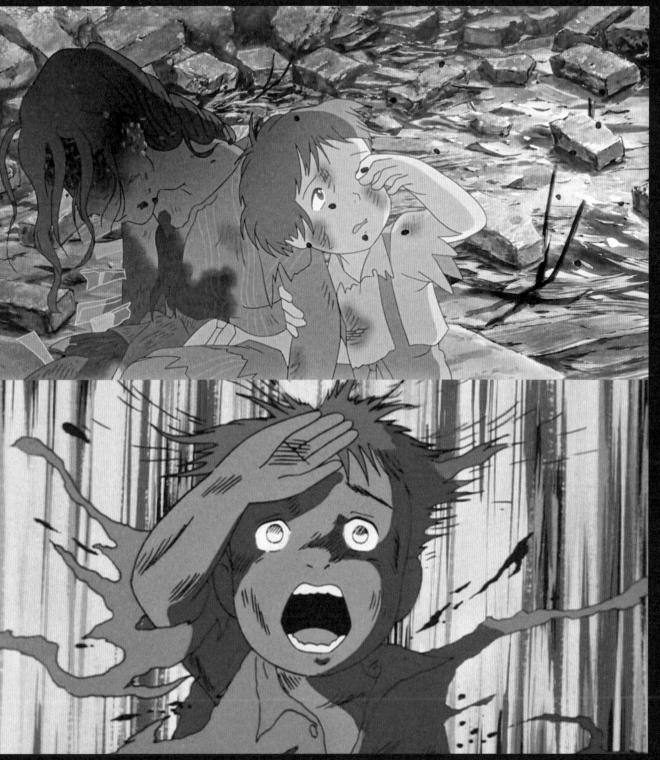

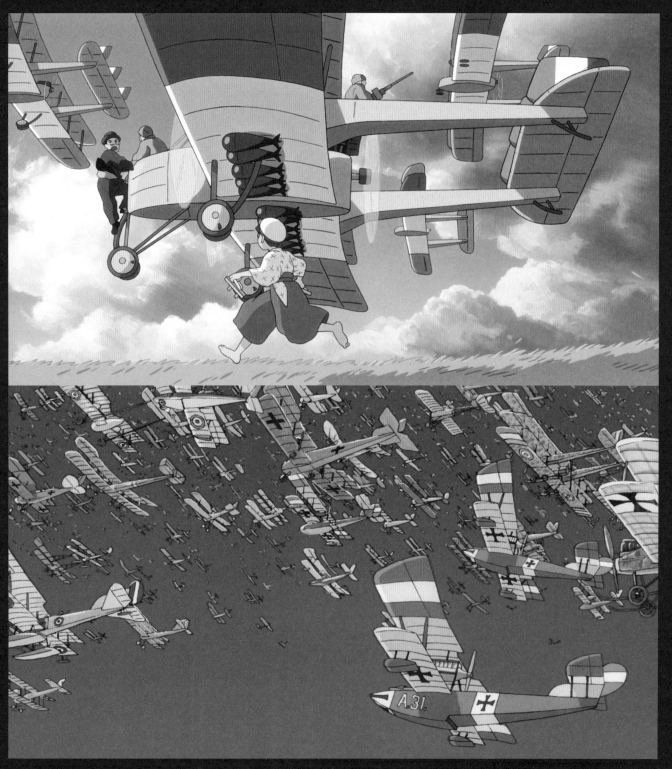

鏡の國のアニメ

ANIME THROUGH THE LOOKING GLASS

AIR CEMETERY

During the war, airplane bombs poured down blindly upon the civilians below, dropped from the sky by faceless pilots—except when animation focuses on these angels of death to tell their tragic stories. The craziest among them were those of the kamikazes, who reactivated a culture of sacrifice inherited from the samurais. This self-elimination in the name of the nation is at the heart of the second story of *The Cockpit* (1993), a three-part film based on the manga *Battlefield* by Leiji Matsumoto. In it, a young Japanese kamikaze literally becomes one with his *Ohka* (Cherry Blossom) plane, destined to crash into an American ship. Before his suicide mission, a *koto* player offers him a short moment of moonlit respite. "Crazy, we are crazy!" exclaimed the enemy commander when he discovered the photograph of the musician among the relics of the human bomb, before being torn to pieces.

The opening words of *The Cockpit* emphasized the technological outrage: "How do we explain to the dreamers who aspired to fly in the sky that their dreams are currently being used to wage war?" This anguished questioning is central to Hayao Miyazaki's *The Wind Rises* (2013), a fictionalized biography of Jiro Horikoshi. This engineer has dedicated his life to designing the most beautiful airplanes he could imagine, and yet his name has sadly become infamous, because it is associated with the Zero fighter-bombers involved in the kamikaze attacks, notably on Pearl Harbor. The movie—its title refers to a verse by Paul Valéry ("The wind is rising!...We must try to live!")—symbolizes the irreconcilable duality between creation and destruction. The height of human inventiveness has produced killing machines. In dreamlike sequences, Jiro converses with his Italian counterpart Giovanni Caproni, creator of the twin-engine Ca. 309 Ghibli. This is where the famous studio got its name! To the young man mortified by the disastrous consequences of his engineering gifts, Caproni replies: "Planes are magnificent yet cursed dreams." These metallic birds that crisscross the sky are also flying scrap metal with the ability to create apocalyptic landscapes.

The filmmaker had a personal reason for tackling this subject. His father ran a factory that delivered rudders for the Zero aircrafts. "As a child, I hated the idea of my father's family making money from war," he confesses. Paradoxically, it fed his passion for airplanes, which he drew every which way. Inspired by Jules Verne and the illustrator Albert Robida, Miyazaki surpassed himself in "The Invention of Imaginary Machines of Destruction" (the name of one of his short films), from the Goliath—a battleship of war—in *Castle in the Sky* (1986) to the giant bombers in *Howl's Moving Castle* (2004). He also excelled in the realistic depiction of Japanese, German and Italian planes from the 1930s.

Twice, Miyazaki's blue sky turns into an aerial cemetery. With his fat talking pig, fastened into a red seaplane, *Porco Rosso* (1992) is a strange historical-mythological fable. In 1929 in Fascist Italy, in a kind of Japanese-style Europe, Marco flies over the Adriatic Sea, disgusted by human stupidity. A flashback to World War I recalls a supernatural event he witnessed. The only survivor of a deadly attack, he finds himself in a sea of clouds. The planes belonging to his fallen friends rise up to the sky like a cloud of dust. From that moment on, Porco sports his bestial appearance. The image is so striking that this pilot of the heavens makes another appearance at the end of the film *The Wind Rises*.

When the deadly dance of planes blackens the sky and the sirens sound, everyone runs to take shelter from the bombs. The invention that was meant to elevate humankind is capable of sowing death wherever it goes, and of crushing innocent people face down into the ground.

19

P eople who are obsessed with war love absurd neverending conflicts. This morbid passion is denounced in Katsuhiro Ôtomo's "Cannon Fodder" sketch, which closes the film *Memories* (1995). The militarized society he depicts worships its cannon. Tirelessly firing its shots against a neighboring city, the phallic weapon is celebrated everywhere at all times: at home, in the factory, and even within the control tower. In this asphyxiating enclosure, zombie workers with cadaverous complexions work, while helmeted schoolchildren religiously await the sacred explosion. When the child, who dreams of becoming a firing commander, asks his father—a simple loader—who they are fighting, his father replies: "You'll understand when you're older." The cannonball clock that adorns his room sets the rhythm to the eternal repetitive nature of the same macabre ritual, so deeply rooted is the taste for war in our human DNA.

The aerial battles of Mamoru Oshii's *The Sky Crawlers* (2008) are also repeated like an endless day. "Since our aerial war is part of a game that is not going to end anytime soon, it is necessary to establish certain rules, like the presence of an invincible enemy." Some time in the future, fifty years after a terrible conflict (a kind of echo of the Pacific War), child soldiers engage in breathtaking battles in the sky. Lacking any memories or emotions, the Kildren have the particularity of never growing up. They are, therefore, the model interchangeable employees of multinational companies that orchestrate the show, pretending to fight for peace. These organize the dumbing down of a society that consumes images of war as if they were new circus tricks. But this work by Oshii is an antiwar film, with the constant waiting, the monotony of the attacks, and the absence of any stakes showing a subdued civilization and an unbridled neo-capitalism. In the same way, the rich O'Hara Foundation of *Steamboy* (2004, Katsuhiro Ôtomo) finances science for the good of humanity, but it does not hesitate to start "just a tiny war against England, because it is associated with the demonstration of our products." This is done to better sell them.

Whether power-hungry politicians and soldiers, wizards fighting for glory, or greedy multinational companies, there are many who need conflicts to assert their domination over others. A true plague on humanity, war is a curse that transforms Marco into a pig in *Porco Rosso* and Hauru into a deadly bird of prey in *Howl's Moving Castle*. It taints, for no reason, all the places in this fantastic film by Hayao Miyazaki, with the royal witch Suliman wreaking havoc on the kingdom to entertain herself and punish those who resist her. The magical moving castle allows you to land in different spaces, opening up to either blood-soaked cities or untouched natural areas. The black zone propels Hauru to the frontline, loaded with weapons, but soon it is his pastoral refuge that becomes contaminated. The young Sophie, transformed into a wrinkled grandmother due to a curse, ends up giving her heart to Hauru and freeing the neighboring land's scarecrow prince with a kiss. Defeated by the love that these young people have for each other, Suliman puts an end to the conflict. Her pastime has lost all interest, because she now realizes that she can never reign unchallenged. According to these anime, war is an addiction. It is invasive and destroys everything: childhood, cities, humanity, and the cosmos.

WAR GAMES

21

"Cannon Fodder," Katsuhiro Ôtomo

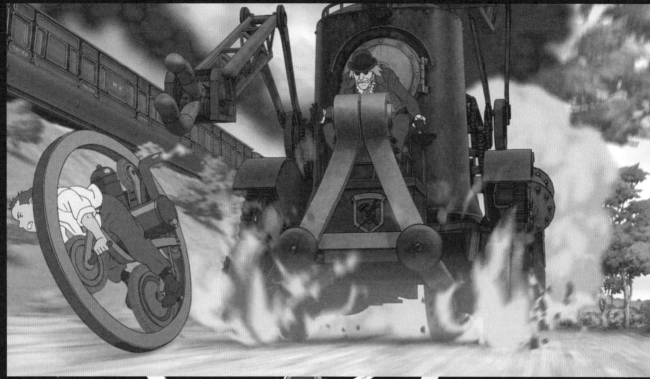

Steamboy, Katsuhiro Ôtomo

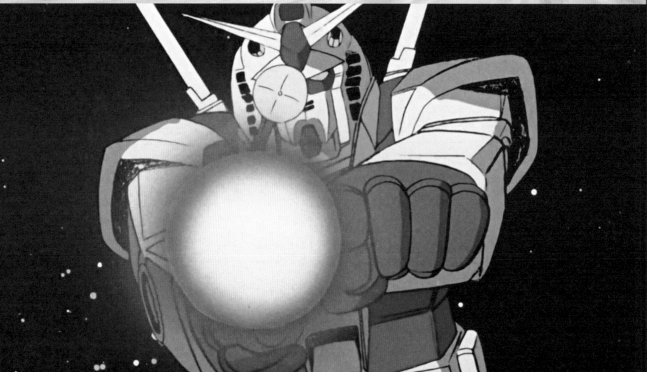

Mobile Suit Gundam, Yoshiyuki Tomino

WEAPONS OF MASS DESTRUCTION

The rise in power of weapons over time is at the heart of the collective film *Robot Carnival* (1987), which opens and closes with a fable by Otomo. In an antediluvian desert worthy of *Mad Max* (1979, George Miller), a walking steampunk-style fortress mercilessly advances on a village. In the epilogue, it self-destructs, leaving behind a relic that is found by a poor man: a sparkling ball. An automated dancer springs from the mechanism, enchanting a family—until the bomb explodes. Between these two segments, there is a parade of futuristic robots, ranging from the most harmless to the most destructive.

In terms of weapons, animators draw heavy artillery. Technological inventions offer an arsenal of highly sophisticated killing machines: giant cannons, supersonic planes, machine guns attached to the body, cyborgs, and computer viruses. Anime companies show an unparalleled ingenuity for self-destruction. Their first source of inspiration are techniques that have already been developed by humans, and these are then slightly extrapolated in their destructive potential.

Each weapon has its own type of warfare. Set in the era of the first industrial revolution, *steampunk* is brimming with retro-futuristic devices that run on steam, iron, and coal. London, 1866, World Fair. *Steamboy* by Katsuhiro Ôtomo pits the members of a family of inventors against each other, who dream of concentrating energy in order to make a giant tower fly. The father, who has been transformed into an iron man following an accident, blindly serves the foundation that sponsors his military research. Metallic machines, steam robots, and mechanical soldiers are springing up everywhere. Fortunately, "where danger lies, so does the saving power," according to the famous phrase by the poet Hölderlin. Perched on his homemade flying engine, Steamboy struggles to prevent the slaughter of London. The end credits show a continuum between inventions that have led to progress and their deadly alternate uses. This is how we go from trains, the Eiffel Tower, and the electric light bulb to the trenches of World War I, full of iron and guns.

Robots are the main propellant behind animated sci-fi. Given the Japanese passion for high-tech, it was to be expected that they would colonize animation in multimedia franchises that are as prolific as they are lucrative (particularly when it comes to toys for children). Whether or not it is coupled with space opera or heroic fantasy, the mecha (for mechanics) genre emerged in the 1960s, with *Tetsujin 28–Gō* (1963–1965). Since then, it has delivered its share of "super robots," such as *Mazinger Z* (1972–1973) and *UFO Robo Grendizer* (1975–1977), led by superheroes battling the forces of evil. Less Manichean, more adult, the *Mobile Suit Gundam* (1979–1980) and *Macross* (1982–1983) franchises favor the realism of real robots. Mixing these two tendencies, *Neon Genesis Evangelion* (1995–1996) narrates the psychological struggle of depressed child pilots, aware of the murderous madness. As a final resort against the overpowering deadly creatures, they have no choice but to synchronize, over and over again, with their robotic armor to try to protect humanity.

Extrapolating from the atomic bomb that could have wiped out Japan, the cyberpunk dystopia invents its share of bacteriological weapons, mutants, and viruses capable of annihilating the human race. Genetic experimentation, nanotechnology, and cyber warfare offer more and more pathological terrain for those who insist on opening Pandora's box. And the weapons are constantly increasing their striking force to reduce the enemy—or civilization—to rubble.

This is it, the dreaded apocalypse has taken place. Entire regions have been wiped off the map. Only a handful of survivors remain, fearing the threat of another such catastrophe. Such is the prologue of many Japanese anime films using twilight tones.

An example of this is the series *Conan, the Son of the Future* (1978) by Hayao Miyazaki. In 2008, a terrible war of magnetic weapons has made Earth deviate from its axis. The continents are under threat of being engulfed. A small group tries to escape and leave the atmosphere, but it ends up on a deserted island that is miraculously spared from the tidal waves. In *Nausicaä of the Valley of the Wind* (1984, Miyazaki), a Christic tale of a young woman established as the new messiah, the catastrophe is a thousand years old. The progress of industrial civilizations has given birth to titanic robots that destroyed the planet during the "seven days of fire." It is now contaminated by a toxic, colorful, and lush forest that continues to spread. Only those wearing gas masks can enter. Led by Nausicaä, the people of the Valley of the Wind are struggling with the poisonous spores that escape from the Sea of Decay. That is, when they are not running from the Ômu, giant insects with big shells whose eyeballs redden when attacked. The worst, however, are the humans who never learn from their mistakes. In this case, Tolmec soldiers who want to resurrect a warrior god to burn the corrupted nature, risk generating a new apocalypse.

Unable to rest, humans continue to disrupt their ecosystem. Because of experiments gone wrong, one day in *Patema Inverted* (Yasuhiro Yoshiura, 2013), the sky absorbs some of the cities and its people. Since then, everything has been turned upside down, and half of the planet lives with reverse gravity. Rounded up in underground chambers, the "inverted" are chased by "bat" men, who appear upside down to them. These soldiers come from the totalitarian society that has been established on Earth and that forbids its population to look up at the sky. More utopian, *Castle in the Sky* articulates one of the common threads of Miyazaki's movies: exhilarated by their voracity and supported by technology, humans abuse nature's balance and sow the seeds of their own annihilation. Such was the destiny of Laputa, a legendary floating island (inspired by Jonathan Swift's *Gulliver's Travels*, 1726) that contains the remains of a civilization so advanced it wanted to dominate the world, before its inhabitants deserted it to reconnect with their earthly roots. Seven hundred years later, new would-be dictators covet its military strength, threatening to relaunch the infernal cycle of destruction.

Mamoru Oshii's *Angel's Egg* (1985) raises reflection to a metaphysical level. A variation on the biblical parable of the great flood, it traces the melancholic wanderings of a blonde girl among the ruins of a collapsed world. She desperately protects an egg, found in a bird fossil, before meeting an enigmatic young man with bandaged hands and a cross-shaped gun. In a deserted gothic city, they contemplate ghostly fishermen who chase whale shadows. The stranger finally breaks open the egg to see what is inside. Both at the beginning and at the end of this mysterious poem, a gigantic machine in the shape of an eye descends from the sky, with ancient living people on board who have been transformed into stone statues.

Straddling past, present, and future, postapocalyptic fictions remind the viewer that all civilizations are mortal, as Paul Valéry had so well understood after World War I. From Earth, which has already experienced five mass extinctions, to the mysteries of Easter Island and the pyramids, not to mention the nuclear threat, the prophecies of the end of human existence are deeply rooted in our long history. Their spectacular impact aims to awaken—at least a little—our conscience.

THE SUNKEN WORLDS

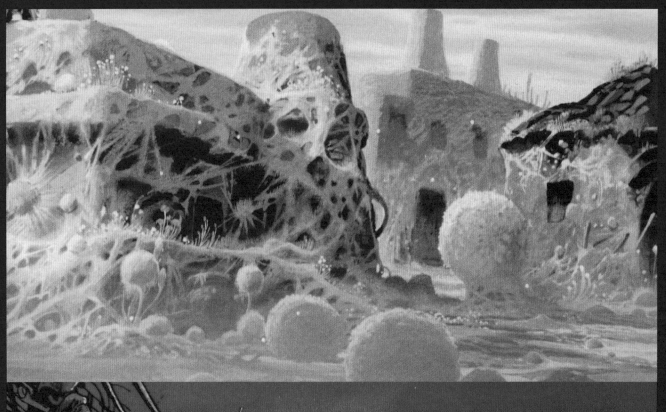

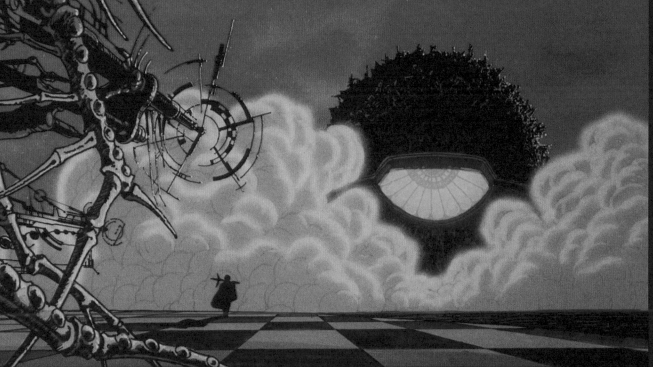

Angel's Egg, Mamoru Oshii

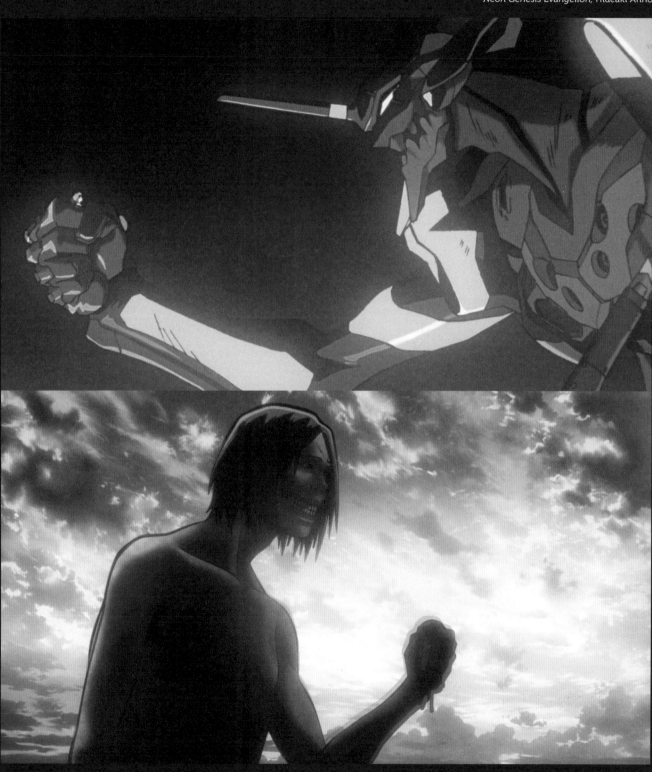

Neon Genesis Evangelion, Hideaki Anno

Attack on Titan: Crimson Bow and Arrow, Tetsurō Araki

The fact remains that no playing field is large enough to satisfy the hegemonic impulse that pulls dark individuals. In the 1960s and 1970s, at the peak of space exploration, animation created countless intergalactic wars. In *Mobile Suit Gundam*, man has migrated to space colonies where he has re-created an artificial environment. In the year 0079 of the Universal Calendar, a violent conflict breaks out between the Federation and the Duchy of Zeon, which demands its independence. The confrontations between Amuro Ray and Char Aznable spread geopolitical lessons on a universe scale.

However, the taste for extermination is not exclusive to the human species. Anime loves to replay the theory of evolution by confronting humans with their radical opposite, whether it be aliens (*Macross*, 1982–1983, *Dragon Ball Z*, 1989–1996), demons (*Berserk*, 1997–1998, *Demon Slayer*, 2019–), or even dragons that threaten the contemporary era (*The Vision of Escaflowne*, 1996). Faced with these nonhuman alterities, the war of the worlds is a fiction incubator. In *Neon Genesis Evangelion*, the Angels land on Earth in 2015, fifteen years after the Second Impact. This devastating explosion occurred during experiments conducted on a winged giant of light discovered in Antarctica and named Adam. Since then, Neo-Tokyo 3 has been rebuilt as a defensive city, unfolding and retracting at will. To avoid a Third Impact, the secret organization NERV develops its own humanoid robots: the Eves. When creatures spring from the bowels of Earth, as in *Attack on Titan* (2013–), a mythological struggle between the forces of chaos and the harmony of the cosmos is replayed. These Titans devour men like peanuts, forcing the survivors to retreat behind fortified enclosures, which they cannot cross. The young Eren Jäger merges with one of the Titans, reshuffling the cards in this anthropophagic struggle.

Confrontation is sometimes part of a cycle of punishment and redemption. In *Princess Mononoke* (1997, Miyazaki), the gods of the forest rise up against the humans who plunder the resources. Nourished by Shintoism, the movie is anchored in a medieval Japan, embarked in a modernization that destabilizes the natural balance. When fury devours them, some gods become cursed, infested by swarming worms. The boar Nago contaminates the young Ashitaka and from then on is forced into exile. His journey leads him to the forges of Lady Eboshi, but also to the meeting of a warrior raised by the wolf goddess Moro—Princess Mononoke appears with blood on her face. The most powerful deity, the horse god, sometimes has a translucent blue body, sometimes an almost human face. He is capable of making the flora emerge and die as he passes, and in diluvian anger he releases a black substance that destroys the forest. It is only when heroes return his decapitated head, stolen by humans, that life can be reborn. *Origin* (2006) by Keiichi Sugiyama features even more aggressive forest spirits. The "druids" control the water granted to the humans of the neutral city and do not hesitate to transform themselves into liana dragons if one penetrates their sacred enclosure. They defend themselves even more violently against a warlike city that seeks to eradicate them.

From this point of view, animation can be read as an art of war that constantly renews its bestiary. Using ancient myths, medieval settings, and current and futuristic issues, it combines Japanese and Western references in order to invent creatures that embody our primitive terrors.

THE WAR OF THE WORLDS

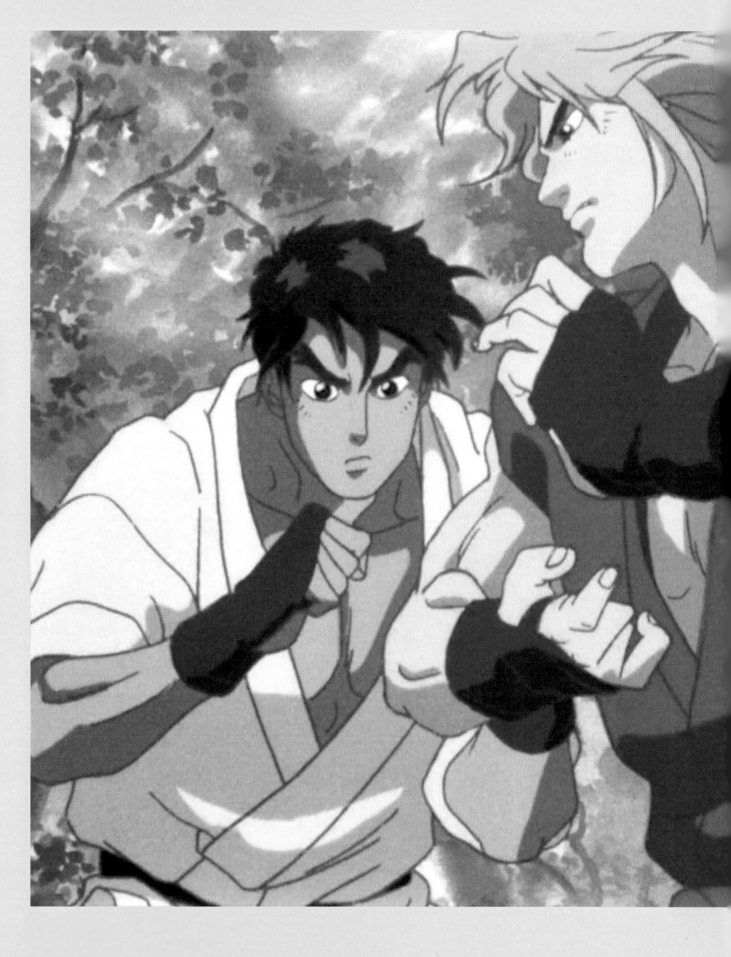

Street Fighter II: The Animated Movie, Gisaburo Sugii

"THE STREET IS MY RING"

S treet Fighter II, *The Animated Movie* (1994, Gisaburo Sugii) is the adaptation of one of the most popular fighting games in video game history, which was a hit in smoke-filled bars, arcades, and then on the Super Nintendo at the end of the last century. Created by the Japanese studio Capcom in 1991, the game *Street Fighter II: The World Warrior,* which has spawned nearly fifteen sequels and spin-offs across all media, remains the genre's founding work alongside *Mortal Kombat,* its pop and ultraviolent rival released by the American Midway studios in 1992. The movie by Gisaburo Sugii—who took his first steps as an animator on *The White Snake Enchantress* (1958) before directing, twenty years later, *Night on the Galactic Railroad* (1985)—is a delightful cocktail of ingredients that led to the success of japanimation.

With a more or less detailed biography, the heroes of the Capcom game take on a new flavor. Guile, a blond, powerful man with a crew cut, a colonel in the U.S. Air Force, for example, joins forces with Chun-li, the Chinese fighter in a blue *qipao* sent by Interpol. They are catapulted, as the embryonic "story" proposed by the video game suggests, to the four corners of the planet, crossing different worlds along the way: India, the Himalayas, Las Vegas, etc. The warriors are caught up in a convoluted plot that mixes spectacular martial jousts with a plot hatched by an international crime syndicate, sprinkled with a touch of science fiction. At the head of the secret organization Shadoloo is M. Bison, who transforms the street fighters into lobotomized terrorists through surveillance cyborgs and psychic manipulation. He is desperate to get his hands on Ryu, whose fame and strength are renowned beyond the borders. To achieve this, he colonizes the brain of Ken,

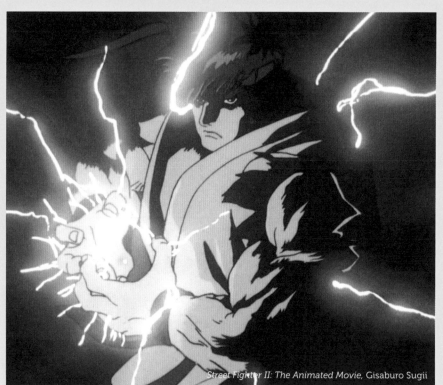

a spiritual brother of the judoka since their training years (sketched in flashbacks). Obviously delighted, the viewer longs for the appearance of the characters that he himself has embodied, joystick or controller in hand. He waits for the moment when each one of them unleashes his scream along with his extraordinary skills: levitation and teleportation of the yogist Dhalsim against the sumo wrestler E. Honda's supersonic arms; electrocution of the "savage" Blanka against the centaur wrestler Zangief; or clawing blows of the matador Vega against Chun-li's lightning kick. And, of course, there is the *ha-do-ken*—the fatal energy ball thrown by both Ryu and Ken at the climactic moment to put M. Bison out of action. All of these elements turn the anime into a reunion between the fighters that the players know so well. So much so, that their moves and special features merge with the history of the video game itself.

It is in contrast to the live-action adaptation directed by the American Steven

Street Fighter II: The Animated Movie, Gisaburo Sugii

Street Fighter II: The Animated Movie, Gisaburo Sugii

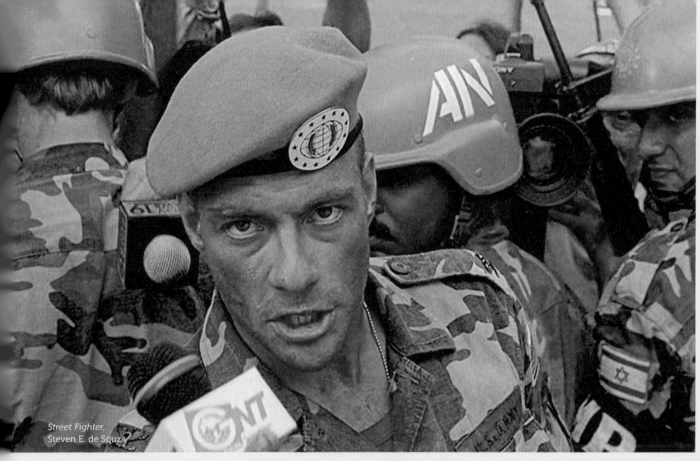

Street Fighter,
Steven E. de Souza

E. de Souza in the same period. For the past thirty years, cinema has been trying to transpose certain cult Japanese video games into film—from the disastrous *Super Mario Bros.* (1993) with Bob Hoskins to *Dragonball Evolution* (2009) directed by James Wong, and even the *Resident Evil* (2002–2016) saga brought to the screen by Paul W. S. Anderson. However, *Street Fighter* (1994) remains the standard of bad taste and grotesque execution. Respected for his work as a screenwriter on John McTiernan's *Die Hard* (1988), Steven E. de Souza combined poor ideas and filming sequences in this instance. It looks as though he imagined his movie to be a cross of *Star Wars, James Bond,* and war movies. One wonders what any of this has to do with the video game that, let's not forget, is nothing more than a gigantic street fight taking place in various places all over the world. And what can we say about the writing of the characters: the chivalrous Ryu and Ken are portrayed as vulgar bandits; Balrog, lieutenant of the big bad M. Bison, is turned into a cameraman at the service of journalist Chun-li, while Honda adopts the appearance of a Hawaiian sumo wrestler. In short, the movie openly mocks its model, and its flop was predictable from the beginning. Jean-Claude Van Damme succumbs to drugs, sometimes disappearing from the set. Raul Julia, cast to play the enormous Mr. Bison, draped in his flamboyant red uniform, became ill with stomach cancer, which forced screenwriters to rewrite his entire role. The illness would claim his life shortly after the movie's release. Despite its surprising commercial success, bringing in nearly three times its budget, viewers attached to the original game are quick to condemn it. It is the beginning of the end for Jean-Claude Van Damme, who has sunk into the depths of cocaine, and Steven E. de Souza's swan song, as he would never again return behind the camera. *Street Fighter* swallowed up its own fighters, taking them out of the ring. If not taken seriously, manga, video games, and cinema do not necessarily mix well—such is the lesson of this obscure piece, which, in spite of itself, has become the typical example of a B-movie.

Street Fighter, Steven E. de Souza

NO FUTURE

A bomb in animation cinema. This was the effect of *Akira*, manga by Katsuhiro Ôtomo published in six volumes from 1982 to 1990 and adapted in 1988. Three months after the release of Isao Takahata's *Grave of the Fireflies*, this hard-hitting work propelled japanimation onto the international scene—it was a time bomb, with the film failing in theaters before becoming a cult movie on video. And yet it had the biggest budget at that time (about a billion yen) for an anime featuring twenty-four frames per second (rare at that time). Ôtomo shatters all graphic standards, permanently imprinting his images on the retina. He delivers a political fable about humankind's destructive tendencies, as he manipulates science without conscience. Infused with a deadly energy, *Akira* unfurls an ultraviolent universe, sharp as glass. His azimuthal narrative, of a chilling irony, features a kind of ecstasy that transforms bodies and pulverizes the decor. The movie immortalizes a nihilistic vision of the future.

"Each era dreams of the next one," according to Michelet's beautiful formula, highlighted in *Metropolis* (2001) by Rintaro. The mutation of a part of Japanese animation toward dark futuristic works, exclusively for adult viewing, is the result of a new generation—a postwar generation. Katsuhiro Ôtomo and Mamoru Oshii (*Ghost in the Shell*, 1995) experienced Japan's reconstruction, its economic boom, but also the violent social conflicts of the 1960s. These filmmakers freed themselves from the influence of Osamu Tezuka, the father of manga and animated series (*Astro Boy*, 1963–1966), inspired by Disney and founder of the Mushi Production studio. They are more interested in popular culture and European comics: from *Métal Hurlant* to the work of the French cartoonist Moebius, the cyberpunk dystopia of William Gibson and Philip K. Dick, and Ridley Scott's *Blade Runner* (1982). In the wake of Gibson's seminal novel *Neuromancer* (1984), cyberpunk blends an aggressive, punk aesthetic with the hypertrophied advances of cybernetics. Omnipotent technologies, without safeguards, are put into the hands of corrupt organizations and men who establish a totalitarian and violent world. The future is represented with a skull and crossbones, Japanese style.

A disturbing coincidence: *Akira* was released in 1988, a year before the deaths of both Osamu Tezuka and Emperor Hirohito, marking the end of the Shōwa era (1926–1989). In the 1990s, Japanese animation extrapolated a dark future from the state of Japan and the world. It anticipated the worst and pushed the boundaries of calamitous hypotheses. It was right about the various tensions that would shake the planet, such as dehumanizing architecture, the strengthening of controlling societies, technology gone mad, globalized terrorism, bacteriological and nuclear threats, and the omnipotence of multinational companies at the helm of a voracious ultraliberalism.

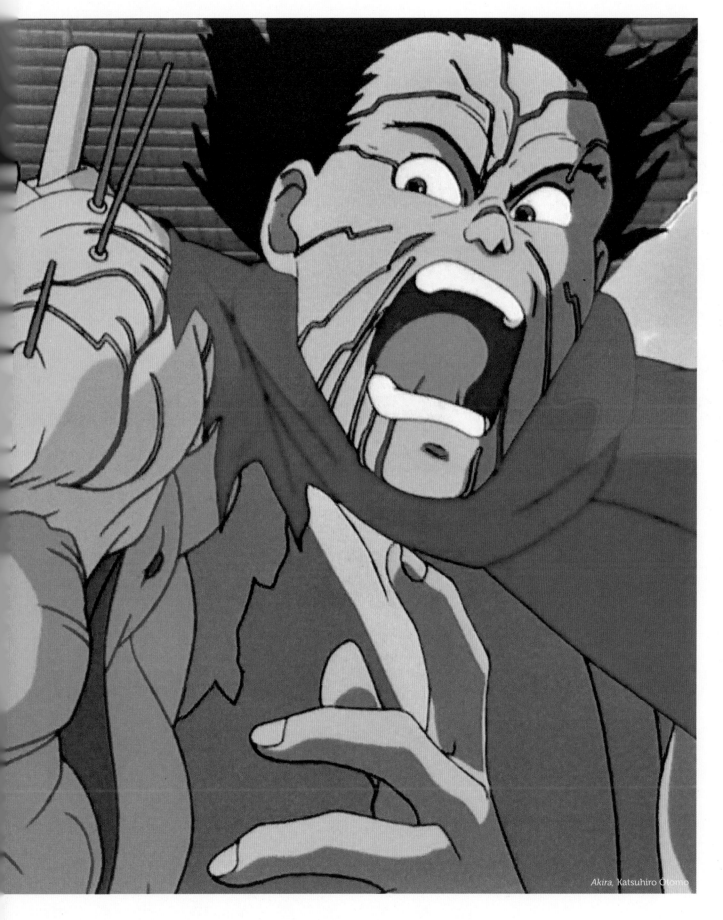

Akira, Katsuhiro Otomo

THE KISS OF DEATH

With its technological hypermodernity that crushes human beings, cyberpunk dystopia is a magnifying glass focused on the devastating impulses of humankind. Eschatological, it willingly exhibits the world's final images. Its imagined end of times, presented as imminent, is converted into paroxysmal stagings and pyrotechnic deluges.

Through sharp strokes, *Akira* imagines Neo-Tokyo in 2019, a degenerate society that has rebuilt itself on the ruins of the apocalypse. In 1988, during World War III, the megalopolis was devastated by a mysterious atomic explosion. Since then, the name of Akira—a mutant locked up in bunker number 28 (in homage to *Tetsujin 28–Gō*)—is rumored to be a threat, or something like a new messiah. Thirty-one years later, this fantasized Japan is once again the scene of scientific experiments conducted by a political-military consortium that is ready to do just about anything. In this drug-ridden urban hell, with an educational system resembling one used by correctional institutions, an angry teenage guinea pig—Tetsuo—and genetically modified child-elders threaten to destroy everything, perhaps for the last time. This is the fantasy of the final apocalypse, reminiscent of the Japan marked by the outcome of World War II. Otomo stages an ambivalent relationship with destruction that is anguishing and inhuman but also sublimated by his staging. The metamorphosis of the suffering bodies reaches incandesence. Faced with his compounding pain and fury, Tetsuo clings to objects, fusing with the metal, absorbing all its surrounding energy until he eventually becomes a monstrous biomechanical and magnetic lump. The complete reduction of this "rotten metropolis" into tiny pieces takes on an operatic dimension. The exploding bombs create fireworks that illuminate the darkness of the extinguished megalopolis, where the human soul is neither living nor dead. A macabre dance celebrates the end of the world; an end that celebrates a possible resurrection.

Thirteen years later, Rintaro connects the threads of multiple influences at the center of sci-fi and anime. His *Metropolis* is an adaptation of the manga by Osamu Tezuka, with whom he created Astro Boy. The round features of the young Kenichi are reminiscent of those of the robot child with both a heart and a conscience—the hero of the first Japanese animation series. The work is also a tribute to Fritz Lang's *Metropolis*, a masterpiece of German expressionism released in 1927. As for the script, it was entrusted to Akira's creator, Katsuhiro Ōtomo. This explosive cocktail offers the spectator another asphyxiating city in the hands of an evil tyrant who oppresses its population, divided between human beings and robots. To establish his planetary reign, the Red Duke manipulates Tima, an android who closely resembles his deceased daughter.

In *Metropolis*, the final bomb is hidden beneath the fragile blondness of a little girl with a perfectly human appearance. Unaware of her deeper nature and ultimate purpose, Tima is the innocent fruit of all transgressions. Her meeting with Kenichi humanizes her, allowing her to feel love and compassion. Hence, her absolute fury when she realizes that her artificial being has been created to enslave the population. From then on, her feelings and her memory are abolished, making her nothing more than a machine that engages its total extinction system. In a sublime finale, the angel of the apocalypse begins a massacre to the sound of jazz music, with "I Can't Stop Loving You" contrasting radically with the images. The kiss of death provokes a checkmate, even if some survivors sow the seeds of hope while birds sift through the rubble.

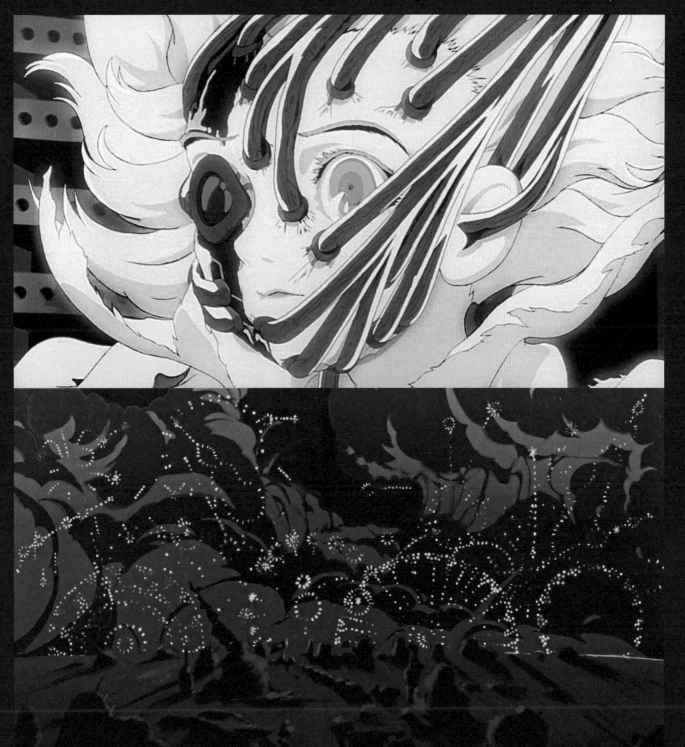

35

Robot Carnival, Katsuhiro Ōtomo

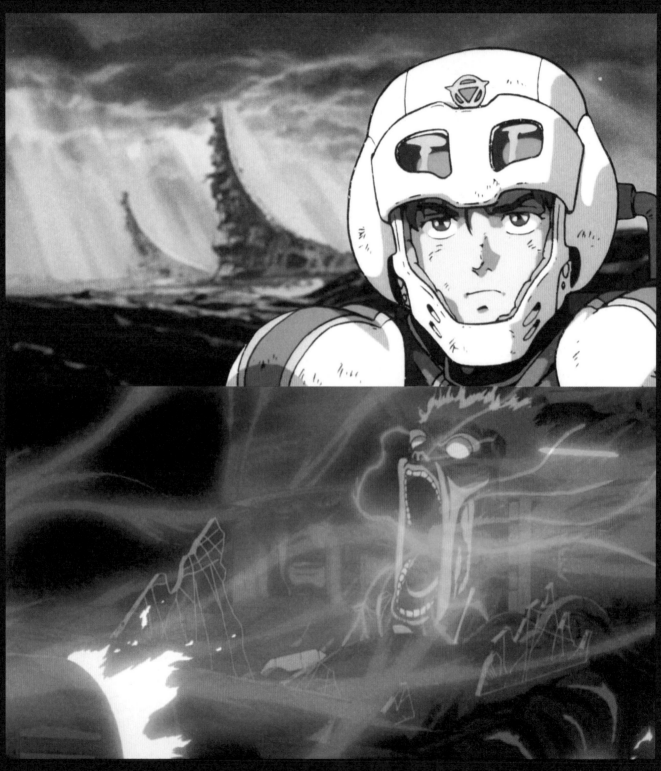

"The Racer," Yoshiaki Kawajiri

REBELS OF THE NEON GOD

" Dual ceramic rotor, two-wheel drive, fuck!" Plump and supersonic, Kaneda's red motorcycle is such a pop culture icon that Steven Spielberg brings it back in one of the races in *Ready Player One* (2018). It will forever represent *Akira*'s two-wheeled rebels, with a marginalized youth, delinquent not only due to boredom, but also in revolt against the totalitarian order and legalized violence. In symbiosis with their vehicles, Tetsuo and his friends zoom across the asphalt in defiance of a society gone haywire. The nightmarish city becomes a playground for biker gangs who confront each other, wearing leather jackets, tribal tattoos, or clown masks. From settling scores to feverish chases, they wreak havoc all over the city. Their anarchist backfires affirm, above all, their inalienable freedom, exhilarated by their speed, with their life and death instincts intertwined.

Another version of the "no future" theme, *Venus Wars* (1989) by Yoshikazu Yasuhiko also follows young bikers who rebel against the authorities. Now provided with an atmosphere, Venus is a grayish industrial zone. At the center of all the covetousness, it is shaken by endemic violence. In the face of generalized chaos, an idle youth throws himself fully into motorcycle races, where anything goes. When, in 2089, Ishtar invades the capital, previously held by Aphrodia, Hiro's first move is to smash a tank located near his former circuit. A model of a disillusioned antihero, distrustful of all corrupt institutions, he finds himself pulled into this dirty war for power against his will. His bike, loaded with cannons, makes sparks fly on the battlefield. But as soon as he can, he takes the road and rides away like a bat out of hell.

A real sensory shock, *Redline* (2010) by Takeshi Koike combines apocalyptic science fiction with lawless racing cars. The most famous of these competitions pits outstanding pilots against each other, stepping on the gas and shooting missiles at everything. Faced with a centaur that has merged with his engine or with devilishly sexy enchantresses, JP is the stylish outsider who fights without weapons, with an old-fashioned car sporting a modified engine, wearing a rocker's quiff in the style of Elvis Presley. Hybrid beings (human/animal/machine) with rough features populate this dystopian future. As if that wasn't enough, the military of Roboworld, the planet where the Redline is held illegally, want to exterminate the racers using disintegrators and biological weapons in the shape of a giant monster. With its crazy kinetics, saturated with sound and fury, the movie glamorizes speed and movement, twisting the images, perspectives, and bodies—that is, the very essence of animation itself.

Sometimes the pilot simply races with death. Pure nihilism. A masochistic short film, "The Racer" (in *Manie Manie*, 1987) shows the final lap of Zack, the undefeated Death Circus champion. Director Yoshiaki Kawajiri scrutinizes his bloodshot eyes and his face twisted in pain. His body and nervous system are at one with the car, consumed by stress. Driven to madness, he ends up annihilating himself at high speed: game over. Continuing on alone past the finish line, his car takes him to join the ghosts of deceased competitors. Ironically, his final self-destruction is magnified by hypnotic music, as well as swirling dancing flames that trace superb figures in the air.

Thus, the racing cars of animation defy both space and time, uttering their roars of revolt or their bloody swan songs.

THE CITY OF LOST CHILDREN

During its High Growth period (1955–1973), Japan experienced unbridled urban change. Low-income housing complexes and their rabbit cages sprang up in an attempt to absorb the country's overpopulation. Like a distorted mirror of Asian cities, dystopian animation often offers only a compact network of sky-scrapers, lit by aggressive neon lights and advertising holograms. Between the mass of rough concrete and sleek glass towers, the hybrid city of *Ghost in the* Shell (Mamoru Oshii) combines the concrete memories of Hong Kong with a phantasmagorical archi-tecture. Anxiogenic, dehumanized, sprawling: the architecture of futuristic megacities reflects a style of political thinking as it alien-ates the population and contaminates its psyche.

What is the design used for these cities, be they postapocalyptic or on the brink of abyss? There are two main trends: *Mad Max* or *Blade Runner*. In one of these, there is a sunless universe with its relics that has fallen under the tribal power of lawless clans, much like *Fist of the North Star* (1984–1987 series and 1986 movie by Toyoo Ashida). Following a nuclear war, a few half-collapsed buildings with shell craters stand painfully in the middle of the burned land. Hordes of bikers decimate the survivors in order to plunder the meager resources left, while the aspiring masters of the world engage in battle. In the other, monstrous megacities are dominated by a few powerful people. Rintaro's *Metropolis* is based on a vertical stratification representing social segregation. From the top of his tower, the Red Duke skims the mountaintops, rendered in twilight due to the class struggle. Organized like an amusement park devoted to consumption, the city below is home to ordinary people. It is also the setting for the summary executions of the robots guilty of trespassing into zones assigned to other species. Because, in this totalitarian world, mechanical beings are discriminated against, reduced to the rank of slaves

and parked in the bowels of Earth. If zone -2 hides nuclear power plants, zone -3 collects all urban waste. It is there that Kenichi and Tima land after the explosion of the laboratory where androids were conceived. Their journey is, therefore, an attempt to go back to the light, no matter what.

Several films contrast two realities at opposite ends of the spec-trum. Among the first manga to be successfully exported to the West, the dystopia *Gunnm* (1990–1995) led to the creation of two original animation videos (OAV, for works that are released directly on video), before being filmed in live action by Robert Rodriguez (*Alita*, 2019). Following a meteorite explosion, humanity is cut in two. Suspended in the sky, the elite city rejects the scum of the earth. In this gigantic open-air garbage dump, cyborgs, heightened men, bounty hunters, and criminals wage a merci-less war. Following a third world war, *Appleseed* (a 2004 film by Shinji Aramaki, a remake of a 1988 OAV) repeats this score. An extraordinary fighter, Deunan Knute is taken from Earth's ruins, where survivors continue to fight with the help of killer robots. She is brought to the utopian city of Olympia, where humans and "bioroids," cloned from human DNA to ensure universal peace, coexist together peacefully. This sheltered city, with its vegetated glass buildings, is as disembodied as the cyborgs who govern it—forbidden from reproducing and strangers to the emotions that are the root of all evil. When this beautiful system finds itself caught in a new war of the worlds, utopia turns into counterutopia. And the ancient stigmas come to ransack the ivory towers, reinjecting a primitive chaos back into society.

In the end, all these architectures of evil seem to be built to keep the teeming people under wraps, mixed with those pretending to be human.

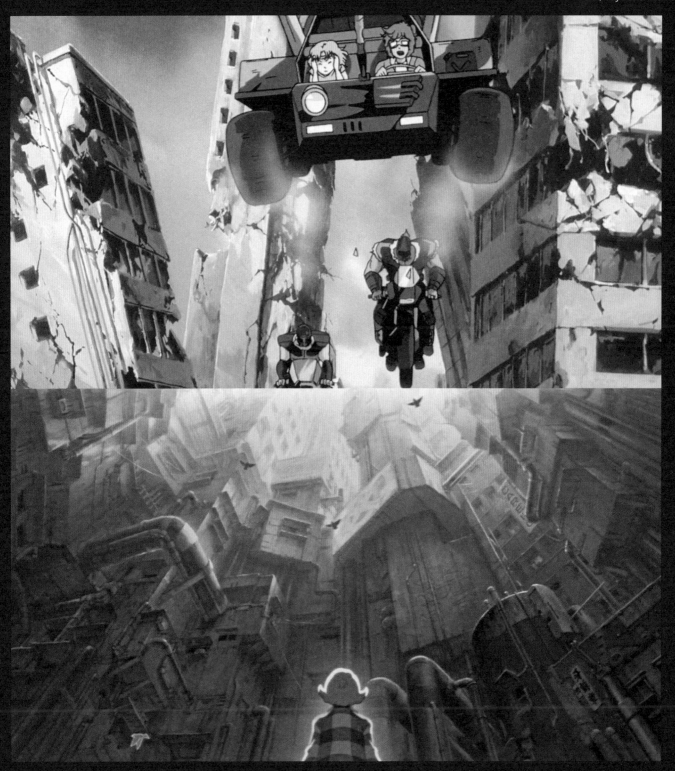

Fist of the North Star, Toyoo Ashida

Metropolis, Rintaro

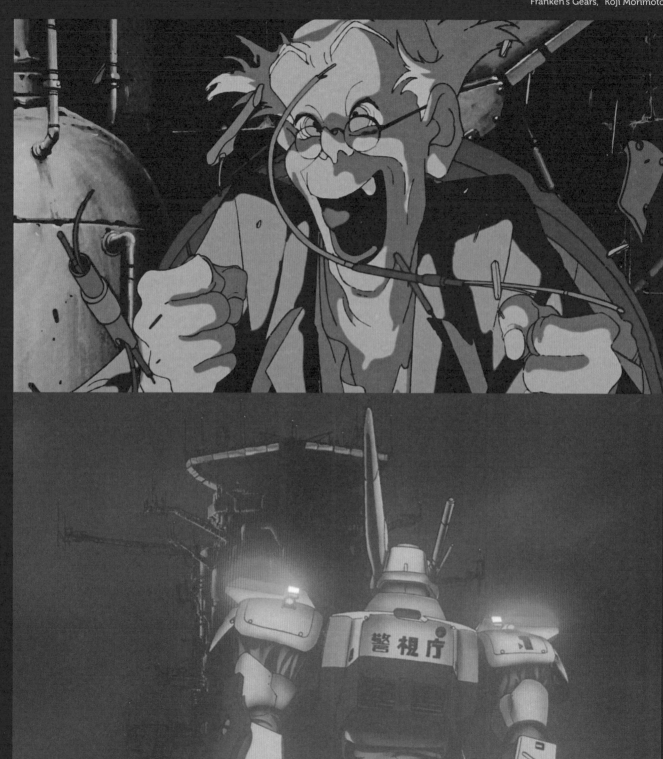

鏡の國のアニメ

40

Patlabor, Mamoru Oshii

To satisfy their desire for power, humans are always making more plans. Their elucidations feed the delirium of mad scientists who seek to ward off the final frontier between life and death. Included in *Robot Carnival*, "Franken's Gears" (1987, Kōji Morimoto) revisits the story of Frankenstein. Like a sorcerer's apprentice, the creator holds a world globe at arm's length, thinking he holds the fate of humanity in his hands. He shoots lightning bolts to bring a gigantic electric creature to life that imitates all his gestures. When he inadvertently falls, he ends up crushed by the robot's embrace, before the globe explodes. Since these aberrations of nature resemble those who shape them, it is therefore not surprising that they display deadly impulses.

Dreaming of a new dawn that is favorable for the fusion of flesh, metals, and computer programs, enlightened scientists allow themselves to be exhilarated by the illusions merchants (military, politicians, multinational companies). Unable to control these ultimate weapons, they all end up on the brink of extinction, having unleashed unlimited forces. Several anime explicitly summon the great myths of destruction. Director Mamoru Oshii, a fan of biblical references, updates the parable of the great flood in his postapocalyptic poem, *Angel's Egg*. For its part, *Castle in* the Sky denounces the hubris of people who think they are God. Muska is one of Miyazaki's few monolithic villains. Ecstatic and crazy, he proclaims himself King of Laputa: "In the Bible, it was fire that destroyed Sodom and Gomorrah. In the Ramayana, it is the arrow of Indra. The whole world will, once again, bow down to Laputa." With lightning bolts and bombs, waking up the killer robots, he launches into a demonstration of the powers he intends to use to his advantage. And that will lead to his stony punishment.

Metropolis and *Patlabor* (1989, Mamoru Oshii) are full of biblical references to proud Babylon and its Tower of Babel, which suffered the wrath of the vengeful Old Testament God for daring to reach for the heavens. With the support of his fascist militia Marduk, the Red Duke's political plot aims to place his "daughter" Tima on the throne, high up in the Ziggurat tower. All these names come from Babylonian legends. Like many scorned artificial intelligence lifeforms, Tima decides to take revenge by simply eradicating humans, who are completely helpless to her powers, which defy all comprehension. "And the wrath of God descended on the Tower of Babel," comments the Japanese detective, initially tasked with stopping the rogue scientist who brought the out-of-control android to life.

In contrast, *Patlabor*'s brilliant and crazy computer scientist, once called Jehovah, intends to repeat the divine punishment and destroy Tokyo thanks to a virus named...Babel! In an uchronical Japan, set in 1999, the Babylon project intends to solve the overpopulation problem by building artificial islands. However, the melting ice caps cause the water level to rise dangerously, renewing the very real fear that the archipelago will become completely submerged. Tokyo is nothing but a vast construction site, where

SODOM AND GOMORRAH

Under the pressure of generals, politicians, or depraved entrepreneurs, science and technology deviate from their orbits. They create a degenerate state of nature that leads to a dog-eat-dog warfare. Respecting the general public's expectations for the franchise, the first *Patlabor* dealt with the derangement of robots designed to ensure the safety of the population in a classic way. Back at the helm for a second opus (*Patlabor 2*, 1993), Mamoru Oshii asserts his vision, taking political thinking up a notch and virtually removing Labors from the equation. He intends to show that nobody's hands are ever completely clean during wartime and, more cynically, that peace is nothing but a pretense built over dead bodies—a parenthesis that poorly masks dormant conflicts. This is what Captain Tsuge apparently wants to prove thanks to complex machinations. After witnessing a bloodbath during a UN peacekeeping operation in Southeast Asia, he plots a terrorist attack in Japan. With the help of fake images, relations with the United States are tightening like an arrow on a crossbow. However, the plot is internal and, as such, unreadable. This game of Russian roulette involves the military, intelligence agents, and corrupt officials, to the point where the entire system is corrupt. A wintery Tokyo, in the grip of terror, is invaded by tanks and helicopters: the city waits, under siege, on the brink of civil war. Tsuge's motivations are more than a little unclear. Is it to highlight the security weaknesses of Japan, who has added the renunciation of war to its constitution? To rehabilitate militaristic Japan through a fake coup? Or, on the contrary, to denounce a totalitarianism that awaits, as always, to rise from its ashes? Oshii blurs the message but delivers a dry reflection on the history of Japan, its alliance with the Nazis, its decimation by the atomic bomb, its occupation by the Americans, and the revival of its industry thanks to the Korean War.

CONSPIRACY THEORIES

And he does it again in *Jin-Roh: The Wolf Brigade* (1999). Hiroyuki Okiura is the director, but it is Oshii who is responsible for the manga that inspires the film (*Kerberos Panzer Cops*) and screenplay. A decade after being invaded by Nazi Germany at the end of World War II, Japan is on the verge of imploding, constantly on the warpath against internal enemies. The country is prey to anti-government rebels—notably the Sect—who continue to multiply their attacks, and also to the various official defense bodies who are each fighting for their own supremacy. The latter hatch convoluted plots to destroy their competitors, bullying ordinary people in the process. This military rewriting of history takes the idea that "man is a wolf to man" literally, as the philosopher Thomas Hobbes put it. It is also a sordid variation on the tale of *Little Red Riding Hood*, a source of dark poetry throughout the fiction. When Fusé, an agent belonging to a clandestine branch (the Wolf Brigade) of the POSEM security police, fails to shoot a suicide bomber who blows herself up, he uncovers a web of dirty tricks. Coming from all sides, they perpetuate the endless circle of violence. "And so the wolf devoured Little Red Riding Hood."

In these two works, Oshii uses a cinematic metaphor to describe the essence of the plot: a script, actors, a director, and overly gullible viewers. This nonsense, which pits people against each other, has a concrete consequence: It prophesies the end of the social and the political systems, which are collapsing on themselves.

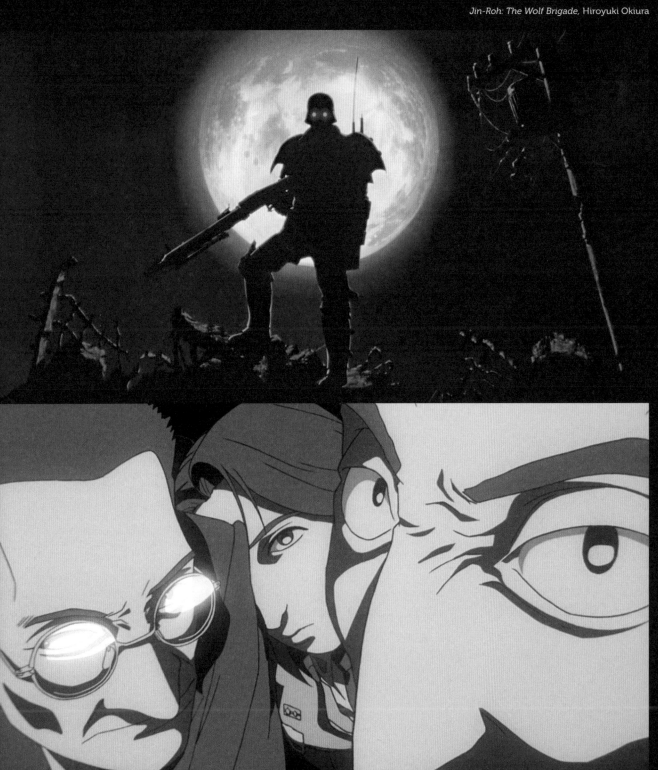

鏡の國のアニメ

44

ANIME THROUGH THE LOOKING GLASS

Blame!, Hiroyuki Seshita

In hard science fiction, technologies that are pushed to their limits decimate the humanity that developed them: genetic experiments go wrong (*Akira*), artificial intelligence life-forms free themselves (*Ghost in the Shell*), cyborgs escape their creators (*Metropolis*), and contaminated robots become killers (the *Ergo Proxy* series, 2006). These deranged beings are the very reflection of the delirium responsible for their conception. Humanity is punished for its sins.

In *Tetsujin 28–Gō* (Yonehiko Watanabe, 1963–1965), the forerunner of the *mecha* series, robot soldiers are created during World War II to ensure Japan's victory. Completed only after the conflict, they are piloted by remote control. The remote control box that activates them becomes the object of all covetousness. And it falls more often than not into the wrong hands, which turn these iron giants against society.

If war is the driving force behind the most perilous inventions, unbridled economic growth is not far behind. This absurdity is denounced by Ôtomo's "Order to Halt Construction" (in the collective film *Manie Manie*). A salaryman (a Japanese businessman) is sent to a remote jungle that has just had a coup. His mission: Stop a real estate construction project in a swampy area—a major sinkhole for the company. The obstacle: The construction site is directed by robots programmed to eliminate all those who slow down the construction work. Imprisoned and powerless, the employee watches the master builder pick up speed until it overheats. The one hope left is to deactivate the central computer. However, the announcement of a new coup d'état leads to a counterorder from his company: Work must resume as soon as possible. He hears nothing as he climbs the sprawling network of cables that lead to the heart of the system with a knife between his teeth.

The loss of control over the biomechanical beings that were supposed to accelerate Tokyo's reconstruction following an earthquake is at the heart of the OAV series *Bubblegum Crisis* (1987–1991). Mass-produced by the GENOM multinational, the Boomers take out a vendetta against those who oppressed them. In *Blame!* (Hiroyuki Seshita, 2017), rare survivors hide from the Builders and the Backups—and to think they once controlled these machines. Through the use of a virus, these extra-human entities have taken over and are now in power. They exterminate humans, declared illegal residents of their city, which is undergoing uninterrupted, anarchic development. Worse still, the new generations have lost any memory of how the system developed by their ancestors worked.

MISTER ROBOT

Blinded by their own presumptuousness, some people believe that innovation—no matter how ubiquitous or inhumane—cures all evils. In animation, ethics are (almost) always replaced by technique. *Roujin Z* (1991, Hiroyuki Kitakubo, based on a screenplay by Otomo) is a chilling tragic-comedy fable. To counteract the aging population, the Ministry of Health is promoting computerized robot beds that are capable of caring for the elderly and meeting their needs from A to Z—unaware that it is being manipulated by a military organization. The first guinea pig is taken from his home to be perpetually connected to the bed's electronic components. His former nurse revolts against this dehumanization. Hacked by an endearing group of sweet old men, the machine itself rebels, dragging the old man along in its crazy race. During its journey, it mutates into a devouring beast that aggregates everything in its path before finally exploding.

The monstrous metamorphosis of technologies that are supposed to serve humankind is a constant in cyberpunk dystopia. Transformed into magnets, the empowered creatures destroy everything within their reach. They eagerly suck up energy, materials, bodies, and souls.

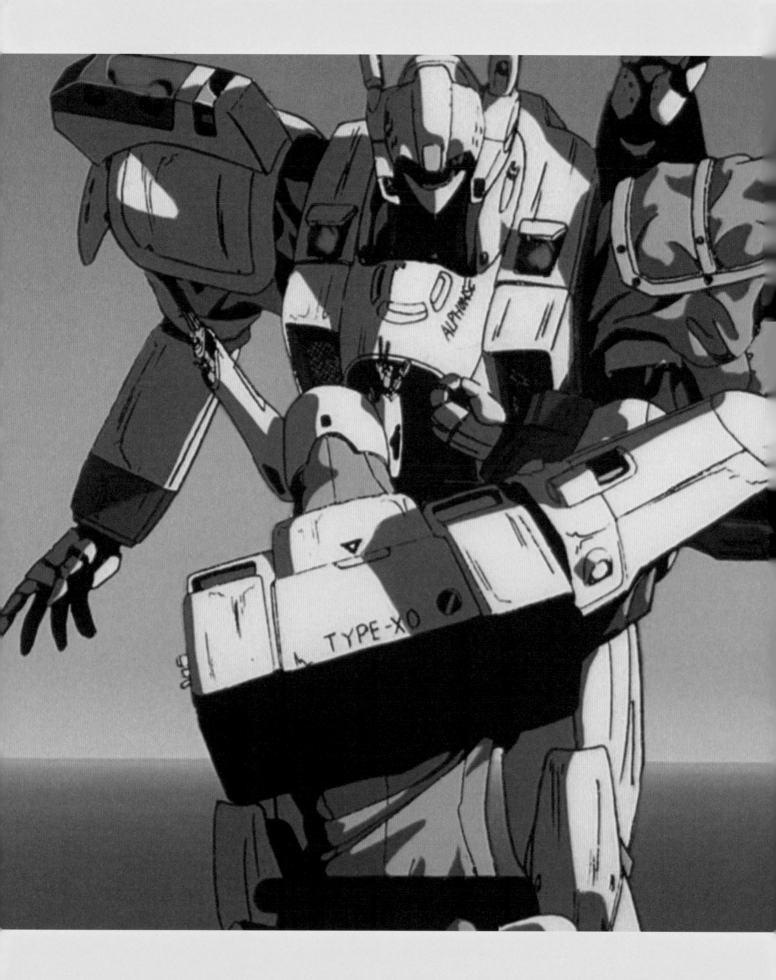

MECHA AND KAIJÛ IN HOLLYWOOD

In summer 2013, as DC Comics and Marvel adaptations began a Hollywood onslaught, casting a shadow over the seasonal blockbusters, a dark horse was released in theaters: *Pacific Rim*. In the era of endless saga franchises (*Fast and Furious,* 2001–), of reboots, and an infinity of spin-offs (such as the *Star Wars* universe since its Disney takeover), as well as the barely disguised rehashes of 1980s hits—locking the film industry into a kind of time loop—Guillermo del Toro's movie appears like an unexpected but lifesaving hit. Buoyed by the commercial success of *Hellboy* (2004) and the critical success of *Pan's Labyrinth* (2006), feted at the Cannes Film Festival, the Mexican moviemaker—who would win an Oscar in 2017 for *The Shape of Water*—was entrusted with a budget of two hundred million dollars to write and direct the final battle between giant robots (the Jaegers), piloted by human beings, and monsters who spring up from the depths of Earth. It is the confrontation of two figures straight out of Japanese culture: the *mecha* and the *kaijû*.

Guillermo del Toro, geek par excellence, fascinated by ghost and monster stories since his teens, is not the first moviemaker to have broken through the Hollywood fortress in order to spread such Japanese mythology. In 1987—two years before the first *Patlabor* by Mamoru Oshii—in *Robocop,* Paul Verhoeven (a Dutch director who went to the United States on the advice of Steven Spielberg), created a new kind of police force made up of futuristic robots charged with protecting a Detroit city plagued by gang violence, using Japanese imagery. This is what the scriptwriter behind the original story, Edward Neumeier (in the cinema review magazine *Torso,* no. 12, 2015), says: "There is something about machinery in Japanese culture, from the illustrations of Hajime Sorayama [to] the *mecha*... ED–209 [a gigantic robot with an articulated head and a rocket launcher arm] was inspired by a Japanese toy. The Japanese clearly have a great influence in today's science fiction, through manga, and place a particular focus on robots. In fact, having human-shaped robots seems to be a big part of their aesthetic." However, *Robocop* is not the genre's prototype; it instead follows the same lines as *Aliens* by James Cameron, released one year earlier. A sequel to the first *Alien* (1979) directed by Ridley Scott, this film's final

Patlabor, Mamoru Oshii

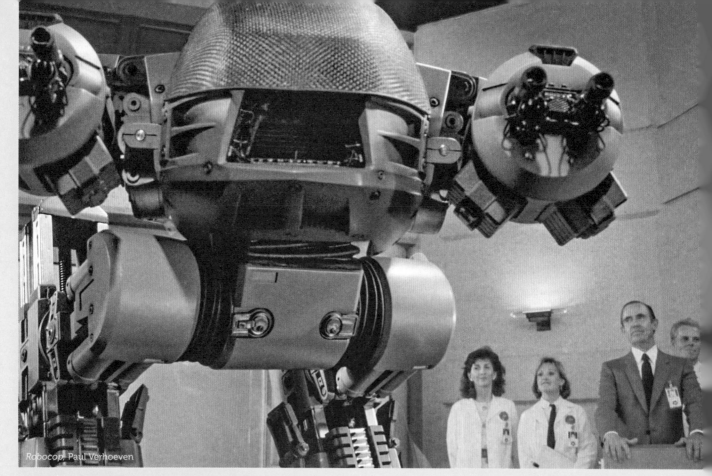
Robocop, Paul Verhoeven

act features a Homeric battle opposing the queen of the Xenomorphs and Sigourney Weaver, harnessed in a robotized armor, filmed from every angle—an intense battle that is widely remembered as the official introduction of the *mecha* to Western science-fiction cinema. In short, since the end of the 1980s, many leading moviemakers have paid tribute to the Land of the Rising Sun, whose imprint is gradually becoming stronger around the world.

Nevertheless, whereas these works contain so many discreet tributes to Japanese culture by infusing their aesthetics in the subtext, Guillermo del Toro makes it the explicit framework and the direct subject of his movie. *Pacific Rim* is nothing less than a collision between the typical American summer blockbuster, designed to fill theaters in the July heat, and a geek fantasy that has long yearned for a movie of this magnitude to tackle the teeming imagery from Tokyo head on. A fusion comparable to the "drift" of the two main characters: the American Raleigh Becket, a former ranger mourning the death of his brother, and the Japanese Mako Mori, the sole survivor of a *kaijū* that wiped out her family. Both are forced to connect their

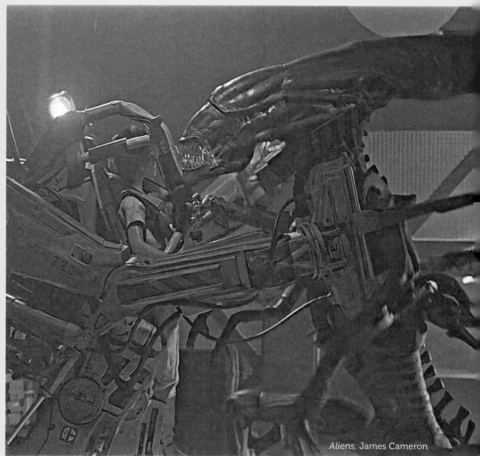
Aliens, James Cameron

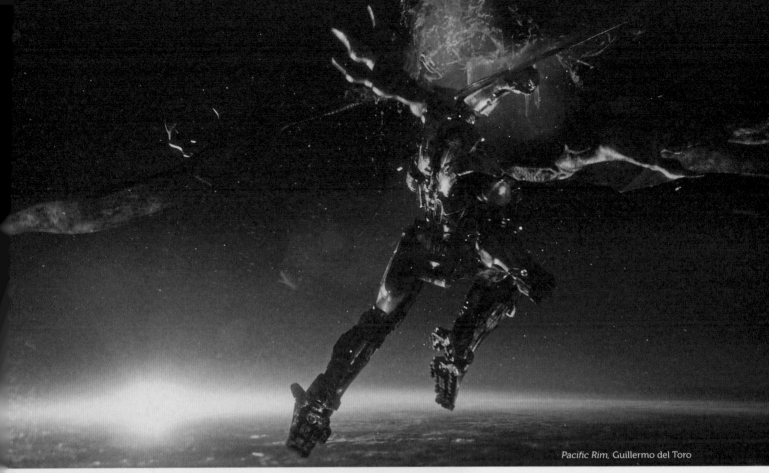

Pacific Rim, Guillermo del Toro

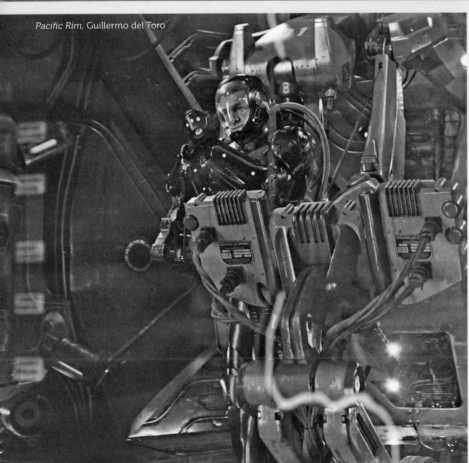

Pacific Rim, Guillermo del Toro

brains to master the phenomenal power of the robot they are operating. In truth, the whole movie is marked by the fusion of the minds. In a flashback retracing the heroine's tragic youth, Godzilla, an emblem of Japanese pop culture born of the trauma caused by the atomic bombings of Hiroshima and Nagasaki, is summoned along with the chivalric iconography of the chanson de geste, born in medieval Europe. Similarly, the sword strike that concludes a duel in the sky, a few hundred yards above the city of Hong Kong, is as much Arthurian legend as robotic fantasy. In fact, from the end of the prologue, the influences are embedded to such an extent that the viewer (almost) makes them his own. As if, in spite of its Western package, the heart of the movie was beating to a Japanese rhythm. It took a genius moviemaker like Guillermo del Toro to achieve such syncretism.

GHOST IN THE SHELL

These words are spoken at the beginning of *Ghost in the Shell* by Mamoru Oshii: "2029. Computer networks stretch across the universe"—and this was before the Internet colonized our lives. A true phenomenon, the work is striking for its philosophical depth. What happens to the consciousness boosted by electronic implants and disconnected from the mutant body? For the visionary filmmaker, imagining the future in the 1990s implies a return to "the most primitive archaism": "This highly developed technique, this frightening future is nothing more than what was once called "magic." From ghosts to androids, from wizards to Frankenstein, from automatons to cybernetic human beings, there is just one step that moviemakers who are ahead of their time happily take. Never before has the alchemical transmutation of humans, robotics, and artificial intelligence come to life with such acuity.

All the more so since technological innovations are revolutionizing animation, allowing the analog and digital to mix. It is now possible to hybridize traditional handmade drawings with 3D computer graphics. The opening credits of *Ghost in the* Shell set the trend: the assembly of the cyborg is coupled with its computer simulation, while lines of fluorescent green code scroll by at top speed (anticipating the Wachowskis' *Matrix*, 1999). The metallic carcass, at first inanimate, transforms into a perfect copy of a human being gifted with movement right before our eyes. Animation breathes life into all the futuristic fantasies and resonates with those of the twenty-first century transhumanists, who envisage improving humans and doubling their life expectancy.

The 1990s and 2000s have definitely given *eiga* manga, according to the expression used by studio Ghibli to designate this art, its credentials. Animation is cinema. In 2001, *Spirited Away* won the Golden Bear in Berlin and the Oscar for best animated film. In 2004, *Ghost in the Shell 2*: *Innocence* was part of the official selection of the Cannes Film Festival—a first. The Production I.G. and Madhouse studios planted the seeds, and new authors, such as Satoshi Kon, blurred the boundaries of reality, dreams, and the virtual. Pessimistic and tortured fables about our future exploded in the face of spectators, at a time when the Japanese economy was crashing on speculative bubbles. The prospective dimension of animation was running at top speed, just before the emergence of the Internet, social networks, and augmented reality headsets that made the virtual image and experience more real than reality itself. These are prophecies that David Cronenberg would have agreed with, being that he analyzed the new television empire as early as *Videodrome* (1983): "Television is reality, and reality is less than television." Today, screens are, indeed, as he predicted, "the retina of the mind's eye," gradually surpassing our concrete world of experiences.

鏡の國のアニメ　50

ANIME THROUGH THE LOOKING GLASS

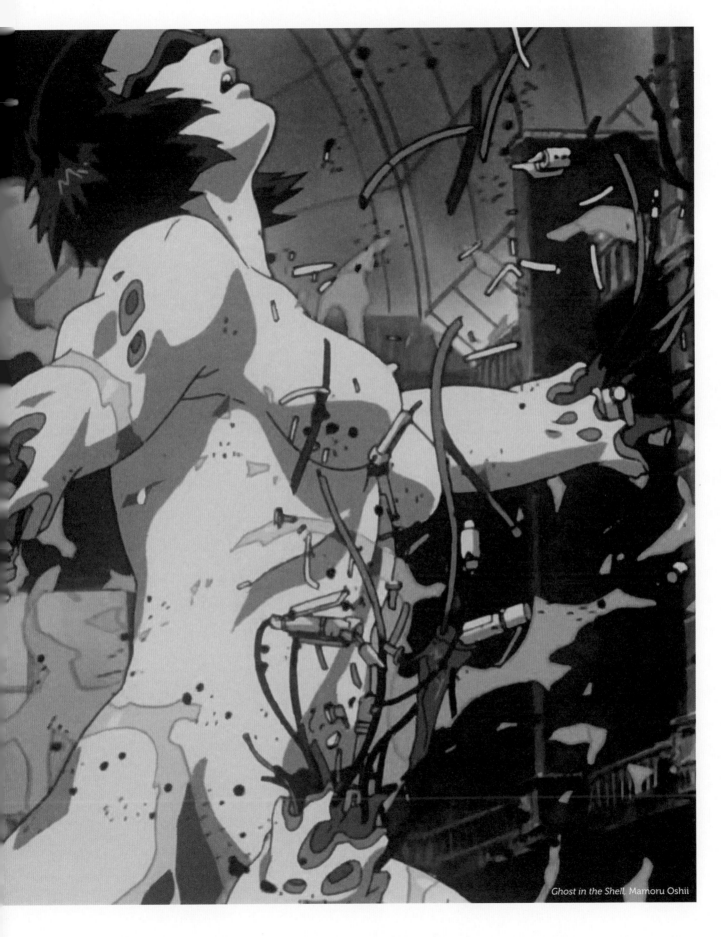

51

Ghost in the Shell, Mamoru Oshii

HUMAN, ALL TOO HUMAN?

Man versus machine. What does he change into when he merges with his mechanical or digital double? What identity does the being endowed with prostheses that increase his physical and mental performance have? This common thread of science fiction has flourished in a country with a passion for robots. So much so that Japanese animation has explored new dialectics of body and mind.

On the one hand, a poor little mortal body; on the other, an eternal mechanical body. This split is at the center of Rintaro's film *Galaxy Express 999* (1979). Tetsurō's mother, who was murdered by the cruel *mecha* count, had a dream of boarding the Galaxy Express 999 train to obtain a body-machine on Andromeda, which he pursues. His initiatory journey leads him to meet a new species. On Pluto, the ghostly guardian of an ice cemetery worships and mourns her original incarnation. On the train, a transparent crystal waitress without facial features works tirelessly to get back her previous flesh. It is impossible to ease a cyborg's melancholy. Cold and smooth, technology dissipates the aura of those who succumb to the smoke and mirrors. Losing one's inherent substance, much like immortality, is ultimately dehumanizing. Promethium, ruler of Andromeda, also engages in genocide, and she lures Tetsurō so she can turn him into electronic components. Her people need to absorb intangible human qualities, such as courage. *Adieu, Galaxy Express 999* (1981) is inspired by the cannibalistic conclusion of Richard Fleischer's *Soylent Green* (1973). The mechanical beings sustain themselves with energy pills produced from crushed human bodies—a finale replayed in Mamoru Oshii's *Ghost in the Shell 2*, version 2.0, where a company steals the souls of lost young girls in order to make animated sex dolls more seductive.

At the end of the 1970s, space opera was already orchestrating fights to the death between species, while preserving the integrity of the living. In the 1990s, the hybridization between humans and technology was more ambiguous. In *Neon Genesis Evangelion*, two life-forms—one too many—clash, but any Manichean antagonism unravels. At first glance, heroic teenagers fight monstrous Angels, who share 99.99 percent of *Homo sapiens*' genes, with the help of their giant robots, the Evangelions or Evas. The Evas are in fact the Angels' alter egos, born of Adam. This first creature even gave birth to two of the pilot children, Rei and Kaworu. His body and soul have, thus, been resurrected into some human beings, blurring the clear division between both life-forms.

The protagonist is, incidentally, plagued by depression. Shinji pilots his Eva under duress, in search of his father's love and the recognition of others. But once the fight is over, he loses his reason for being. Who am I if my identity is no longer defined by this robotic shell with which I synchronize with to defend humanity? True experimental delirium, the two concluding episodes of the anime are similar to a psychoanalytical treatment that slips into aggressive interrogation. Intertitles pepper the hero with existential questions and answers, as do his comrades: "Why do you fly?," "Separation anxiety," "Who are you?" Shinji falls into the abyss of questioning, "Is it me? The real me? The fake me?" In extremis, he manages to assert himself and to break out of his expressionist prison. This ending, which expands its graphic palette to the point of vertigo, so destabilized fans that Hideaki Anno had to propose an alternative version in the movie *The End of Evangelion* (1997). Nevertheless, the moviemaker has used original means to underline the psychic flaws born from the confusion between human and machine.

53

" Since the arrival of technology, man is able to fulfill his desires. We are the best of the best. Controlled metabolism, boosted brain, cybernetic body. Until recently, we were but science fiction." The sentence is clear: *Ghost in the Shell* unravels the human/machine separation. Human beings are now made up of a clever mix of both organic and technical components. Its original format is replaced by copies (upgrades or downgrades). The movie's cyborg heroine makes a dramatic entrance: an angelic leap from a city tower, after tearing out her power cables and revealing her erotic body without genitals. Motoko Kusanagi, a major in the antiterrorist section 9, goes after the Puppet Master. The centerpiece of Project 2501 orchestrated by section 6, this computer program was originally designed to hack the brains of public officials for both industrial espionage and intelligence manipulation purposes.

Hybrid, overpowering, and sometimes melancholic, the major never stops questioning his identity. What about subjectivity, when his borrowed body (shell) is made up of robotic and electronic implants? This empty shell belongs to the government, as does its secret-filled memory. Kusanagi has only his own ghost, a refuge of the "self" and the last vestige of humanity. In this transhumanist society, old-fashioned human beings—not modified—are marginalized and doomed to programmed obsolescence. All are threatened to be colonized by artificial intelligences capable of implanting false memories into them. In a soaring sequence, Kusanagi emerges from a dive to the bottom of the ocean and meditates on what constitutes her innermost being: her thoughts that are hers alone, the meaning of her destiny, the way she processes the plethora of network information. In short, her conscience. Yet she feels confined, her evolution limited. This is why she will ultimately choose to dissolve into the computer matrix.

HYBRIDIZATION

A variation of the first movie, *Ghost in the Shell 2: Innocence* almost dispenses of its iconic heroine, who returns only to lend a hand to her ex-teammate Batou. Tired and disillusioned, he is forced to investigate gynoids—female androids—who exterminate their owners before committing suicide. An inadmissible infringement of the moral code is engraved in the system of these robot dolls, who imitate their human models. Throughout his journeys, Batou (himself a cyborg) philosophizes about augmented beings and artificial life. To the forensic scientist for whom the difference between human beings and robots is only a matter of faith, he reminds that "Descartes did not distinguish between man and machine, the animate and the inanimate." His main antagonist, Kim, is a total cyborg who has chosen a criminal path. His diagnosis is undeniable: since being equipped with all kinds of components, the man is now literally a machine, calculable, reducible to his attachments and to his digital data. These beings are devoted to an aggressive form of self-mechanization so they can exceed the limits of their own functioning. However, in doing so, they can no longer be sure they really exist. That is where their underlying terror of living dolls comes from. A supreme paradox explored by animation that leads viewers into the "Valley of the Strange." This concept, by roboticist Masahiro Mori, designates the trouble that seizes us when faced with anthropomorphic robots: they are too similar to human beings but, at the same, far too artificial, maintaining traces of a rigor mortis reminiscent of our own mortal condition.

55

Neon Genesis Evangelion, Hideaki Anno

Serial Experiments Lain, Ryutaro Nakamura

Technological progress has increased tenfold, giving rise to a desire to supersede Darwinian natural selection—to make the human species evolve toward new life-forms by freeing itself from the body. This is the obsession of certain enlightened people.

The hidden goal of some of the leaders of *Neon Genesis Evangelion* is to bring humankind to the final stage of evolution, through a Third Impact between the Evas and the Angels. The aim behind the "project of complementarity of the souls" is for humanity to recover its original state and is based on the Great Whole. With its uncertain ending, the original series keeps all options open. This demented idea takes on an eschatological meaning, like a return to an undifferentiated and transcendent form within Mother Earth. But it can also be understood metaphorically: After having defeated the last Angel and having endured a violent inner turmoil, Shinji overcomes his identity disorder by allowing himself to connect to others and by also becoming the sum of all his relationships.

Others rely on their dematerialization within the network's unlimited universe—a source of absolute power. Such is the case of the Puppet Master in *Ghost in the Shell*. During journeys through the infinity of digital data, this artificial intelligence becomes aware of its own existence. It escapes its creators and begins to consider itself as a thinking, living entity. A new form of sentient life, born from the ocean of information technology, it intends to break free from its chains and rise to a level of consciousness that has never been seen before. To achieve this, it needs to merge with Major Kusanagi. At the end of the film, their intertwined voices sing the prophecy of the new times: "And now, where will the newborn go? The Net is vast and limitless."

DARWIN'S NIGHTMARE

What use is the body if one can sail freely in Wired? In the series *Serial Experiments Lain* (1998), teenagers commit suicide and send postmortem emails to the living: "I can be anywhere, no matter what happens to my flesh." At the center of the matrix with its mythical powers, the body is no more than a hologram of information: consciousness, a sum of electrical connections, and a place where memory is either rewritten or erased. The voices of Wired are railing against the neoteny of humans—turned into useless animals, agitated by hollow desires—unable to continue their evolution. For the proponents of this new religion, diving into the Network is the only way out. Instead of being just sad, separate monads, people will finally be truly connected to one another. Better still, the god of Wired intends to break the barrier between the two universes to interconnect them without the need for any devices. All this thanks to Lain, whose essence is indefinable. This introverted high school student experiences the splitting of her identity into several avatars, who run rampant in the virtual world against her will. "Who are you, Lain?" is repeated like a demonic mantra. The character's three incarnations result in increasingly violent interferences. To understand the nature of her wild double who sets the Web on fire, the shy young girl becomes a geek, turning her childhood bedroom into a cyber cave. A third Lain—pure evil—seeks to destroy them and reign as high priestess over the computer kingdom, her face distorted by hatred.

In another style, the difference between a character—lost in different layers of reality—and his doubles, is at the heart of Satoshi Kon's thriller *Perfect Blue* (1997), which is reminiscent of slasher movies. Pursued by a crazy fan and exploited by her agent, an ex-pop star turned actress gradually slips into schizophrenia. Between hallucinations and the story within a story, the movie anticipates—well before the arrival of social networks—the issues of widespread image access and of digital harassment.

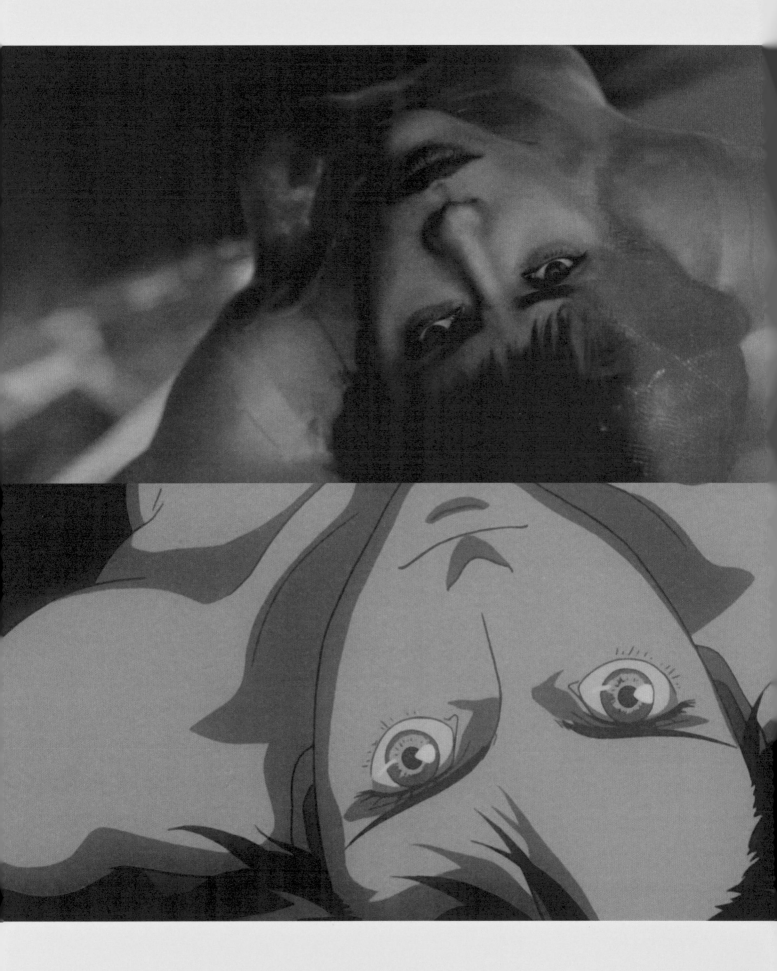

Ghost in the Shell, Rupert Sanders

Ghost in the Shell, Mamoru Oshii

LIVE ADAPTATION: BETWEEN LIGHTS AND SHADOWS

For the past several years, Disney Studios has picked up a new habit: that of remaking their animated classics into live-action movies. It must be said that, in a world accustomed to remakes to reboots, from homages to postmodern references, reproducing well-known stories is still the easiest path—or, at least, the most convenient—to success. This is how, from *Aladdin* to *Lion King*, *The Jungle Book*, and *Mulan*, today's viewers are (re)discovering their childhood heroes embodied by real-life actors, such as Will Smith, Donald Glover, Neel Sethi, and Liu Yifei. At a time when American blockbusters are multiplying the number of franchises and masked comic superheroes, reusing tried and tested recipes seems much less risky than inventing new formulas. As the saying goes, the best soups are made in old pots. Obviously, Japanese anime is no exception to this rule. The teeming worlds created in the Land of the Rising Sun appear as potential havens for producers across the Atlantic. For better or for worse.

Ghost in the Shell is a textbook case. In 1995, Mamoru Oshii's movie, an adaptation of the work of mangaka Masamune Shirow, was a turning point in the history of science fiction, seen by movie-makers around the world. At the launch of *The Matrix* project, the Wachowski sisters presented it to their producer, Joel Silver, and indicated that they were inspired by its editing and its action sequences when conceiving their own staging. Without forgetting

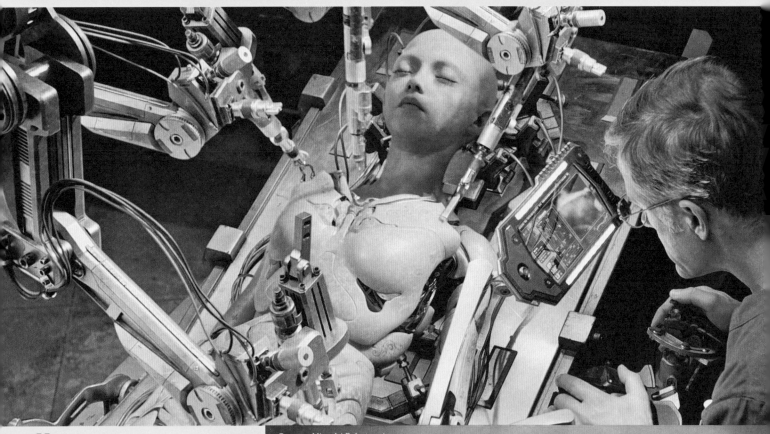

Gunnm, Hiroshi Fukutomi

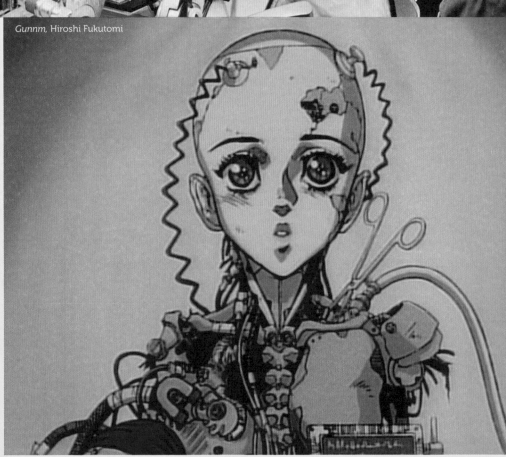

Alita: Battle Angel, Robert Rodriguez

their movie's own visual identity—from the lines of code that structure the credits to the image of human beings plugged into the matrix through cables in the back of their necks—it was clearly inspired by Oshii's work. But in 2017, when Hollywood finally transposed anime through Rupert Sanders' camera, with Scarlett Johansson in the role of Major Motoko Kusanagi, people realized that the complexity of the original film—halfway between action movie and philosophical mysticism—had all but disappeared. Anime's side roads give way to a smooth narrative, driven by a style we have seen a thousand times before. And when Takeshi Kitano appears, the actor and director renowned for his contemplative yakuza films with tragic-comedic touches, it is to play the token samurai and provide a somewhat artificial Japanese flavor. The live-action version of *Ghost in the Shell* is nothing but a ghost reminiscent of Oshii's twilight gem.

There are, however, exceptions. *Alita: Battle Angel,* an adaptation of *Gunnm* Manga *Seinen* created in 1990 by Yukito Kishiro, is a cleverly executed success that remains faithful to the original material. Released in 2019, Robert Rodriguez's movie comes mostly from the mind of its producer, James Cameron. The visionary moviemaker behind *Terminator* (1984) and *Titanic* (1997) had, since the 1990s, dreamed of directing this successful dystopia and had already adopted the Japanese imagery of *mecha*—characters equipped with robotic armors—in his *Aliens,* in 1986. Although he could not direct the movie himself, overwhelmed by the development of the *Avatar* (2009) sequels, James Cameron partly held the reins of the project. Hence, the heart and intensity that emanates from the cyborg heroine, a figure to whom he has been attached for nearly thirty years.

INCEPTION

In a society dominated by computer-generated images, both reality and identity are crumbling. Film shots are blurred between daily life, nightmare, and video or digital captures. With her stylized graphics, *Lain* dissolves the boundaries between what is real and virtual. But things are not going well, as highlighted by the obsessive views of the cable network. The "real life" Lain turns blue on more than one occasion as her screen's blue light shines on her, reflecting the halo of her computer double. When she walks down the street, sometimes as flat as a Web page, her shadow is speckled with the same colors as her browser. Her demonic version pops up here and there to harm her loved ones. Is it a split personality or perhaps a misunderstanding of her true nature? Because Lain could well be nothing but a software, an omniscient program intended to connect the human subconscious. Thus, doubt and derealization contaminate everything: the event, the veracity of the images, the being's very existence, and its relationship to others.

This parasiting of the real world by the virtual one leads to a bug in the narrative of *Ghost in the Shell 2*, which replays the same hallucinogenic scene in a loop. Even when tiny variations occur, Batou and Togusa relive their neural duel with Kim several times over. This disjointed cyborg puppet manipulates them, using electronic signals to generate a completely false reality. Better armed to uncover pretenses, Batou denies his human partner: "Virtual experiences have entered your brain." This mental trap is played out inside a house of illusions, in a lawless place, where criminals and corrupt multinational companies fail. On the edge of the fantastic city, and of reality, there is a slum, both archaic and futuristic at the same time. Based on déjà vu and the reusing of images, these sequences are pure chimera that questions the very essence of human consciousness.

The ability to penetrate the dreams of others and to implant ideas in their unconscious is not new. Although the concept of inception was popularized by Christopher Nolan's movie released in 2010, this film was actually greatly inspired by *Paprika* (2006) by Satoshi Kon. Adapted from a novel by Yasutaka Tsutsui, the animated film plunges viewers into a state of surrealistic vertigo, where dreams, cinema, computers, and the Internet are offered as fantasy machines projected onto reality—plunged to the point of drowning. Scientists have developed a device that records psycho-therapy patients' dreams so they can decode them. This device, called "mini-DC," is obviously stolen to be used for evil purposes. A megalomaniac pretends to establish a new cosmic order by entering the consciousness of dreamers, invaded by nightmares that are not their own. Overcome by madness, the characters become empty shells who either try to commit suicide or split into a phantasmagorical version of themselves. Like an unstoppable collective haunting, their dreams merge together into a series of magical creatures. This carnival parade combines religious symbols, pop culture icons, and consumer society objects. In the end, this whirlwind of continuously recycled images challenges viewers on the very nature of cinematic illusion. Satoshi Kon is the uncontested master of blurring the mental layers that make up our perception of the world. His incessant story-in-a-story thread makes the boundaries between reality and imagination indistinguishable.

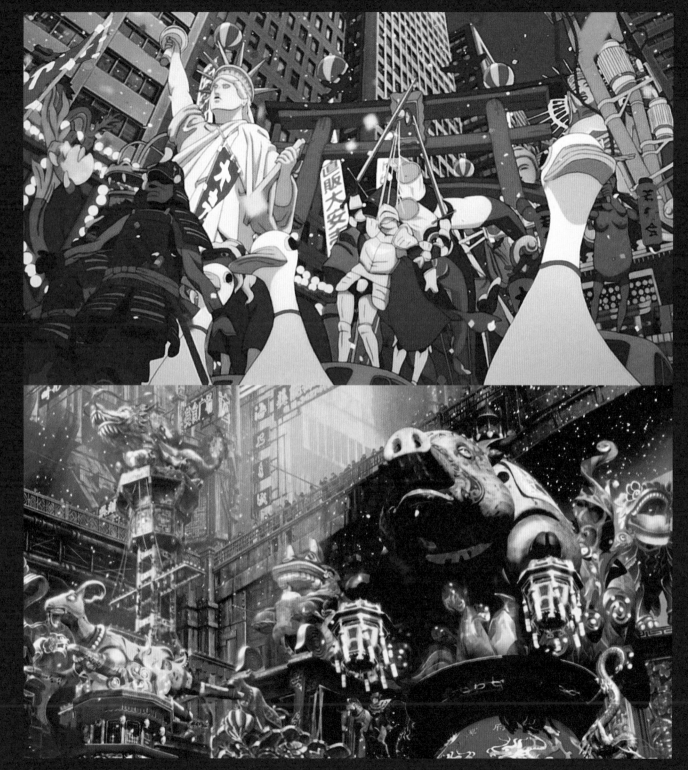

Paprika, Satoshi Kon

63

Ghost in the Shell 2: Innocence, Mamoru Oshii

鏡の國のアニメ

64

To ensure their security and well-being, the people of the technologist counter-utopias are willing to sell off their freedom and personal data. Some even agree to become 100 percent digital so they can live in "paradise," within a computer system governed by supposedly divine figures (*Expelled from Paradise*, 2014, Seiji Mizushima). In the retrofuturistic series *Fractale* (2011, Mari Okada), individuals have terminals grafted into their bodies, which emit "lifelogs" to a floating server recording all their personal and biological data. Composed of a billion calculators, this network claims to maintain peace and equality among humans, who enjoy idleness and voluntary servitude. The collection of their physiological and digital information allows, above all, their implacable control by a dominant caste.

The new technologies are drifting quickly toward globalized surveillance. With the *Psycho-Pass* series (2012–2013), we enter the world of health and social credit. In this security dystopia, computerized devices constantly scan the population to assess their mental health. Public Safety Bureau detectives are responsible for identifying potential criminals before they commit a crime. Then, the Sybil program delivers its decisions: forced therapy, imprisonment, or lethal measure. The verdict is immediate, because the system believes in *a priori* guilt instead of individual responsibility. This retelling of *Minority Report* (Steven Spielberg, 2002) establishes a society based on ultimate transparency, obsessed with risk prevention thanks to files and algorithms. Sybil regulates all aspects of life to provide as much happiness as possible to its members, who are forced to give up their free will in return. Cameras and drones invade every available space, while scanners dissect minds to the depths of their innermost emotions. The life of individuals is governed by their pass, which varies in color to reflect their state. Holograms pop up to assess the day's psychic stability, to hammer out their mantras ("Have a good day with a healthy mind"), or to indicate the number of calories to be ingested or the collective stress level ("Take a psychological protection pill"). In the midst of this health obsession, an inspector—with an irreproachable status—goes against this reductive vision of justice and questions Sybil's reliability.

A sanitized society based on absolute biopower, this is the terrifying world of Takashi Nakamura and Michael Arias's *Harmony* (2015), which goes so far as to cite Michel Foucault's analyses regarding the ability of politics to control basic life. After the Maelstrom nuclear disaster, a part of humanity manages to overcome pain, disease, and death, thanks to neuroscience. This utopia that drips with benevolence makes health its cardinal value. Each individual must implant the Watch Me system and entrust his or her body to the computer calculator. No more alcohol or caffeine. On the one hand, the New Humanity behavioral study group intends to go even further to save humans from his own inhumanity. It aspires to control their will, at the risk of making their very conscience disappear. On the other hand, freedom lovers consider that total surveillance coupled with good intentions kill and suffocate any hint of a soul.

HEALTH PASS

Since the advent of the Internet and social networks, society exists well and truly on a grid and our virtual existence encroaches heavily on our perception of the world. In the multimedia *Sword Art Online* franchise (a 2010s animated series and films), reality is but a brief prologue. Players line up for a new video game before their complete immersion in the SAO universe, thanks to a Nerve Gear headset that replicates all five senses. "It's a virtual space, and yet I feel more alive there than in the real world." This is an extreme theory taken literally by the designer, who removed the disconnect button from the "game." It is impossible to get out of SAO, unless you successfully complete the one hundred levels, a game over that results in the physical death of the participant in a bloodbath worthy of *Battle Royal* (2001, Kinji Fukasaku).

A leading figure of the new generation, Mamoru Hosoda has examined this revolution with more realism, between daily attachments and a parallel life online. Even if these worlds have repercussions on one another, he differentiates the aesthetics of the real (naturalistic, detailed, in traditional animation) and that of the cybernetic space (dreamlike, with bright colors on a white and flat background, using computer graphics). His participation in the *Digimon* license, through two medium-length films (1999–2000), was a trial run for *Summer Wars* (2009). Oz is a virtual universe with millions of members that has been built as a mirror of our society. With its shopping malls, its business district, and its sports arenas, everyone can lead an alternative social or professional life, thanks to a personalized avatar. But trouble arises and starts a cyber war. Love Machine, a form of artificial intelligence, escapes from an American laboratory and hacks into users' accounts, violently affecting the real world until eventually triggering a bomb to begin its countdown. The resistance takes shape within a family gathered for the grandmother's birthday. A guardian figure, this matriarch defends the link between generations and the perpetuation the samurai's honor. She mobilizes her troops to fight to the end. Less pessimistic than his elders, Hosoda praises collaborative intelligence as a way to combat technological excess. Thus, the sharing of resources among millions of strangers, ready to help one another, destroys the black monster made up of stolen avatars.

In 2021, Hosoda repeats with *Belle*, a utopian fable aimed at the millennial generation that has never lived without the Internet and its digital extensions. Motherless, discreet Suzu ignites the Web with her crystalline song. In the U network, avatars are automatically generated by algorithms that reveal each person's innermost being. Suzu becomes Belle, an immensely popular singer. Between a retelling of *Beauty and the Beast* and the promotion of J-pop, the movie combines a Japanese vision with a Disney dimension. She creates beautiful counterpoints between everyday life and the other world, which is quick to bring out both sad impulses and passions. A fundamentally positive heroine, Belle comes to the rescue of Dragon, vilified by an unruly community and pursued by a league of unjust vigilantes. Harassment, spreading rumors, concealing identity: *Belle* battles with psychological violence online.

In one mode or another (fantasy and/or realistic), the virtual world has concrete and potentially violent impacts on social interactions. It unravels our connection to the world and to others to the point of becoming, at times, a mental prison. The Japanese phenomenon of *otaku* (drowned in fictional universes), and of *hikikomori* (who live reclusively in extreme isolation), is only the tip of the iceberg dissected by animation.

THE WAR OF THE AVATARS

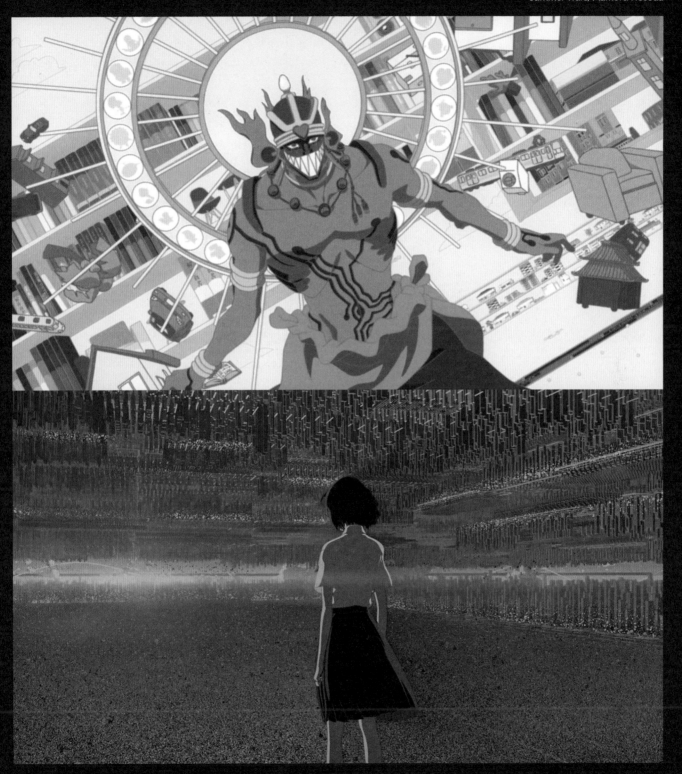

Summer Wars, Mamoru Hosoda

67

Belle, Mamoru Hosoda

鏡の國のアニメ

02 THROUGH THE LOOKING GLASS

Threatened from all sides, the worlds of animation are on the brink of collapse. Wars create corpses, the nuclear button is within reach of paranoid hands, humanity is attacked by machines, Titans, or demons. Fortunately, "heroes with a thousand and one faces" are watching over the situation. Innocent children and old-timers refuse to give up their weapons, especially those of the heart. They work hard against all odds, despite the Herculean task ahead. Ready to sacrifice themselves, they are determined to fight in order to defend their threatened vision of humanity.

On the other side of the mirror, we discover protective forest spirits, animals that whisper in the ears of humans, and wonderful worlds in dreamlike colors. When animation that is devoid of realism and the apocalyptic shifts into phantasmagoria, viewers travel to poetic lands that sublimate everyday life and liberate living forces. It praises play and imagination, which break the shackles.

Populated by fantastic creatures, Japanese anime ultimately sets up nature as a sanctuary. Its fables encourage us to preserve the wonders of Earth by infusing flowers, forests, and the bright blue sky with a magical aura that vibrates with energy. The spiritual breath that animates them also invites us to cherish beauty, to open our eyes wide, and to reactivate the ancestral link that unites man with the gods, the supernatural spirits, and the cosmos.

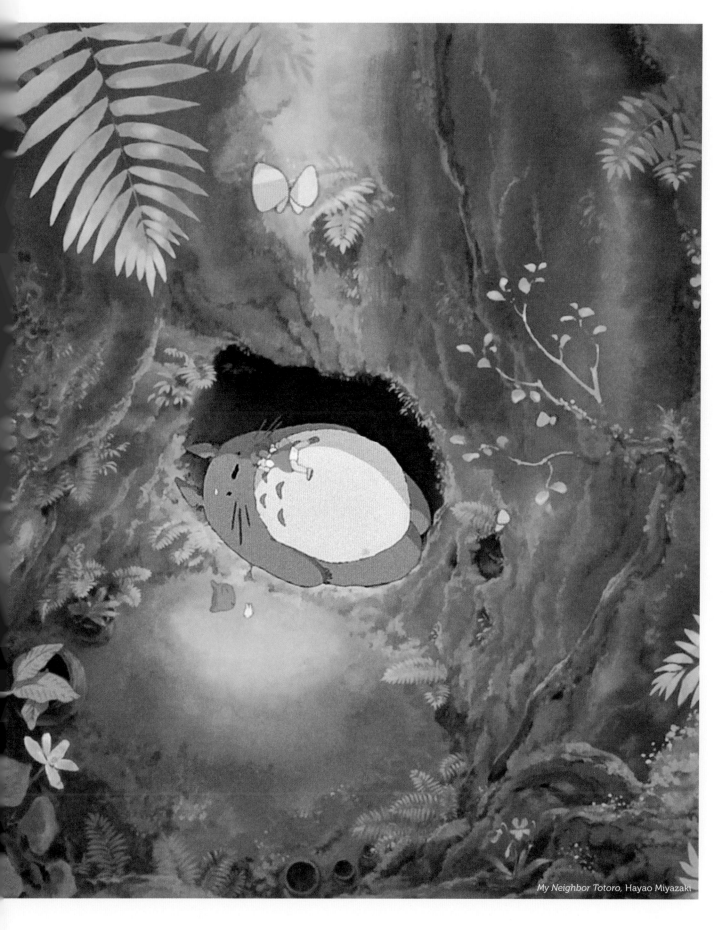

My Neighbor Totoro, Hayao Miyazaki

69

STAYING ALIVE

In the face of inevitable disaster, some young people prove to be heroes. Driven by a force bigger than themselves, they discover their secret weapon and draw unexpected strength from their iron will. Endowed with superpowers or simply with a pure soul, their self-sacrifice proves that nothing is lost. That the community, faced with the risk of implosion, can stand together in the face of danger. That it can reinvent itself. Epic, mythological, sometimes rebellious and melancholic, often truculent, they fight for survival with all their might.

In the late 1980s, the phenomenal success of certain multimedia franchises popularized initiation stories for boys (*shōnen*) and girls (*shōjo*) in Europe. Heroic and crazy formulas were reinjected into a dynamic, modern Japanese form: manga, available in anime, movies, video games, and other derived products. The monkey-child with supernatural powers from *Dragon Ball* (Akira Toriyama's work published from 1984 to 1995) was a lucrative spearhead and continues to this day (*Dragon Ball Super: Super Hero*, 2022). Rude and unruly, he enchanted child audiences with his naive temperament and his hopeless energy. On the girls' side, the "magical girl" celebrates the metamorphosis of gangly teenagers into powerful heroines capable of defeating humankind's enemies. *Sailor Moon* (1992–1997) propelled girl power to the forefront. Also worth mentioning is the *sentai* ("combat squads")—superheroes erected as guardians of Earth, such as in *Bioman* (1984–1985). With martial arts choreographies inherited from the kabuki theater, they mix tradition and modernity, like samurais galvanized by bioparticles and robotic armors.

Placed under the banner of friendship, effort, and courage that eradicate monsters and protect the planet, heroic variations are flourishing. While some of them do not escape stereotypes, or commercial or pedagogical logic, others are authentic learning narratives that celebrate—in one way or another—resilience in the face of disaster. Their vast narration seizes on great existential or political questions. Preferring multiple hypotheses to moral lessons, heroes disturb the established order with their carnivalesque comedy, their elegiac celebration of nature, or their disillusioned melancholy. Some are frankly ambiguous, beyond good and evil. Creators of values instead of defenders of a conservative order, they assert a subversive force that sends conventions flying. From the messianic girl in Hayao Miyazaki's *Nausicaä* (1984) to the elastic Luffy in *One Piece* (1999–) and *Space Pirate Captain Harlock* (or *Harlock 78*, 1978–1979), these heroes manage to save some parts of the world. By reconnecting with ethics, they liberate powers of action that, in the best of cases, bring a sense of enchantment back into our lives.

71

In tune with their hearts, timeless heroes engage in epic battles to defend their people or preserve Earth. When chaos strikes, young people risk their lives to confront deadly forces. They do not hesitate to fight body and soul to save the widow and the orphan—to restore peace or balance. With their noble values slung over their shoulders, they reactivate an ancestral code of honor, inherited from myths, initiation stories, or the moral principles of *Bushido*, the way of the samurai.

In the postwar period, Osamu Tezuka created the canon of the hero who fights against evil and injustice, from *Leo the Lion, King of the Jungle* to *Astro Boy*, or *Phoenix 2772* (manga adapted in 1980 by Taku Sugiyama). Programmed from birth to be a space pilot in a robotic society, Godō rebels against the lack of freedoms, segregation, and the plundering of resources. Sentenced to hard labor for speaking out against the senatorial caste, he shakes off his chains and gradually acquires the status of a redeeming hero. He confronts the powerful but, above all, the phoenix—the firebird holder of the universal energy. The invincible galactic creature lays down its weapons before the tenacity and kindness of the young man, who agrees to sacrifice himself in order to regenerate the Blue Planet. In the prison-city of *Metropolis* (another Tezuka manga adapted by Rintaro), a selfless gesture is enough to bring back hope. Kenichi's gentleness in teaching Tima to say "I" and to take ownership of his first name establishes the android as its very own identity. He treats the garbage robot, who makes of his body a shield to protect the children—seeds of another future—with the same humanity.

The modernity of Isao Takahata's *Horus, Prince of the Sun* (1968) was a milestone in animation, laying the groundwork for the future work of Hayao Miyazaki, who designed the film's Scandinavian village. This mythological adventure is set in a credible time and space, making the action more dynamic due to its focus depth. *Horus* is an exemplary fable at human level. The eponymous character valiantly defends the villagers threatened by the wizard Grunwald, who has sworn to exterminate them. He goes through all kinds of trials, leading up to a crescendo against the wolf pack, the giant pike, or the forest of doubts filled with hallucinations. Like Ulysses in his time, he must resist the charms of the beautiful and fragile Hilda. Bewitched by the sorcerer, she hypnotizes young and old with her songs before sowing discord. To win the title of "Prince of the Sun," Horus must first forge the sword that he took from Mogue, a man of stone (like the King Arthur's sword stuck in the rock, which inspired Disney's *The Sword in the Stone* in 1963). He will only succeed by joining forces with the villagers, because Takahata's work is a praise of mutual aid beyond the vicissitudes— the only way to preserve the community.

As for Hayao Miyazaki, his heroes are almost always pairs of children whose valor is matched only by their innocence. Pazu and Sheeta from *Castle in the Sky* reconcile Heaven and Earth; San and Ashitaka, humans and the forest, in *Princess Mononoke*; Sophie from *Howl's Moving Castle* frees Hauru from his curse and ends the war. Like Rodrigo in *El Cid*, they are young, "in souls nobly born, valor does not depend upon age." Their freshness does not come from the short time spent on Earth, but from an unfailing integrity, from a pure essence, foreign to the compromises of adults. Impervious to political maneuvers, far from the military concerns of their attackers, they express their fundamental humanity in each of their actions. In immediate resonance with the universal, their childlike souls push them to rise above perilous circumstances. To, ultimately, absolve humanity.

THE LAST SAMURAI

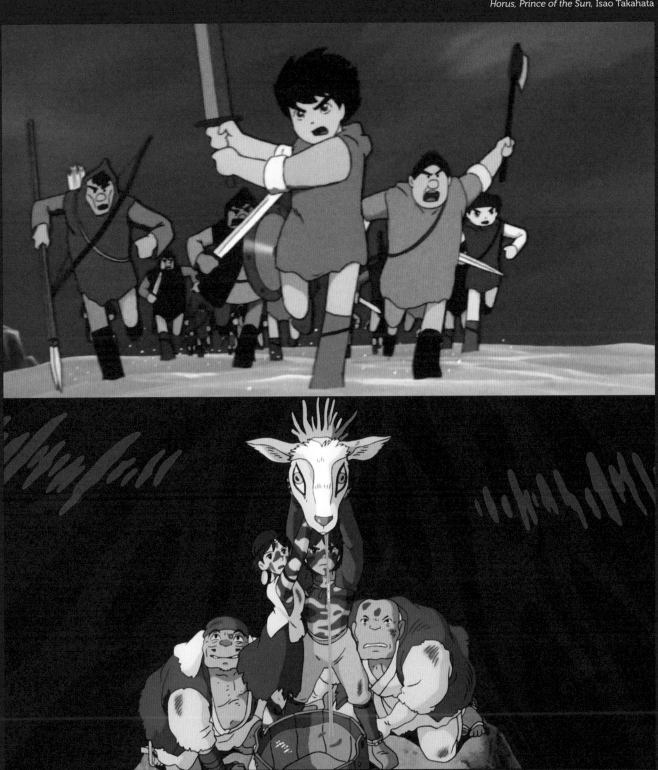

73

Princess Mononoke, Hayao Miyazaki

Steamboy, Katsuhiro Ōtomo

Castle in the Sky, Hayao Miyazaki

With its deadly mechanics and inventive devices, Hayao Miyazaki's nuanced cinema highlights the dangers of technology, which damages the hearts of humans and leads them down a destructive path. However, he also celebrates its power when wielded by pure hearts who use it to connect with the vastness of the universe. Ready to make any sacrifice, these epic heroes carry within them the ethics of the living, allowing them to defeat the gravediggers and escape the inevitable disaster. In *Nausicaä of the Valley of the Wind*, the environmental peril pushes a young girl to transcend herself. In the midst of the imposing war machines, she rides her white glider, light as the wind, to save what can be saved. In doing so, she becomes both the prophet of humanity threatened by its hubris and the liberating messiah who reconciles nature and society. Unprejudiced, Nausicaä loves even the Ômu, the big hideous insects that heal her and whose sufferings she soothes. As she relentlessly surveys the Toxic Forest, she realizes that its depths contain the means to regenerate the planet. From then on, her destiny is to bring together humanity, plants, and animals.

Facing the military aircraft, Pazu and Sheeta of *Castle in the Sky* fly on their bird-shaped Flapter. They enter the heart of the floating island of Laputa, which has a preserved plant screen that contains a potentially aggressive technology when in the wrong hands. Before the activation of the robot soldiers by the dictator Muska, the children meet a robot gardener, who tends to the flora and fauna. At the height of the devastation, when the stone foundations of the island break up and threaten to take everything with them as they collapse, it is the roots of the gigantic tree that protect the children and propel Laputa toward the endless skies. Thanks to the levitation stone, to the secret formula uttered by the princess, and, above all, to the faith of the heroes, this magical kingdom flies away, out of reach of human miasmas.

Miyazaki's animism sanctifies the vital, unfailing, and ancestral relationship with nature. In an ambivalent—and often tragic—way, progress deviates humans from their very being and causes an imbalance within the cosmos. But the technique, used with probity, allows the emphasis of the devastating ego possessed by the all-powerful. Because these epic battles narrowly avoid the ultimate catastrophe, they incite us to use technological inventions with foresight, but also, importantly, to never lose sight of our love of nature, celebrated by Shintoism. It took the chaos and destruction of the forest in *Princess Mononoke* for the wolf princess—a tribal figure of the "noble savage"—to bring the unconscious humans back to reason, with the help of the forest gods. His flesh tattooed by the curse of the monstrous boar, which takes revenge for the blows inflicted on his ecosystem, Ashitaka holds the viewer's image. He follows an initiatory path through which he experiences the sacred link with the world, which invites him to reflect on himself. Attentive to the vibrations of Earth, Miyazaki's heroes have a

THE ANGEL'S LEAP

ORPHANS OF LIFE

The road to a heroic path is paved with pitfalls. At the origin of the metamorphosis lies a founding rupture: mourning, banishment, or the emergence of a stranger. Miyazaki's children are orphans, including Pazu and Sheeta; Mononoke, taken in by a she-wolf; and Princess Nausicaä, who witnesses the king's assassination. For many, solitude is the springboard to adventure. Horus reaches his threatened village only after his father's death. Until Bulma's arrival, Son Goku of *Dragon Ball* is a true savage who lives like a recluse in a mountain, following his grandfather's recent death. Without parents, Naruto is rejected by his tribe for reasons he ignores.

The myth of Oedipus is one of the most powerful myths in existence. Characters must face the enigma that surrounds their birth and their true nature. Abandoned, taken in by a good soul, or resolutely alone, they travel the vast world driven by a threat they unknowingly inherit, or to carry out the quest they have been bequeathed. Son Goku religiously holds onto his grandfather's crystal ball. In *The Dagger of Kamui* (Rintaro, 1985), Jiro is a chiaroscuro figure who aspires to "follow his path." Chased from his village for the murder of his adoptive mother—of which he is innocent—he is educated by the warrior-monk Tenkai, who makes him a ninja and a shadow assassin. This manipulator pushes him to commit parricide by leading him to believe that he is a stranger. Only the delivery of a sword and a riddle will allow him to pierce the mystery of his origins. Thrown into a treasure hunt, he ends up foiling a plot with multiple ramifications and understanding who he is, unearthing a hidden sister in the process.

Immediately recognizable, many of the anime orphans have distinctive markings on their bodies or have a unique appearance, such as Son Goku's monkey tail, Naruto's spiral around his belly button, and Luffy's elastic body in *One Piece*. Signs of their curse or their status as the chosen ones, these scars, tattoos, or growths are key pieces of their family puzzles. Foreshadowing a destiny like no other, they materialize a troubled lineage to the point of establishing their hybrid, even superhuman, nature. Son Goku's simian appendage is a clue to his supernatural origin: as the saga unfolds, he turns out to be a Saiyan, an alien with a human face. Note that *Dragon Ball* is freely inspired by a great classic of Chinese literature, *Monkey King: Journey to the West*. In this folk novel (Wu Cheng'en, sixteenth century), a colorful monkey leaves his mountain in search of spirituality and immortality—the starting point of a series of fantastic and colorful adventures. The series narrates the fabulous pilgrimage of the young orphan as he seeks to gather seven crystal balls. Endowed with colossal strength and unparalleled innocence, he is among the only ones who can ride the supersonic cloud, a sign of his pure heart.

Another orphan who has conquered millions of readers and viewers is the mischievous Naruto (who gave his name to Masashi Kishimoto's manga, adapted into anime in 2002–2007). He aspires to become the greatest ninja master of all time. Having grown up without the love of his parents, he would like everyone to recognize his value. However, his true origins are taboo. With his buzz cut, his feline moustache tattooed on his cheeks, and that mysterious crest around his navel, the young boy is initially unaware that the nine-tailed fox demon that destroyed his village has been sealed within him. Abandoned because of a disability, Allen Walker (*D.Gray-Man*, 2006–2008, based on a manga by Katsura Hoshino) has many marks, including the stigmata of a cross on his hand, white hair, and a cursed pentagram carved over his left eye. However, this boy is an innocent chosen one, an exorcist of the congregation of the Shadow in conflict with the Millennium Earl and his Akuma demons. Endowed with extraordinary powers, all of these orphans will have to follow a long initiatory journey to reveal the extent of their strength and their greatness.

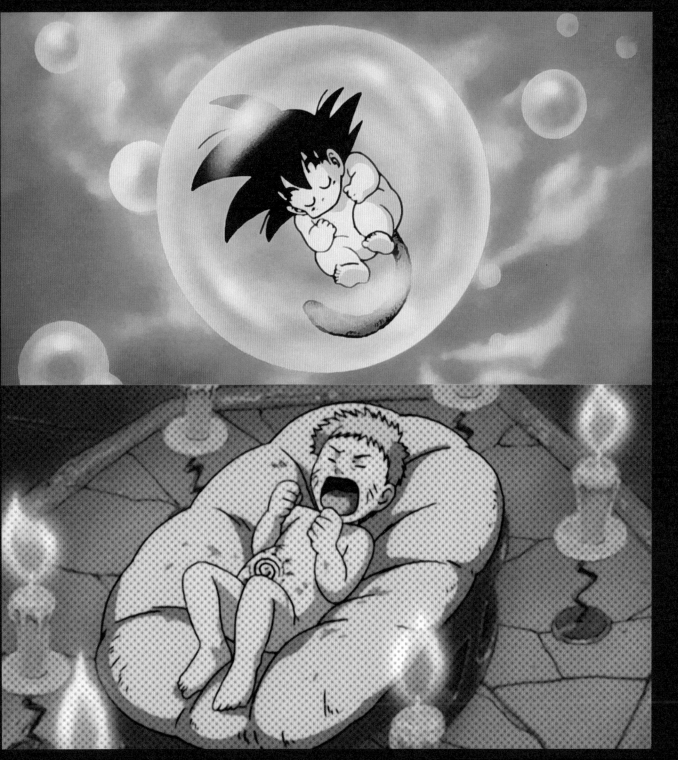

77

Dragon Ball Z, Daisuke Nishio

places, and train. You only know these mountains. You've never seen the ocean, have you?" This is how the clever Bulma, in the pilot of the first *Dragon Ball* anime series, encourages Son Goku to follow her in her quest for the seven crystal balls scattered all over the planet. To bring them together will provoke the appearance of the dragon Shenron, capable of granting any wish and raising the dead. She lures him with promises of cities, people, monsters, and even dinosaurs. So begins the incredible odyssey of Son Goku, a naive young man who has never seen girls or cars, or even other human beings, besides his grandfather.

The initiatory journey is one of animation's most fruitful keystones. As Joseph Campbell showed in *The Hero with a Thousand Faces*—the bedside book of both George Lucas (*Star Wars*, 1977) and George Miller (*Mad Max*)—archetypes infuse myths across all continents and eras. The first stage is the uprooting and then the quest that moves the character: treasure hunting for Luffy, the eradication of a monster for Horus, the purification of Earth for Nausicaä, etc. Discovering the vast world brings about its share of trials and confrontations with evil or transcendent powers. Along the way, the apprentice heroes undergo many trials, experiencing all kinds of situations and social organizations. They receive the saving assistance of people they meet along the way, thus re-creating an adopted family based on shared values and an unfailing friendship. They grow up and become fulfilled, until the ultimate confrontation—the climax that completes their deepest aspirations and potentially offers the regeneration of the entire community.

A necessary part of many initiation stories is the perfection of gifts or superpowers. Often unstable, the hero in training must learn to channel his or her inner strength and emotions. Son Goku deepens his martial skills with different masters. The first one, Turtle, teaches him the *kamé hamé ha* cult technique, a concentration of energy in his hands directed against the enemy. The monkey-child participates in many martial arts championships to compete with the greatest and win the supreme title. From *Dragon Ball* to *Dragon Ball Z*, the boy becomes an adult, and the slapstick fantasy, typical of the early days, shifts to science fiction—dark and violent—where intergalactic battles against horrible villains abound, from Freezer to Majin Boo to Cell. Son Goku's power continues to grow until he eventually passes the torch to his son, Son Gohan, whose potential will grow exponentially over the course of his adventures, until reaching the stage of Super-Saiyan 3. As for the 220 episodes of *Naruto* (not to mention its sequel, *Naruto Shippûden*, 2007–2017), they explore all the phases of the learning process that ultimately leads to the coronation of the Hokage Masters. Although Naruto's antics lead to him failing the entrance exam at first (because he demonstrates his ability for metamorphosis by transforming himself into a sexy naked girl), he soon shows exceptional talent. The ninja apprentice benefits from the lessons of the greatest sensei and acquires more and more techniques (cloning, invocation, imprisonment of the dead, etc.). He faces his share of enemies and crosses different universes, such as the Land of Waves and the Forest of Death. By defending clan values and finding his place, he conquers the hearts of the villagers and that of his peers. This recurring theme of *shōnen* manga can also be found in *Bleach* (2004–2012) and *Hunter x Hunter* (1999–2001, 2011–2014).

THE GREATEST SHOW ON EARTH

The initiatory journey unfolds unlimited narrative arcs in a variety of universes, through encounters as impromptu as they are formative. In *Galaxy Express 999*, at each train station, Tetsurō explores the tacit laws of the planets he crosses, facing bandits or ghosts, before the ultimate test against the mechanical queen, who wants to steal his soul. In *The Dagger of Kamui*, set in the nineteenth century, Jiro's treasure hunt takes him from the wilderness of feudal Japan to cold Russia, as he heads to the New World. Lost in wide open spaces, where firearms replace swords, he meets Native Americans and outlaws. Such a scenario allows us to navigate from one genre to another, to relocate the ninja in a Western landscape and enrich the sociohistorical issues underlying the quest.

Cowboy Bebop (1998–1999) by Shin'ichirō Watanabe is a jazzy series that has made a name for itself. Its main theme is space opera: in 2071, an exploding Moon portal has scattered survivors throughout the solar system. Spike, a seductive bounty hunter, sails aboard his ship, the *Bebop*, to honor his contracts and eat his fill, from Mars to Titan, Venus, or Ganymede. These action-filled worlds are filled with scenery reminiscent of film noir, gangster movies, thrillers, Westerns, and even horror movies, depending on the "sessions" titles and the featured music and styles (mainly jazz but also mambo or waltz). With its retrofuturistic aesthetic, the work multiplies the cinephile homages drawn from both Eastern and Western heritages, from Lupin III to Bruce Lee and Clint Eastwood, via Han Solo, the bounty hunter from *Star Wars*. The credits pack a punch and are even a tribute to Saul Bass, creator of Alfred Hitchcock's and Otto Preminger's unusual opening sequences. This range of graphic universes carefully weaves the multiple facets of Spike, who hides a heavy past.

PIRATE GAMES

A fruitful successor to *Dragon Ball* in the manga prepublication magazine *Weekly Shōnen Jump*—known worldwide for its record sales—Eiichirô Oda's *One Piece* (manga, series, movies) is unbeatable in terms of scope and energy. Hidden somewhere along the Grand Line, One Piece is the most legendary of treasures. It makes pirates rush into the ocean, flying black flags with skulls on their ships. Luffy, with his unassuming physique, takes his straw hat and his smile everywhere he goes. However, he has but one dream and one obsession: to become the king of the pirates. Nothing scares him, because he ate the demon fruit—a source of immeasurable powers. Luffy is an elastic boy. Bullets cannot pierce him and he uses his "gum-gum" rocket to hit giants or climb citadels. His strength and his personality attrack a perfect crew. With their strong characters, Zoro the swordsman, Sanji the cook, and Nami the navigator all have their own pasts to deal with, their heads full of goals, and their own exceptional talents. Between two oceanic crossings, each landing creates an incredible geography and an original civilization. From the mushroom or giant hand-shaped islands to the heavenly ones, through those featuring pirates or gold, the worlds of *One Piece* are full of wonders and exoticism and are sources of a perpetual graphic renewal. Transponder Snails serve as telephones or surveillance cameras, News Coos deliver newspapers, and sea creatures (sea boars, panda sharks) scare the crowds. Under the rule of dictators, monsters, or spells, these micro-societies reveal perverted governments, such as the City of Slaves, which the elastic boy fights with determination. Underneath his debonair exterior, Luffy cannot stand injustice and confronts tyrants of all kinds. A combination of action and slapstick that does not exclude the tragic, *One Piece* is one of the most extensive human comedies ever explored by animation, which can, decidedly, do just about anything.

Cowboy Bebop, Shin'ichirō Watanabe

Rabelaisian comedy (named for sixteenth-century French satirist François Rabelais), of carnivalesque essence, is a devastating weapon against resignation, tyranny, or inevitable disaster. Son Goku from *Dragon Ball*, Luffy from *One Piece*, Spike from *Cowboy Bebop*, and Lupin III from *The Castle of Cagliostro* (1979, Hayao Miyazaki) are gluttons who think only of eating, no matter the circumstances. Despite this tropism being a recurrent joke (Son Goku devouring his bowl of rice), it also evokes the heroes' formidable appetite for life, as they battle devastating passion. Particularly those of dictators who oppress their people. To live life to the fullest goes hand in hand with the refusal of servitude. Luffy is a carefree man, but he rolls up his sleeves in the face of every iniquity and fights his way to the greedy world government. These heroes, always in motion, carry a comic force that disrupts reality, shakes up guilty conformism, and awakes the unenlightened.

LAUGHTER IS A HUMAN TRAIT

The unusual vein that flows through *One Piece* has distant ramifications in the first creations of the Toei studio, where Hayao Miyazaki made his weapons. In particular, he drew the final chase in *Puss in Boots* (Kimio Yabuki, 1969), testing ideas that he reused in his first feature movie, *The Castle of Cagliostro*. "I only live for adventure," declares Lupin III. Hayao Miyazaki reinvents a popular figure in Japan, invented by the mangaka Monkey Punch (Kazuhiko Katō), who made him the descendant of Maurice Leblanc's Arsène Lupin. Miyazaki has already worked on some episodes of the first two *Lupin III* series (1971 and 1977). In *The Castle of Cagliostro*, Lupin is the archetypal gentleman thief who lives life at a thousand miles an hour while playing tricks on villains. Although he enters this European-inspired principality to rob a casino, the soft-hearted bandit then seeks to save Clarisse. This beautiful princess is being held against her will by Count Cagliostro, who is manipulating the world economy with his counterfeit money factory and is looking to get his hands on his family's hidden treasure. As a sign of the character's success, a new interpretation was born in 2019: *Lupin III: The First* by Takashi Yamazaki.

A mixture of quirky humor and racing action (such as the initial two-horse chase), *The Castle of Cagliostro* has a frenetic pace. Like Cary Grant in *To Catch a Thief* (Alfred Hitchcock, 1955), Lupin is a multifaceted character with endless gadgets (James Bond style). His fellow travelers are a silent man inspired by James Coburn in *The Magnificent Seven* (John Sturges, 1960) and an old-fashioned samurai, perpetuating the spirit of *Bushido*. Anything goes in order to rescue Clarisse. A series of anthology sequences occur in the castle with its twisted towers—a tribute to *The Shepherdess and the Chimney Sweep* (Paul Grimault and Jacques Prevert, 1953), a truncated version by the producer of the future *The King and the Mockingbird,* released in 1980. A true acrobat, Lupin jumps about on the rooftops, almost always on the verge of plunging into a void. The final fight at the top of the clock is a masterpiece of staging, involving the relentless movement of the cogs and the dizzying dives until the fatal blow that crushes the Count between the clock's hands. In the epilogue, the triggering of a secret mechanism revives a Roman city swallowed up by the water, thus preserved from human rapacity.

Because it plays at revolutionizing the established order, this earthy humor is subversive. The ethics of laughter, like an explosion of vital forces, is often more effective than the brute force. But from time to time, we simply laugh to avoid crying.

MELANCHOLIC REBELS

Aristocratic bandit, galaxy pirate, or dark-eyed bounty hunter—some heroes are up in arms against the abuse of power. Older, rebellious at heart, they have few illusions about humanity. Yet they fight against all odds to preserve what can be preserved. With his long hair and delicate features, his scar and his eye patch, Harlock is an anachronistic and rebellious space pirate. An outlaw banished from Earth, he wanders in outer space aboard his ship *Arcadia*. According to the famous mangaka Leiji Matsumoto, at the origin of this work adapted to anime (*Captain Harlock 1978*, Rintaro), his skull and crossbones banner affirms his convictions loud and clear: "I live free under my own flag and according to my own principles, never looking back." His iron will battles the cruelty of humans and aliens, but independence is his mantra. It matters not if he breaks the rules imposed by a depraved government or if he ruthlessly exterminates the Sylvids. With a human appearance, these green-skinned beings are equipped with a vegetable organism and want to colonize Earth. Harlock is an ambivalent hero who stands beyond good and evil, but he has an unfailing devotion to his friends, whom he takes in on his ship. To Stellie, the little orphan girl he has sworn to protect, he offers his ocarina—an instrument that colors the series' Saturnian theme. The same melancholy haloed the eternal traveler Maetel from *Galaxy Express 999*, another manga by Leiji Matsumoto brought to the screen by Rintaro in 1978 and featuring an appearance by Harlock. Inspired by a Julien Duvivier film (*Marianne of My Youth*, 1955), the character wears her evanescent blondeness over her mourning clothes. Although she joins Tetsurō's journey, their heartbreaking separation exacerbates an elegiac tone that mourns the loss of youth and of loved ones.

Hayao Miyazaki prefers characters that mix both light and shadow, strength and fragility, over the virile and Manichean superhero culture. While his child pairs are pure, his adult protagonists are more troubled, from Lupin III, an amoral and chivalrous outlaw, to Porco Rosso, who is both misanthropic and altruistic. The latter is passionate about planes but disgusted by human nature—as an ex-pilot of the Italian army turned bounty hunter, he saw his friends die during World War I. This results in him developing a pig's head and a hatred for compromise: "I'd rather be a pig than a fascist." Marco/Porco wants to be free as a bird, despite the fact that the army is after him for "unpatriotic subversion" and "pig exhibitionism." He carries this melancholy with him, as though surviving his friends has condemned him to a life of solitude.

Behind their stylishly casual energy, the characters in *Cowboy Bebop* are all prisoners of their past, whether they suffer from amnesia or remember too much. When Faye finally regains her memory, she discovers that there is nothing left, that she has nowhere to go except the *Bebop*. As for Spike, his casualness and his praise of the pure present moment are shattered each time his memories come back to haunt him: a rainy evening that forever changed his destiny, when he lost his loved one. From far and wide, the narrative breaks down into romantic stases, where red rose petals scatter in the rain, upon the debris of a cathedral window. By running away from his past, Spike feels like he is living in a waking dream, much like a sleepwalker. By facing his demons, he settles his accounts once and for all—the only way to assert his freedom and verify that he is truly alive. Even if death is at the end of the road.

85

EUROPEAN-JAPANESE CONNECTIONS

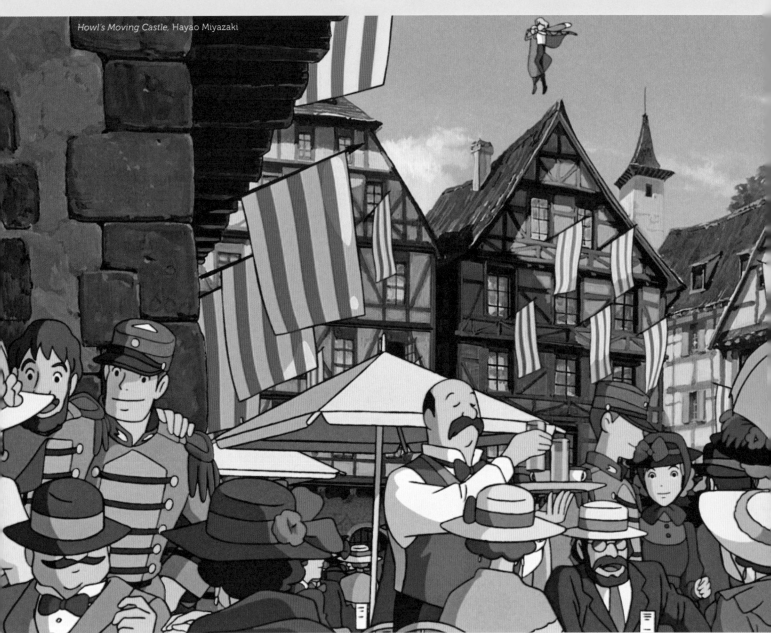

Howl's Moving Castle, Hayao Miyazaki

The King and the Mockingbird, Paul Grimault

The graphic ramifications between Europe and Japan have taken sometimes discreet and unexpected, but also sometimes dazzling turns. France in particular often serves as a source of inspiration. Charles Aznavour's name inspired that of Char Aznable in the science-fiction franchise *Mobile Suit Gundam* (started in 1979) sounds like a silly joke. The sublime rice fields of Hayao Miyazaki in *My Neighbor Totoro* (1988) pay tribute to Japanese landscapes, but also to the vineyards of Alsace, a region in the northeast of France, where the director stayed. The half-timbered houses of *Howl's Moving Castle* (2004) are reminiscent of Colmar, a city in Alsace. You can even recognize the Pfister house, a two-story architectural gem in Colmar. More fundamentally, Hayao Miyazaki and Isao Takahata were captivated by the formal maturity of *The Shepherdess and the Chimney Sweep* (1953) by Paul Grimault—an adaptation of a fairy tale by Andersen with the help of Jacques Prévert—which gives this French cartoon both a political and poetic dimension. Although this version, released in a hurry by the producer, was not endorsed by its authors, the two future creators of Ghibli felt that a radically new path was being charted, far from the attractive sweetness of Disney fables. The highlight of this realization for Takahata: when a subject displeases the King of Tachycardia, he pulls on a rope that opens a floor tile, sending the unwelcome person into the void, before going on as if nothing had happened. Not a drop of blood is shed in this scene of immense cruelty, which has a striking visual impact and works in the concepts of depth, space, and metaphor. High-flying animation that marks him for life.

Sometimes, Western directors take up the challenge of adapting a manga. A Japanese story resembling a European graphic novel, *A Distant Neighborhood* (1998–1999) narrates a mature man's return to his hometown and how he, through a leap in time, reinhabits his fourteen-year-old body just before his father leaves home. With this remarkable manga, Jiro Taniguchi conquered more readers and critics in Europe than in his native country, destabilized by his eclecticism. Marked by the *gekiga* style, which

flourished in the postwar period to deal with social problems in a raw manner, as well as with the works of Enki Bilal and Moebius, Taniguchi gradually established his own visual rhythm, both realistic and contemplative, that intertwines reflections on daily life or memory with the characters' spiritual quest. Belgian director Sam Garbarski has adapted A *Distant Neighborhood* (2010) to a live-action movie, transposing the plot to a small town in France. In 2021, the Frenchman Patrick Imbert signs the adaptation of another manga by Taniguchi: *The Summit of the Gods* (2001–2003), based on a novel by Baku Yumemakura. A perfect fusion of Japanese and Franco-Belgian traditions, this animated movie begins like a journalistic investigation. The challenge is to find the camera of a legendary mountaineer (who really existed), Georges Mallory, who disappeared on Mount Everest without a trace. Had he or had he not conquered the "roof of the world"? But the work quickly slips into a metaphysical journey with Habu Jōji (an invented character). This solitary climber, a little misanthropic, has one existential obsession—to tackle these mountains, as grandiose as they are chilling, and that quietly swallow up bodies, without oxygen. In these fractured

Mutafukaz, Shōjirō Nishimi and Guillaume Renard

landscapes rendered with maniacal rigor, the man's insignificance is emphasized by the size of the shots, which goes hand in hand with his boundless determination, glorifying freedom at the risk of death.

On occasion, a Japanese filmmaker and French cartoonist work hand in hand. In 2017, Guillaume "Run" Renard codirected the animated version of his comic book *Mutafukaz* (2006) with Shōjirō Nishimi, who worked on *Mind Game* (Masaaki Yuasa, 2004) and *Tekkonkinkreet* (Michael Arias, 2006) for Studio4°C. In Dark Meat

City, in a nightmarish California, life is hard for society's rejects—especially for Lino, with his round, black head, and for his friend Vinz, who sports a flaming skeleton face. After a scooter accident, Lino is plagued by hallucinations. The shadows of some of the protagonists appear to him as monsters with tentacles. Pursued by mysterious men in black, he gets caught up in an international conspiracy that gradually reveals his true nature as a hybrid: unlike his mother, his father belongs to the Macho race—aliens who have infiltrated Earth in order to monopolize its resources.

With its variegated graphics, *Mutafukaz* transcends all cultural boundaries. It combines genres—film noir, gangster movies, science fiction—and quotes cult films, such as *Invasion of the Body Snatchers* (1956) by Don Siegel and *They Live* (1988) by John Carpenter. Because even without looking through John Nada's glasses, Lino is able to flush out the supernatural creatures that hide beneath a human appearance to better oppress the population. With *Mutafukaz*, Run and Nishimi offer an explosive cocktail between the comic book, the comic strip, and manga.

The Summit of the Gods, Patrick Imbert

THE COLOR OF DREAMS

There are encounters that cannot be forgotten. In 1963, Hayao Miyazaki and Isao Takahata did not yet know each other as they waited for a bus, side by side, in the rain. We find this rainy scene sublimated in *My Neighbor Totoro* (1988), as if fiction sealed this founding encounter through the powers of purity and imagination. While two girls wait in the middle of nowhere, a giant stuffed animal—something between a cat and a panda—makes itself heard through heavy steps and materializes before the amazed eyes of the oldest, Satsuki. She offers him her umbrella before the little creature is carried away by the Cat Bus at full sail. Immediately recognizable, Totoro is Ghibli's coat of arms, projecting its aura on each of the studio's films. It is also the emblem of all the wondrous that interferes with reality in order to transcend it. An illustrious ambassador of Japanese animation around the world, Miyazaki is by far the most inventive fantasy creator ever. *My Neighbor Totoro* is heavily emotionally and historically charged, so much so that its magical realism links the intimate to the universal. This big beast guides the little girls—and the viewer—through the forest populated by protective spirits. But beware: to see Totoro, you must reconnect with your childhood spirit, sitting somewhere between joy and melancholy.

Japanese wonder has a wider spectrum than Disney's enchanted worlds. While dragons, talking animals, and magical powers naturally exist in the universe of fairy tales, myths, or heroic fantasy, Japanese animation is brimming with parallel worlds that are separated from everyday reality. Set in an enchanting or nightmarish elsewhere, they offer all the elements of a frenzied quest through secret passages that take the characters to the other side of the mirror. It is up to the latter to restore the balance and experience their humanity. These worlds, with dreamlike colors, praise the imagination, playfulness, and artistic creation. The narrative and graphic delusions are everywhere, from the pop star mermaid to the cat statuette that comes to life to tell its sad love story, the cities of clouds, edens of greenery, and witch academies.

Above all, the filmmakers weave unexpected links between the real and the wondrous to sanctify the beauty of nature and the fragility of existence in their most imperceptible dimensions. Between metamorphoses and transgressions of borders, this magical Japanese realism bubbles with spirituality. Animism, which endows each plant or object with a moving life, is its cornerstone. In this way, spirits sanctified by the Shinto or Buddhist tradition are brought out. In short, a thousand wonders that capture the poetry of reality, or its magic, both literally and figuratively.

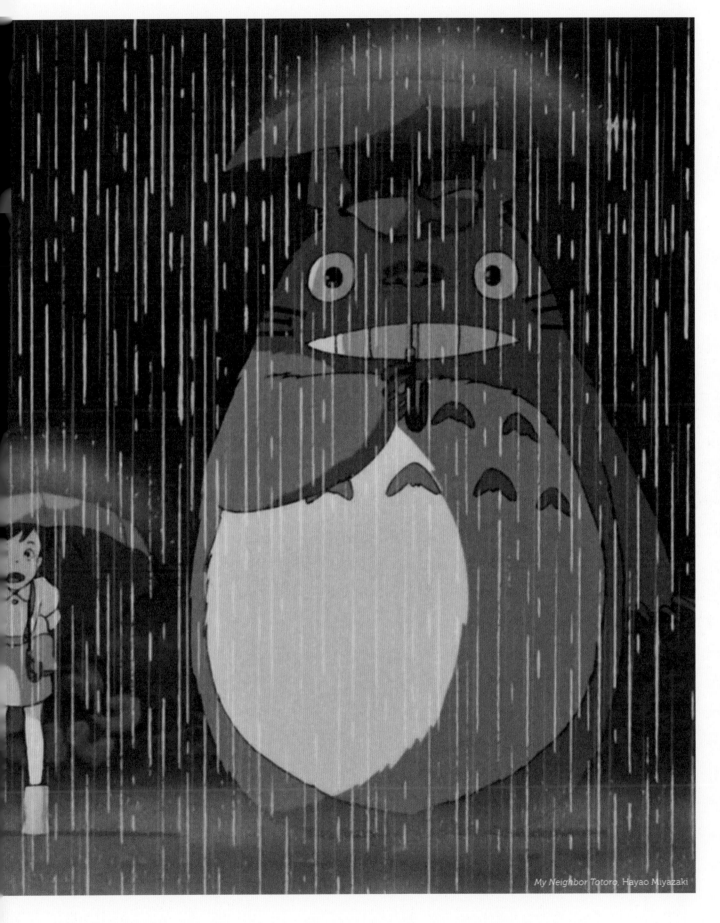

My Neighbor Totoro, Hayao Miyazaki

THE STORY'S ENDING

I he tale is the universal platform for the wondrous: enchantment has all the trappings of nature, of the obvious. At any given moment, talking animals, magical creatures, and spirits link the visible and the invisible.

Aspiring to become the "Disney of the East," Toei Dôga (created in 1956) started producing one animated feature film per year, inspired by Chinese tales (*The White Snake Enchantress*, 1958; *Journey to the West*, 1960), then by classics of Western children's literature (*Gulliver's Travels Beyond the Moon*, 1965; *Puss in Boots*, 1969). Signed Taiji Yabushita, his first creation is inspired by the Chinese legend of the white serpent. This story pits a snake-woman, in love with a mere mortal, against a monk who slays the spirits. The subject of several adaptations in its country of origin, this tale features a more or less ambivalent figure, either in love or evil. Teeming with wonders, Toei's animated version emphasizes the couple's unfailing love, beyond their antagonistic nature. This celestial spirit metamorphosed into a princess is ready to give up her immortality so she can resurrect the young man who loses his life confronting the monk. Seized by the strength of their feelings, the latter ends up granting them his blessing: the sun calms the storm and the lovers sail toward their future, according to the happy ending that is expected of the genre.

Although it is true that the adaptation of tales is a classic in children's animation, some filmmakers show their bravery by injecting ambitious issues into it. *Princess Arete* (Sunao Katabuchi, 2001) is a feminist story. Locked away by her father in a dungeon awaiting her future husband, a rebellious princess keeps escaping to explore the real world. She is not resigned to her fate and absolutely wants to reach her own potential. A sorcerer wins her hand by removing her "evil spirit", and he then transforms her into a docile princess, who he imprisons in an old ruined castle in the middle of a land that he has deprived of water. After resignation comes the time for battle: the young girl escapes, sheds her riches, then steals the emerald of the water serpent to replenish the village and put an end to the tyranny of the cursed sorcerer.

Isao Takahata's *The Tale of Princess Kaguya* (2013) also denounces the oppression of women at court. A testament of his work, the filmmaker brought to the screen a famous Japanese legend: the story of a lunar princess sent to Earth to atone for her excessive fascination with human beings. Discovered by an old man among bamboo shoots, Kaguya miraculously grows up to become extraordinarily beautiful. Taken to the city to meet rich suitors, she who used to live free in communion with nature, discovers submission and the weight of etiquette. Faced with this misfortune, the celestial beings descend from the Moon to exfiltrate him. *The Tale of Princess Kaguya* is a philosophical fable and an artistic manifesto. Handling different styles, Takahata intends to "avoid the fairy tale for reality," even within the tale itself. Thus, the realistic framework—childhood in the woods, life at court—is only occasionally shattered by the appearance of the wondrous—the blossoming of the child, the discovery of gold, the Buddhist procession. The line revives the artist's original gesture, favoring the sketch—open and unfinished—to retranscribe the Japanese feeling of *mono no aware*. Basically, the awareness of the ephemeral, the sweet and melancholic surprise felt in contact with everything. Polymorphic, the wondrous surrounds reality with a poetic aura and transcribes the most fleeting of feelings.

93

鏡の國のアニメ

94

ANIME THROUGH THE LOOKING GLASS

The Cat Returns, Hiroyuki Morita

From Aesop's fables to Walt Disney's cartoons, talking animals are what children's dreams are made of. Animation has never ceased to embody this magical metamorphosis—a fantasy of communion beyond the species. Thus, dogs, squirrels, or birds become the fiction's heroes or the main character's faithful companions. The love story of *White Snake* is born from an act of compassion for the reptile sold at the market, rejected by all. In addition to the snake-woman and her fish-maid, the young man is accompanied by a panda and a fox, who are an echo chamber for his emotions. As for the bestiary invented by Osamu Tezuka, it is so rich that Disney is accused of having plagiarized the animated series *Leo the Lion* (1966–1967) for its own *The Lion King* (1994). Instead of attacking the studio, Tezuka Productions proposed its own feature film in 1997, directed by Yoshio Takeuchi. Now a father, Leo fights one last battle to protect the jungle from adventurers desperate to obtain a moonstone, before handing the throne over to his son. In his adaptation of Kenji Miyazawa's *Night on the Galactic Railroad* (1985), Gisaburô Sugii transforms the children of the story, Giovanni and Campanella, into anthropomorphic cats. This choice reinforces the fairylike strangeness of interstellar travel, which soothes the loneliness and wounds of everyday life.

However, there are sharp-tongued animals that fill more original and ambiguous roles. Animals improvise as music repeaters in Isao Takahata's *Gauche the Cellist* (1981). They challenge the awkward musician to help him make Beethoven's *Sixth Symphony* his own. In *Horus, Prince of the Sun*, if the bear Koro is the adjuvant of the solitary hero, Chiro the squirrel and Toto the owl, perched on Hilda's shoulders, are in a gray area. A spy for the wizard, Toto whispers real horrors to her and tries to make her slide down the slippery slope to evil. In *The Cat Returns* (Hiroyuki Morita, 2002), Haru saves the life of a cat stuck in the middle of city traffic. And to her surprise, he stands up and thanks her using real words! Nothing in this realistic environment predisposed the intrusion of the wondrous. Is it a dream, Haru thinks, after his nightly encounter with a procession of cats perched on two legs? This strange parade carries with fanfare their paunchy king, who has come to offer his son in marriage. But beware, some beasts seek to steal human beings' souls. The shaggy ruler kidnaps the girl and makes her grow whiskers. Miyo has another bad encounter in *A Whisker Away* (Jun'ichi Satô, Tomotaka Shibayama, 2020). A high school girl makes a Faustian pact with a strange creature, half man-half cat. He convinces her to accept a mask so she can inhabit the body of the cat Tarô, taken in by the boy she loves. After coming and going as she pleases, Miyo is trapped by the treacherous spirit, who then steals her face and identity.

ANIMAL FARM

This hybridization between man and animal is rich in meaning. It sometimes denounces voracity, such as when Chihiro's parents are transformed into pigs, or reminds us to be humble like Porco Rosso after the carnage of war. Full of humor, Miyazaki even represented himself with a pig's head in a self-portrait. Sometimes it is to castigate our negligence toward nature, as in Mamoru Hosoda's *Wolf Children* (2012). In *Pom Poko* (1994, Isao Takahata), the *tanuki* who fight against the real estate madness of men are either mute four-legged beasts who get decimated or talkative anthropomorphic spirits. Not to mention the foxes, who adopt a human appearance so they can survive. Carriers of the morals behind the fables, humanoid animals willingly hold up a distorted mirror to human beings. It is then up to them to recognize themselves in it.

like fairy tales, heroic fantasy is full of witches, dragons, and spirits. As an unchallenged principle of fiction, magic—be it white or black—flows naturally. It does not arouse astonishment, either because the protagonists master it or because they find it perfectly normal for reality to have a transcendent side. Suspension of disbelief pulsates to the rhythm of supernatural adventures and affects the characters as much as the viewers, who accept to believe in it for the duration of the story. These works are radically located elsewhere, in another world that is not subjected to the imitation of reality. This is how young Sophie becomes a wrinkled grandmother in *Howl's Moving Castle*. In *Tales from Earthsea* (2006), Goro Miyazaki takes up his father's torch—his father had always dreamed of adapting this book by Ursula K. Le Guin—all while finding it difficult to detach himself from his father's influence. Dragon, magic sword, spiritual wizard, evil double, bewitches who long for immortality: all the ingredients are present in this perfect heroic fantasy cocktail. Revived by Peter Jackson's *The Lord of the Rings* (2001–2003) or the *Game of Thrones* series (2011–2019), the genre offers a salutary change of scenery: it reactivates folkloric universes and beliefs from the depths of time.

On the myth side, *Arion* (1986, Yoshikazu Yasuhiko) resurrects the Greek gods of Olympus in a flamboyant initiation story, while *Buddha, the Great Departure* (2011, Kôzô Morishita) and *Buddha 2: The Endless Journey* (2014, Toshiaki Komura) adapt a manga by Osamu Tezuka devoted to Buddha's future and his long path to enlightenment. Destined for the throne, Prince Siddhartha has a front-row seat to the suffering of humans who endure slavery, the caste system, and the barbaric wars of ancient India. While his friend Tata, of the outcast class, is able to borrow the body of any animal, Siddhartha projects his luminous aura onto beasts, "inferiors," and even his enemies. Leaving his palace riches behind to embark on his spiritual journey, he will reach enlightenment and show his people the path to regeneration. Between the exhibition of atrocities and the spiritual breath, this odyssey revives the original legend of Buddha, so that it will not exist solely on paper for the younger generation. Unfortunately, the failure of these films delayed the release of the trilogy's final opus.

ABRA-CADABRA

Going in the opposite direction, *Kiki's Delivery Service* (1989) reinjects ancestral beliefs into the heart of a modern, European-inspired city. Here, modernity, with its faith in technical and scientific progress, has contributed to the disappearance of magic and the weakening of religion. This is a source of disenchantment that Miyazaki's film fights with its own weapon: imaginary. Kiki and her black cat enter a realistic world where people are unimpressed when seeing her riding a broom. But the old watchmaker is delighted by her appearance, because he has not seen a witch for a long time. Thus, the presence of magic on Earth is fully integrated and accepted by society. Warmly welcomed, Kiki sets up her small delivery business that suits her special talents. She struggles to find her place in the community, but uses her powers to help or save her friends. In contrast, lunar or extraterrestrial beings sometimes appear in everyday life, causing both amazement and chaos as they transgress the order of the world, despite their perfectly human appearance. Before, eventually, becoming part of the landscape and beginning their emotional education, as in the *Lamu* series, the origin of two films by Mamoru Oshii (*Urusei Yatsura: Only You*, 1983, and *Urusei Yatsura 2: Beautiful Dreamer*, 1984).

Buddha, the Great Departure, Kôzô Morishita

鏡の國のアニメ

ANIME THROUGH THE LOOKING GLASS

SECRET

When the magical space-time continuum is an autonomous bubble, adjacent to reality, the title characters are able to establish portals to this other dimension. They unexpectedly follow intercessors, open secret passages, or come across miraculous objects.

The cat is a privileged guide to these wonderful worlds. In *Whisper of the Heart* (1995, Yoshifumi Kondō), the young Shizuku is intrigued by Moon, who catches the train like a human being. She heads for an old antique store, where she finds the Baron's statuette, a creature to which Ghibli later devotes an entire film in an intertextual game: *The Cat Returns.* Two universes exist in parallel to Haru's daily life, disturbed by her encounter with the feline people. A voice sets her on the path of the Cat Bureau. Similar to *Alice in Wonderland,* the girl appears gigantic in the Baron's dollhouse. He is ready to help her. Kidnapped by the king's henchmen, she is teleported to a mysterious land through mirror doors that open in the sky. Consequently, she shrinks and begins her bestial transformation. In *Mary and the Witch's Flower* (2017, Hiromasa Yonebayashi), the young girl follows a black cat deep into the forest to a glittering flower. Mary is unaware that a witch covets the magical powers of her bellflowers. When an intense fog envelops the woods, she enters them despite their typical fairy-tale warning. After crossing a small stone bridge, she discovers an antique broom hidden under the trees, which the blue flower activates in flashes of light. Tattooed with a mark on her hand, Mary can now ride this broom to Endor College, a chilling amusement park located on a flying cliff (reminiscent of Miyazaki's *Castle in the Sky*).

In this way, girls who appear perfectly ordinary are confronted with something extraordinary, governed by rules that defy all understanding. Before her journey of initiation, Mary was bored to death at her great-aunt's house. An apathy and lack of self-confidence also endured by Akané in The *Wonderland* (2019, Keiichi Hara), until the appearance of the alchemist Hippocrates in her aunt's curiosity store, who establishes her as a goddess of the Green Wind. It is while going down to the cellar, adorned with a magical pendant, that Akané steps on the threshold that leads her to Wonderland. Before the spider-web bridge disintegrates, she jumps into a black hole and lands in a bright wheat field—the journey can now begin. In *Spirited Away* (Hayao Miyazaki), the young girl is sad to move to a new town. When her parents get lost along an old forest path, dotted with oratories and sacred statues, she begs them to turn back. Likewise, when they enter a dark and windy bottomless tunnel. This rift in space-time leads to a deserted city—an old theme park, according to her rational father. This is not the case: reality shatters, changing texture and codes. While the adults gorge themselves on mouthwatering dishes, Chihiro crosses a bridge that overlooks a sumptuous traditional bathhouse. She is immediately chased away by the young Haku, aware of the danger incurred by the one "who smells human," particularly at night.

In contrast to the previous examples, Aoyama from *Penguin Highway* (2018, Hiroyasu Ishida) is a smart boy who applies the methods of scientific analysis to a supernatural phenomenon. Penguins springing out of Coca-Cola bottles proliferate in the city before being magnetized toward a watery sphere that appears in the middle of a field. This is the door to a surreal universe, a metaphysical end of Earth, which delights the boy. All these secret passages are mirrors that blur the boundaries of reality that make divine spirits and magical places appear.

PASSAGES

FLOATING ISLAND AND PUTRID GOD

Magical worlds offer an opportunity for endless graphic experimentation. The design of the cities and creatures obeys only the fecundity of the imagination and the stroke of the pencil, so that its wondrous stuns the perception and heightens the sensations tenfold.

With its narrative within a narrative, *Whisper of the Heart* deciphers the mechanisms that lead to the invention of such utopias. Between school pressure and first loves, Shizuku is searching for her path. In an antique store, she discovers the statuette of the Baron cat with a melancholic look. Following the example of her friend Seiji, an apprentice violin maker, she begins to write a novel. The adventures of the Baron and Shizuku take shape before our eyes, in an antipodean natural fairy-tale style that traces his daily life. In his only work as a director, the late Yoshifumi Kondō (who died at the age of forty-seven) took advantage of the aesthetic lessons of the two Ghibli masters: the sociological realism of Isao Takahata intertwined with the unbridled fantasy of Hayao Miyazaki. Omnipresent on the project, he took care of the supernatural passages. Drawn by the painter Naohisa Inoue, with his characteristic style, the tale's backgrounds come to life in vast impressionist paintings, forming a vaporous and shimmering space with skyscrapers made of foam, cloud towers, and asteroids woven with precious stones. Between the register changes and the praise of the craft running through the film, it is the animation that, in its ability to embody incredible universes, is the story in the story.

From Howl's Moving Castle to the floating island of Laputa to the Poison Forest, Hayao Miyazaki has etched phantasmagorias that are overflowing with strange places and creatures into our memories. One of the most whimsical is that of *Spirited Away*. The young girl is trapped in a luxuriant and anachronistic city, haunted by gods as fascinating as they are eccentric. To give her parents back their human form, the young girl has no choice but to work for the witch Yubaba. Deprived of three-quarters of her name, she falters when her body starts to become transparent. But she rolls up her sleeves in the face of adversity, galvanized by Haku, a bewitched boy who transforms into a white dragon. A hostess in these public baths, she welcomes all kinds of revisited Shinto spirits, from the Faceless Ghost to the Stink God, and the ghosts with paper masks or the god in the shape of a giant radish.

With its goldfish who wishes to be a little girl, *Ponyo on the Cliff* (2008) is an original retelling of *The Little Mermaid*, a tale by Andersen adapted in a classic way by Toei in 1975 and later by Disney in 1989. Entirely hand-drawn in a childish, pastel graphic style, the movie opens in a marine kingdom full of miraculous lives. On his legged boat, surrounded by a bubble of light, the wizard Fujimoto looks impressive with his long red hair and his striped frock coat. His daughter Brunhilde—a name taken from Germanic mythology—has a human face and wears a bathrobe. Eager to discover the wide world, she takes advantage of her father's distraction to escape by means of a translucent flower-medusa. Ejected onto the shore along with the trash, she is saved by a young boy, Sôsuke, who renames her Ponyo. After licking a drop of Sôsuke's blood, she begins her transformation into a little girl. To join her friend, she rides the gigantic waves that threaten to engulf the city. A ball of energy, Ponyo brings wonder into the heart of reality. In spite of the threat of submergence, everything becomes a pretext for enchantment and adventure. *Ponyo on the Cliff* is an ode to fiction, electrified by the forces of wonder that transgress the law of species, reconciling human and nature.

101

Spirited Away, Hayao Miyazaki

TOM THUMB AND HIS PEBBLES

What could be more fertile than the boundless inventiveness of children to transform reality in the blink of an eye? An unbridled retelling of *Alice in Wonderland*, Rintaro's "Labyrinth Labyrinthos" (short film in *Manie Manie*, 1987) goes through all the layers of a little girl's imagination, who is chasing her cat Cicerone. After entering a clock and diving into a mirror, a clown guides her into the moving theater of her unconscious mind, a distorted world full of spectral silhouettes, ghost trains, and cardboard men who fall like dominoes.

In *My Neighbor Totoro*, Hayao Miyazaki magnifies the poetic look of young souls, the only ones capable of making contact with the spirits of the forest. The wondrous takes on a spiritual tone. As Mei and Satsuki move to the countryside to be closer to their sick mother, they meet magical creatures who fit perfectly into their daily life. Although they are enchanted in the extreme, they are not really surprised by these apparitions, which help them to heal their wounds. Everything happens as if the filmmaker, whose childhood was marked by his mother's tuberculosis, fantasized about amazing friends to protect the girls in the woods' maternal cocoon. Elevating the strange to the sublime, he connects the infinitely small and the infinitely large, from the usually despised critters of the credits (lizards, caterpillars, grasshoppers) to the giant camphor tree. As for the noiraudes, they are little balls of soot hidden in the nooks and crannies of old uninhabited houses, only detectable by children. And it is through a bucket with a hole in it that Mei sees acorns scattered like the pebbles of Tom Thumb. This improvised magnifying glass sheds its light on the invisible and foresees the vision of the little white Totoro, half-transparent, hopping around in the grass. Mei follows him to a tunnel of leaves that leads to the tree's roots. She then tumbles into a sublime well of greenery that contains the great Totoro. Finally, the Cat Bus is a means of transportation, as crazy as it is fantastic, that helps Satsuki to find her little sister when she gets lost in the countryside, before dropping the children off at their ailing mother's bedside.

The ability to see the infinitely small is at the heart of *The Secret World of Arrietty* (2010), scripted by Miyazaki but directed by Hiromasa Yonebayashi, whom Studio Ghibli helped to get his foot in the door. A young boy with a weak heart is resting in the Tokyo countryside before undergoing major surgery. In the anarchic garden of the old family home, Shô learns to detect the microscopic beauty literally hidden among the blades of grass. As soon as he arrives, he thinks he sees a small being running to hide. According to his ancestors, tiny people live lurking in the house. His grandmother, who dreams of giving them a dollhouse, has never managed to see them. The family of young Arrietty is a breed of Borrowers, on the verge of extinction, who do everything within their power to avoid being seen by human beings. Her humble home, installed in the crawl space, is made up of small objects gleaned from her hosts. For her, a lump of sugar is a war treasure. Shô manages to create a bond of friendship and trust with Arrietty—unlike Mei, who appears framed between the teeth of a Totoro baying at crows. The disproportion of size underlines the threatening gigantism of men, who tend to monopolize everything.

103

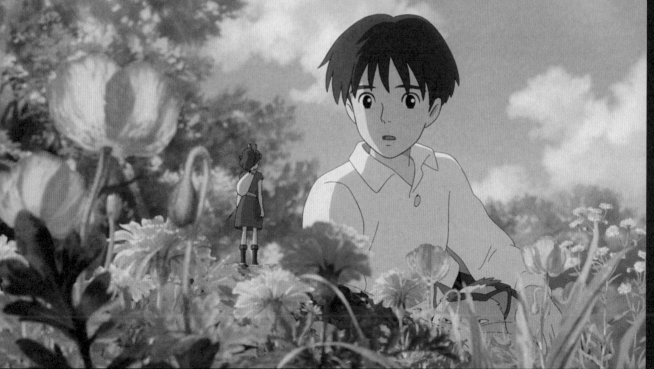
The Secret World of Arrietty, Hiromasa Yonebayashi

Belladonna of Sadness, Eiichi Yamamoto

CABINET OF CURIOSITIES

Pictures at an Exhibition, Osamu Tezuka

Self-Portrait, Osamu Tezuka

Besides all the great commercial successes, Japanese animation is full of avant-garde works. These short and medium-length auteur films, which are highly acclaimed at festivals, are a fertile breeding ground for formal innovations that are free of any narrative or economic diktat. The filmmakers try out the countless possibilities of animated creation. A color remake of his 1927 black-and-white silent film, *The Whale* (1952, about eight minutes) by Noburō Ōfuji was, for example, distinguished among the official selection of the Cannes Film Festival of 1953, presided over by Jean Cocteau. The filmmaker works with cut paper silhouettes, which are swallowed by a whale during a storm. He plays on the superposition and dissolution of forms, mixing rain, waves, sea creatures, and human shadows, all within a dreamlike and mythological atmosphere.

In addition to his manga and successful series, Osamu Tezuka also directed or produced several experimental works at Mushi Production since the studio's creation in 1962, including the medium-length film *Tales of a Street Corner* by Eiichi Yamamoto and Yûsaku Sakamoto. Devoid of words, this urban poem orchestrates improbable encounters—a red balloon, a teddy bear, a mouse, and a little girl—and gives life to posters stuck on the walls, making them play music or dance. When the war invades the city, this joyful parade is suddenly transformed into aggressive propaganda, with guns posted everywhere. Another example with Osamu Tezuka's signature is *Pictures at an Exhibition* (1966); it has an eclectic style that brings together ten short films exploring the flaws of modern society. Each of them embodies a movement from the piano suite of the same name composed by Modest Mussorgsky in 1874, with music arranged by Isao Tomita. In 1988, a year before his death, Tezuka ironically drew himself with a slot machine head in *Self-Portrait* (eleven seconds long). Not surprising, given that the artist often denounced the shortcomings of capitalism being detrimental to the humanism that he bitterly defended all his life.

In 1973, *Belladonna of Sadness* closes the *Animerama* cycle, composed of three erotic films for adults by Eiichi Yamamoto (the first of their kind in the history of Japanese animation). Inspired by the essay *The Witch* (1862) by Jules Michelet, this feminist and subversive work narrates the sexual persecution of a young woman, raped by the lord of the region, who starves and tortures his serfs. To survive and get revenge, she sells her body to an erotomaniac devil. Transformed into the Belladonna of Sadness, she sows the seeds of desire wherever she goes, disturbing the established order and is, eventually, burned at the stake. At times graceful, lascivious, or bloody, this sensual poem offers a hallucinatory journey through sublime paintings in ink, watercolor, or charcoal and collages in different styles: in no particular order, of Gustav Klimt, Egon Schiele, Odilon Redon, art nouveau, German expressionism, etc.

In a completely different register, *The Red Turtle* (2016), an unusual film in the Ghibli catalog, was awarded a Special Prize Un Certain Regard at the Cannes Film Festival. Contacted by the studio, which was charmed by his short film *Father and Daughter* (2000), the Dutch filmmaker Michael Dudok de Wit received script assistance from the French director Pascale Ferran. Fruitful exchanges were also established with Toshio Suzuki, who was then chief producer of Ghibli, and especially with Isao Takahata (*Grave of the Fireflies*): "Amazingly, despite our big

Belladonna of Sadness, Eiichi Yamamoto

The Red Turtle, Michael Dudok de Wit

107

cultural differences, we were on the same page," the Dutchman recounted at the 2015 Annecy International Animation Film Festival. *The Red Turtle* is the studio's first international coproduction (France, Belgium, Japan), its animation having been realized in Angoulême, a city in the southwest of France, under the direction of Jean-Christophe Lie, animator of the *Triplettes of Belleville* (Sylvain Chomet, 2003). Devoid of dialogue except for a few desperate cries, *The Red Turtle* is a metaphysical poem that reenacts the evolution of humans since the dawn of humanity. After being shipwrecked on a desert island, a wannabe Robinson Crusoe tries to escape from his lonely hell by building a raft, which is systematically destroyed by a red turtle. When the turtle is stranded on the beach, the man turns it over in anger and leaves it to dry out in the sun. Full of remorse, he returns but discovers a beautiful young woman with red hair, who the rain awakens, in the split shell. They then couple and restart the cycle of life. The charcoal settings and arid colors, which make this untouched nature hostile, avoid any Edenic vision, even if a few dreamlike sequences and hallucinations born of solitude provoke escapes from the island-prison. Critically acclaimed, *The Red Turtle* was a relative success in European cinemas but was shunned in Japan, because of its stripped-down aesthetic that distances it from the wondrousness that permeates Hayao Miyazaki's worlds.

❝ If I were told that the world was going to end tomorrow, I would still plant an apple tree." Martin Luther's words could resound on the frontispiece of many a cartoon. In the lead would be *The Man Who Planted Trees* (1987) by French-Canadian Frédéric Back, based on a short story by Jean Giono, in which a solitary man reforests, seed by seed, barren heights beaten by the wind. Through this tirelessly repeated microscopic gesture, he resurrects not only lush nature, but also the community, making it able to embrace the future once again. This animated short film deeply marked Isao Takahata, a herbalist who celebrates the grace of each flower in the quasi-botanical illustrations featured in his films. Japanese animation is galvanized by a vital breath that magnifies the world's splendor, encouraging its nature's preservation—so badly damaged by urbanization, pollution, and amnesia. It is as if humanity had broken the ties with its roots and its ancestral environment. This type of cinema seeks to revive the memory of the fundamental link that unites humankind with nature, with the spirit of our ancestors, with folklore, and with their history.

The religious and philosophical thought that makes the heart of Japan beat is a syncretism of Buddhism from China and Shintoism specific to the archipelago. Composed of the *kami*—multitude of deities—and the *yôkai*—supernatural creatures—Shintoism is an animism that lends life to every being, plant, and object. These divine spirits are everywhere, in the heart of the elements, rivers, and mountains, symbolized by *torii*—shrines—and statues. They also represent the souls of the deceased and of houses. By using the plasticity of drawing, films materialize these spiritual entities in order to connect the profane and the sacred, the visible and the invisible. To revive spirituality even in the heart of concrete cities, to celebrate the cosmos in eavery little thing beyond consumerism, to restore faith in the sublime and the interdependence of beings—such is the particular consideration of Japanese filmmakers.

As Sergei Eisenstein had already noted in his book on Walt Disney, animation is the "direct embodiment of the method of animism. A time-lapse during which an inanimate object is endowed with a life and a soul." For Osamu Tezuka, "by making something move, we breathe life into it—this is what we call 'animism', the thought that leads us to believe that every object has a soul. Animation is indeed, in this sense, a kind of animism" (*The Animation Filmography of Osamu Tezuka*, 1991). If Ghibli enchanted us with its elegiac tales or its odes to nature, the new generation is not to be outdone. For their part, Makoto Shinkai, Mamoru Hosoda, and Keiichi Hara propose environmental fables that invite today's youth to take up the torch and preserve our life cycle.

NATURE AS A SANCTUARY

The Tale of Princess Kaguya, Isao Takahata

FANTASTIC SPIRITS

Like hieroglyphs, Miyazaki scatters signs to be deciphered everywhere. Spiritual tipping points toward another dimension, they magnify the fragile beauty of the world, which must be preserved at all costs. To do this, you have to learn to see, along with his everyday heroines, who enlighten the viewer and remind him or her that nature is vibrant with spirit. After her magical encounter with Totoro, Mei wakes up in a place that has completely changed its configuration: the secret passages have disappeared. To comfort her, her father and sister take her to pay homage to the guardian of the woods in a symbolic journey strewn with silent incantations: passage of the *torii*—the gateway to Shinto shrines—a sacred cord around the thousand-year-old tree that the family warmly thanks for its protection. Although Miyazaki draws from Buddhism and Shintoism, still very much alive in Japan, he does not hesitate to modernize the spirits that populate the forest. Since the plot of *My Neighbor Totoro* is set in the countryside of the 1950s, a time of reconstruction and change, it was necessary to invent "transitional ghosts," as he put it in an interview with Noriaki Ikeda. A very original *Yôkai*, the Cat Bus is the incarnation of this hybridization between the Shinto tradition and postwar modernity. It is on board that Satsuki finds Mei lost in a sacred place where electric pylons stand next to six Buddhist Jizo statues. Proof of Miyazaki's poetic and environmental commitment, the Totoro no Furusato Foundation actively works to protect the Sayama Woods, where "Totoro forests" celebrate the birth of the character, invented during the filmmaker's long walks.

Miyazaki has particularly sublimated the spiritual force of the elements, from the Calcifer fire that moves the walking castle toward the waves unleashed by Ponyo to join her friend Sôsuke, not to mention the wind that propels the aircraft or the floating island of Laputa. The credits of *Castle in the Sky* summarize this ancient civilization's prehistory. It pays tribute to the generosity of the Goddess of Wind, who blows the clouds and activates the mills, enabling men to mine the iron from the rock. Voraciously, they have dug the ground to excess until they have to abandon the polluted Earth to live in the air. Thunder from the sky reduces this flying city to rubble and leaves the survivors to return to a humble terrestrial life. After passing through the fantastic tunnel marked by a *sekijin* rock, Chihiro finds herself in a luminous meadow dotted with ritual statues and swept by the wind, pushing her into the vast world of the *kami* and *yôkai*, so that she may test her own humanity. Miyazaki even painted blue sky galore to make flying machines that embody the dreams of birds made accessible to humans.

A eulogist of the vibrant forces of the Cosmos, Makoto Shinkai is a lover of the sky, which he compares to an "extraordinary screen" and whose tormented nuances he captures. He sketches the subtle variation in hues, especially at dusk, when the deep blue is streaked with reddish tones, slowly drenched in darkness and covered in stars. Although it causes the disappearance of the village of Itomori, the comet of *Your Name* (2016) traces sprays of color along the infinite reflection of the clouds, illuminating the countryside as well as the city with incredible splendor. In *Weathering With You* (2019), the sunshine girl manages to chase away the heady rainy grayness, clearing the sky and bringing back light. That is, when she is not stepping on drops of water turned into fish. Thus, different signs dot reality with a transcendent aura, intimately connected to nature.

THE TWILIGHT OF KAMI AND YÔKAI

The wondrous and the fantastic are particularly conducive to environmental fables with multiple different readings, because they transfigure the soiled nature and climatic catastrophes into powerful fictional representations. The Sea of Decay in Hayao Miyazaki's *Nausicaä* was inspired by the scandal of the release of four hundred tons of mercury into the waters of Minamata Bay from the 1930s to the 1960s, causing fish and fishermen to be poisoned. The environment's denaturation takes a nightmarish form, with a density that is even more striking than Cassandra's predictions. In *Ponyo on the Cliff*, the wizard Fujimoto spreads the liquid of life to protect the endangered sea. His daughter-fish is picked up by a trawler with piles of garbage that could have suffocated her without Sôsuke's intervention. In *Spirited Away,* the Stink God who disturbs the bathhouse is actually the spirit of a polluted river. Chihiro washes him in a medicinal bath and removes a thorn stuck in his muddy bulges. A bike and a mountain of trash spill onto the ground, releasing a venerable wrinkled-headed dragon that flies away with ease. This anthology sequence comes from a precise memory, and from a real bicycle found in a stream and cleaned by Miyazaki. As the filmmaker sums up, "it's hard for Japanese gods today." The tired inhabitants of deteriorating natural spaces need a rejuvenation cure. Going to the baths may give them the strength to remind humans that there is something sacred beyond greed. Haku, the young hero, is also a white dragon—*kami* of a river that has been concreted.

Faced with a similar problem in *Summer Days With Coo* (2007, Keiichi Hara), an Edo-era *kappa* (a Japanese water sprite) witnesses the murder of his father by a samurai who wants to drain the dragon swamps—where these folk spirits live—to make rice fields. Sealed in a stone during an earthquake, he is awakened by a boy from the contemporary era. Damnation! He no longer recognizes the landscape, buried by urbanization. The marshes are gone, as are all members of his species. Year after year, he tries to adapt to his new life in the loving family of Kôichi. In addition to being cut off from his biotope, he becomes prey to the paparazzi and the entertainment industry. Seeking refuge at the top of an iron tower after a TV show, contemplating the city that has spread its grip everywhere, he thinks about suicide and asks his late father for a sign. A dragon materializes in the sky, filmed by the cameras of the spectators, who cannot believe their eyes.

In these fictions that criticize disenchantment and ugliness, the twilight of the gods is intimately linked to the destruction of nature and the victory of cities over the millennia-old countryside. For divine spirits are also endangered species.

With its elegiac poetry, animation celebrates nature in its perpetual metamorphoses, according to the seasons, but also evokes the decline in faith. The malleability of drawing allows for a simple petal to be magnified, as in *The Tale of Princess Kaguya* by Isao Takahata. Joy is in the air when Kaguya manages to escape from the palace to dance among the cherry blossoms. The lightly traced lines, the delicate pastel colors, the swirling of the camera make the princess merge with the elements. In contrast, during a stuffy banquet, everything is dark. The princess runs away in despair and is now only a mass of lines furiously scribbled with charcoal. Her growing melancholy pushes celestial beings to cover her with the shawl of oblivion so as to wash her "of the terrestrial filth." But Kaguya becomes emotional before she leaves: "Joy and sadness… Everything that lives on Earth is so full of nuances! Birds, insects, wild animals, grass, trees, flowers…they all foster clemency."

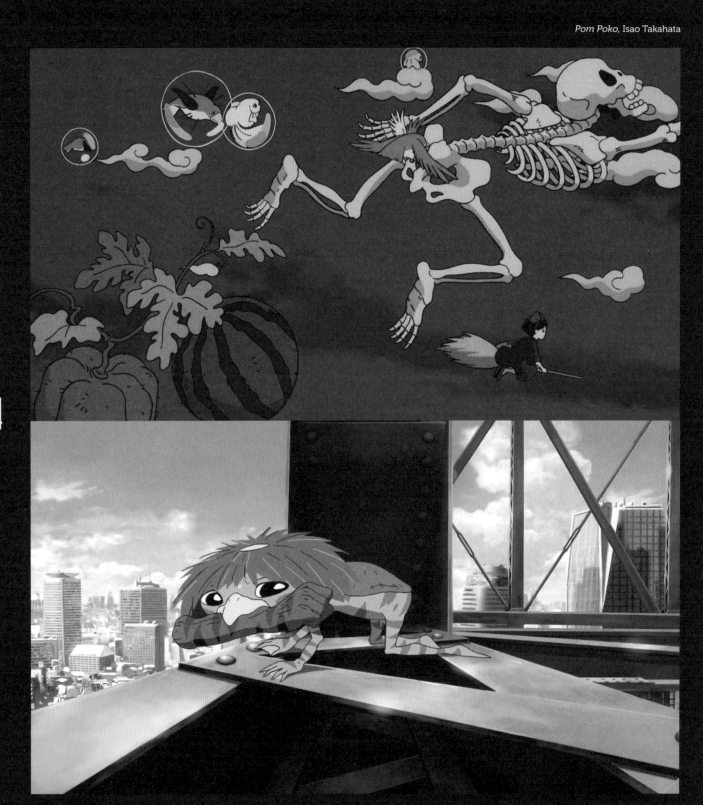

Pom Poko, Isao Takahata

Summer Days With Coo, Keiichi Hara

The *kappa* (a Japanese water sprite) in *Summer Days With Coo* finds happiness only by exiling himself in a temple lost among preserved rivers. He was invited there by a *kijimuna*, a folk spirit from the island of Okinawa. To live in peace and escape trouble, he chose to take on a human appearance. A similar choice is made by the *kitsune* of *Pom Poko* (1994) by Isao Takahata. These trans-fox *yôkai* prefer to melt into the mass of humans and integrate into the capitalist society. This is the complete opposite of the *tanuki*, who also master the great art of metamorphosis: they literally go to war against the destruction of their environment, "in the autumn of 31 of the Big Belly era." Eventually they resign themselves, defeated by the inexorable march of urbanization, exemplified by the construction of the new city of Tama, in the capital's outskirts, in 1966–1967.

To denounce deforestation and landscape degradation, Takahata revived magical creatures that were popular in Edo era legends and later used in political caricatures. Close to the raccoon, these animals really exist. The filmmaker represents them just as they are in "documentary" shots, when they are chased away from homes or run over by cars. Out of the sight of human beings, they inhabit their bodies as supernatural and mischievous beings, standing upright and talking out of turn. Their carnivalesque dimension is underlined by their most notable attribute: their testicles, these "huge balls" that they use as a red carpet, a parachute, or a weapon. As a result of the economic boom and population explosion of the 1960s, the *tanuki* have seen their mountains planed by bulldozers, eaten up by cranes. Cornered, they organize their resistance in a way that alternates between farcical, martial, and fantastic. After reactivating their transformation powers, their first military operation is to sabotage the construction work. Then, they change tactic and metamorphose into ghosts or Buddha statues in order to spread fear of the punitive gods. Nothing was achieved; the construction site started up again. With the help of three wise men, the *tanuki* embark on a symbolic gesture: a fantastic charge called "Operation Ectoplasm." They try to resurrect the ancient belief in the nocturnal processions of *yôkai* wandering the city streets (*hyakki yakô*), as represented on numerous painted scrolls (*emaki*). This hallucinatory parade overflows with folkloric and artistic references, from mythical animals to specters to angry Buddhist deities. This proves to be the ultimate disappointment as, instead of terrorizing the inhabitants, spectators rejoice. One amusement park CEO even claims authorship of the feat to attract visitors to his temple of entertainment. It is not insignificant that, a decade later, the dreamlike parade of *Paprika* (2006, Satoshi Kon) is not only populated by spirits, but by a medley of postmodern references. Refrigerators and dancing cars are next to traditional figurines, such as the lucky cat (*maneki-neko*) and a papier-mâché Buddhist daruma, as well as Russian dolls, a statue of Liberty, and schoolgirls with cell phone heads. The supernumerary objects of the globalized consumer society have invaded the imagination of hypnotized crowds. Compared to this whirlwind of images and illusions, the spirits of nature and the divine incarnations pale in comparison.

THE MONSTROUS PARADE

Wolf Children, Mamoru Hosoda

SUN GIRL AND

Many anime deal with the extinction of species or climate change through intimate and political parables.

Blending family drama and fantastic tale, Mamoru Hosoda's *Wolf Children* explores the duality of humans. In particular, its renounced animal part, which has generated a certain contempt for the living. In a realistic setting, a student falls in love with a lonely boy, who reveals his true nature to her one night under a full moon: he is the last descendant of the Wolf Men, capable of taking on human or lycanthropic form. After his death, Hana ("Flower") raises their two children, who have inherited this mixed blood, alone. In order to hide their secret, she leaves the narrow-minded city for the deep countryside. In keeping with cyclical time, she works hard to cultivate the land, then works to protect the environment. While young Yuki ("Snow") has an appetite for human sociability, Ame ("Rain") is more misanthropic. He reconnects with his primitive fiber during frantic runs in the mountains, which lyrically praise the untamed landscapes. Initiated by an old fox, he succeeds him as wolf in charge of the wilderness, threatened by torrential rains. The storm offers a catharsis to each, leading them on their own path, breaking the partition between wilderness and civilization.

Like Mamoru Hosoda, Makoto Shinkai offers hope for a revival of Japanese animation, after Hayao Miyazaki's multiple retirement announcements (the latter, however, is preparing a new film, due in 2023, based on the novel *How Do You Live?* by Genzaburô Yoshino). With their own style, these artists are committed to the planet, especially since Japan's geography makes the country particularly vulnerable to earthquakes, typhoons, and heat waves. With their combative poetry and their fantasy anchored in the contemporary, Makoto Shinkai's last two fables are addressed to the youth to incite them to "change the face of the world," as the teenagers of *Weathering With You* (2019) claim. Because "Tokyo can disappear, or at least radically change its shape," according to what he told *Le Monde* newspaper. Was the town of Itomori not leveled by a meteorite detached from a comet in *Your Name?* It takes the unconditional love of young heroes to go back in time and rewrite history. In *Weathering With You*, Tokyo is nothing more than a grayish city, drowned in perpetual rain, which reactivates the fear of submersion. A city of umbrellas and raincoats packed with people. After leaving his native island, Hodaka lives by his wits. His employment by a newspaper specializing in the paranormal leads the high school student on the trail of a "sunshine girl." Radiant, Hina has the power to stop the flood, to send the drops back into the sky and bring the light back. But this gift has a price: her body's evanescence, at the risk of disappearing.

In contrast, it is the drought that assails "the kingdom without rain" in *The Wonderland* (Keiichi Hara). Due to the lack of water, "the colors fade little by little, the meadows turn yellow." In this film reminiscent of *The Wizard of Oz* (classic dream musical, Victor Fleming, 1939), the capricious Akane becomes the Goddess of the Green Wind, whose mission is to save the depressed prince of the Castle of Eternal Rain. The film's convoluted script clearly hammers home its message: scientific progress is a source of both wealth and poverty, and it makes one insensitive to beauty. Akane's odyssey, however, takes the viewer on a journey through landscapes, seasons, and climates to see the damage—a rocky desert, a red sandstorm, polluted land—as well as the wonders to be preserved—clouds of stars, a sublime dawn, a resplendent field of flowers. In the happy ending, the sword of the reinvigorated prince changes a drop of water into a bird that rises into the clouds and pours the long-awaited rain on the land.

WIND GODDESS

"MILLENNIUM MAGIC"

The loss of connection with the world is born of amnesia, favored by the desire to forget the traumas of war, then by the economic boom and the Americanization of society. In the age of social networks and the global village, traditions are shaken and memory is declining. To battle against this culpable attitude, animation revives legendary beings and times long gone by coupling the wondrous within historical frameworks.

Mai Mai Miracle (2009) by Sunao Katabuchi is set in the countryside of the 1950s, where Shinko is fascinated by her grandfather's stories. The ten-year-old girl uses "ancient magic" to reinvent ancestral life: "Instead of this wheat field, there was…" According to her overflowing imagination, the animation jumps back in time and re-creates, step by step, a universe with strange customs. Shinko weaves a parallel between the arrival of the Tokyoite Kiiko, dressed "like a foreigner," and that of an ancient prefect and his daughter, who were forbidden by etiquette to live as they pleased. Sunao Katabuchi tenderly sketches the daily life of these children who invent tales or deify a goldfish that died far too quickly. And this, despite the tragedy that strikes: a father's suicide, the sadness of Kiiko, who has difficulty remembering her dead mother. Drawn by her friend's "ancient magic," she finds a photograph that, illuminated by fireflies, reignites her memory. The film suggests the importance of bringing the dead to life through storytelling, whether it be our ancestors, a mother, or even a simple goldfish.

In Mamoru Hosoda's *The Boy and the Beast* (2015), a runaway kid wanders, alone, through the back alleys of contemporary Tokyo. Drawn by strange figures, he walks on a manhole decorated with a labyrinth and enters an anachronistic and supernatural place: the world of the Beasts, populated by martial arts masters and governed by a philosopher rabbit. Its inhabitants have hidden the existence of this gap in the space-time continuum and blocked any connection with humans, so wary are they of the darkness that inhabits their soul. Renamed Kyuta, Ren becomes the disciple of a sensei like no other, Kumatetsu, a grumpy man with a big heart who becomes a substitute father figure. As he grows up, Ren manages to navigate between these two worlds, which provokes existential dilemmas, dangerous interferences, but also a salutary catharsis. Faced with a disintegrated reality and broken family ties, his initiatory journey with old-time swordsmen—whose honor codes remain intact—allows him to chase away his inner rage and to rebuild himself.

In contrast, *Lu Over the Wall* (2017) catapults a legendary being into the disenchanted contemporary times, which no longer believes in folklore. The mermaid invented by Masaaki Yuasa is a hybrid being, and a fan of electronic music. The slightest note provokes her mutation into a human who launches into a frenzied dance. Lu turns the life of Kai, the son of a morose divorcée, upside down and shakes up the small fishing town. The old men consider her an evil creature, responsible for the drowning of loved ones. The boom generation intends to make profit from her through the creation of an amusement park. Youth is regenerated by coming into contact with her magic and zest for life. True to his psychedelic vision, the filmmaker constantly changes his style. From the marine pachyderm that comes to save his daughter, Lu, to the geometric shapes taken by the sea that the mermaid then propels into the sky, the film is a formal kaleidoscope that deals with the survival of legends and adolescent malaise.

These conflagrations between the past and the present fill in memory gaps and reweave the bond between generations.

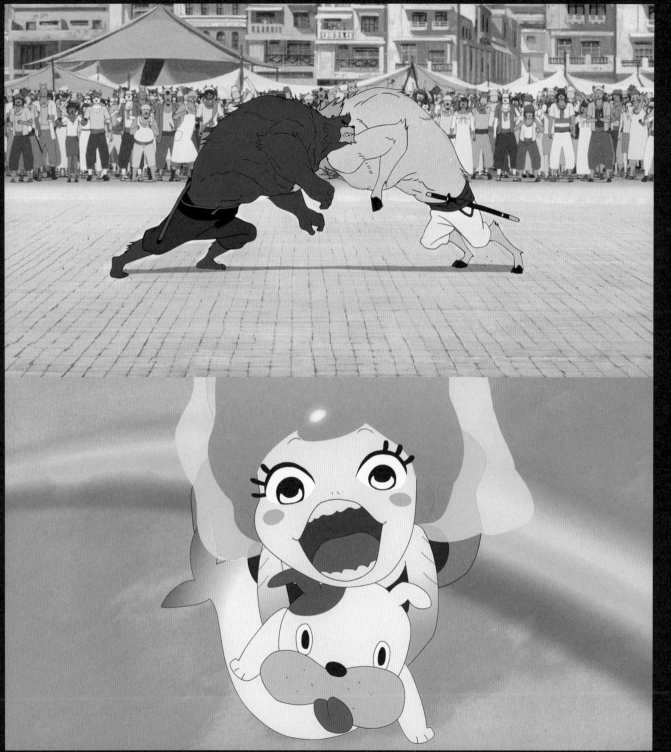

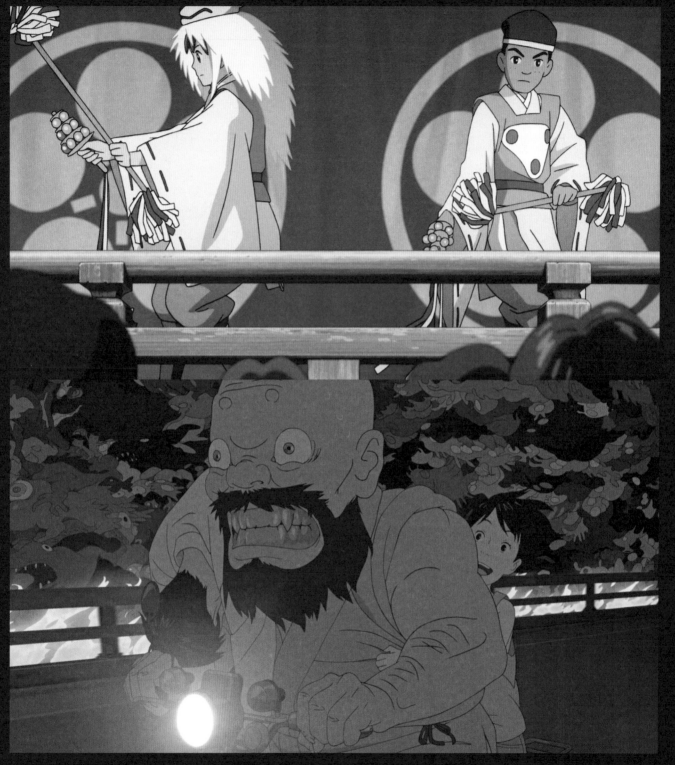

A Letter to Momo, Hiroyuki Okiura

THE TEMPLE OF FOLKLORE

Rites, traditions, and legends have been forgotten or have been drained of their substance. Humans do not really believe in the spirits of nature anymore. Faced with the spectral parade of *tanuki* (mythological raccoon dogs) who do not want to die, two drunken men talk: "It's our nerves playing tricks on us...These stories of fox weddings, of lantern processions, we've been told so many times... It messes with our minds and we think we see them walking. It's all in your head" (*Pom Poko*, Isao Takahata). Faced with this stinging disavowal, which links folklore to a mental pathology, many anime make use of festivals to reinject spirituality back into reality.

In Makoto Shinkai's *Your Name*, two teenagers—a city boy and a country girl—find themselves suddenly projected into each other's bodies and existence, neither of them understanding the reasons for this mysterious teleportation. In addition to being a high school student who dreams of Tokyo, Mitsuha has taken over the family torch as a priestess at Miyamizu Shrine, while her father occasionally engages in politics. During a Shinto ceremony, she dances in traditional clothes and performs the *kuchikami-sake* rite (rice chewed, spat out, and fermented into alcohol) for the god Musubi. The grandmother wants to pass on the ancient forgotten language to her granddaughters as well as the deep meaning of their beliefs: "We don't know the meaning of our holidays anymore. Only the form remains. The writings have disappeared, but tradition must endure." The bracelets of sacred threads that they weave symbolize the passage of time, the invisible link between the gods and humans, as well as the spiritual union between Mitsuha and Taki, the boy from Tokyo—although they have never met and do not live in the same time frame. After understanding that the comet fell on Itomori and killed Mitsuha three years earlier, Taki makes the long journey to the god's hidden shrine, drinks the *kuchikami-sake*, and begs Musubi to allow him to save his soulmate.

At the beginning of *Okko's Inn* (2018, Kitarō Kôsaka), Okko doesn't really understand the meaning of the Shinto ceremony she is attending. The festival celebrates the Hananoyu hot springs, which are seen as a gift from the gods to heal their wounds. After the sudden death of her parents in a car accident, the girl is taken in by her grandmother, who runs a traditional inn near the sacred springs. There, bathed in spirituality, the young girl mourns, helped by ghosts who appear to her when melancholy becomes too overwhelming. Animism gives life to the spirits of dead children, who haunt the place with good humor. They push Okko to accept the loss and to reconcile the past with her future by becoming an "apprentice innkeeper." She will, thus, perpetuate the altruistic profession of her ancestor—a function that risks disappearing if the young generation turns away from traditions. A similar thread is drawn in Hiroyuki Okiura's *Letter to Momo* (2012). To help the eleven-year-old girl cope with the death of her father, three *yôkai* spring from her tears. They escaped from an illustrated album of the Edo era that she discovered in the attic of her new house, located in the countryside, in her mother's hometown (a return to the roots called *furusato*). These scruffy *yôkai* do nothing but eat, but they roll up their sleeves when it comes to helping Momo save her mother: in the middle of a typhoon, hundreds of supernatural creatures form a giant umbrella to allow her to find the doctor stuck on the neighboring island.

Centered on death and passage, these works celebrate the memory of the dead. Animation takes on a ritual and memorial function so that the traditions, the cult of the ancestors, and the gods endure like a compass of contemporary times.

TIME MACHINE

Time travel allows us to resurrect the dead or to know beings that do not yet exist. Based on a temporal rift—mimicked by the plot loops—*Your Name* narrates the efforts of Mitsuha and Taki to find each other across the three-year gap that separates them. To save her from cosmic disaster, the young man must connect their parallel worlds. Their mental conjunction occurs atop an asteroid crater, overlooking a sea of clouds at dusk. Stuck in their respective times-spaces, the characters cannot see each other, but they feel each other's presence: "Are you here, in my body?" Originally separated, each in their own frame, they end up being united in the same plane. By breaking the temporal barriers, the magic of incarnation makes the connection of souls palpable.

In Mamoru Hosoda's *The Girl Who Leapt Through Time* (2006), an awkward high school girl lives her final moments. By a miracle, she goes back in time just before her bicycle collides with a train. Makoto literally dives into the inner workings of time, through stylized shots that contrast with her daily life. She then uses her power for futile things before discovering the damaging consequences to her actions. Other stories are written, and each fork in the road has its own set of consequences that are potentially dangerous for her comrades. Based on a cyclical game of repetitions and variations, Mamoru Hosoda's first personal film is a teenage chronicle—even if some of the characters come from the future. Such is the case of Chiaki, Makoto's friend, teleported to the time of the high school girl in order to contemplate a painting that had disappeared in her own time. Painted in the midst of war, this ancient work captures the beauty of a decaying world, which justifies a trip back in time.

Hiromasa Yonebayashi's *When Marnie Was There* (2014) makes full use of the oscillation characteristic of fantasy, which vacillates between rational and supernatural views of events. By placing realism and onirism (when visual illusions occur while awake) on the same level, animation reinforces this feeling of in-between and gives life to this limbo. Doubting the love of her adoptive mother, withdrawn into herself, Anna leaves to treat her asthma on the Hokkaido coast. At the edge of a marshy creek, she discovers an old abandoned house that seems to recover its former glow at dusk—favorable, like sleep, to the emergence of ghosts. Anna's melancholy brings Marnie out of the swamp villa. The deep bond that unites her to this blonde girl, who mysteriously appears, helps her to heal her wounds. In reality, Anna is living an anamnesis: she goes back in time in a phantasmatic way and meets her grandmother in a dream, who raised her for a short time after her parents' death. This embodied journey into memory allows the young girl to mend her broken filiation and to open herself to the world.

When the time machine is purely imaginary, it allows us to navigate in family history. Mamoru Hosoda's *Mirai* (2018) uses wonder to help Kun come to terms with the arrival of his little sister, Mirai. Unable to bear being relegated to the background, the five-year-old boy experiences hallucinations that break all space-time rules. He meets the "Mirai of the future," the teenage version of his little sister. He also discovers his mother as a child and his grandfather as a young adult during World War II. These leaps back in time and into the future end in a climax, when brother and sister travel in the family tree, so that Kun knows where he comes from. He then manages to look forward to the expansion of the family.

Fantastic by essence, temporal paradoxes consecrate the plurality of universes—a source of unnatural chronological twists that are formidable engines of fiction.

123

鏡の國のアニメ

After the apocalypse—ultimately repelled by a handful of resistance fighters—and the exploration of fantastic worlds that abound in creativity and counterbalance resignation, it is time for realism. For the observation of reality. For the introspection of souls. Japanese animation has exhibited the metamorphosis of society and lifestyles, the radical changes that have transformed the Land of the Rising Sun in the second half of the twentieth century. From the scenes of family life to the schoolyard to the company, it sketches the human tragic-comedy with great acuity. Between the studies of manners and feelings, directors provide detailed insight into passions using chronicles that do the characters justice. They examine daily life, with its share of hazards, drama, and joy. With just one pencil stroke, this cinema's modernity captures urban promiscuity, the pain of family abandonment, or the wound of love. With a stylistic flexibility, far greater than in live-action movies, how emotions are represented is animation's prerogative. The drawing moves away from the objective, realistic world toward subjective views, reminiscent or dreamlike, that illuminate the psyche of beings in the making. From a sensation perspective, many anime pay tribute to artistic creation as a vital dimension that feeds the soul. Without counting the craftspeople, painters, musicians, and poets who enhance the work of the designer and the filmmaker—as vibrant praise of the "manga films" that capture the shimmering flashes of reality so well.

03
LIFE NOW

Your Name, Makoto Shinkai

JAPAN'S METAMORPHOSES

After the nuclear trauma, the capitulation, and the consequent deep recession that shook the country for a decade, Japan had to rise from its ashes. Its rise to prominence was accompanied by profound sociocultural and political changes, which were influenced by the American occupation and then the economy's exponential revival. The advent of a parliamentary democratic regime was accompanied by an unprecedented capitalist modernization. The country held the world's second largest economy for some forty years, just behind the United States, before being overtaken by China. Japan's animation filmmakers were direct witnesses to these upheavals: from the "ashes generation" that lived through war (Hayao Miyazaki, Isao Takahata) to the "baby boom" generation that experienced the High Growth period (1955–1973), as well as the violently repressed revolts of the late 1960s (Katsuhiro Ôtomo, Mamoru Oshii). As for the "newcomers," who were in their twenties in the 1980s and 1990s (Satoshi Kon, Mamoru Hosoda, Makoto Shinkai), they witnessed the Asian economic crisis of 1997 and, in particular, the digital revolution. The twenty-first century, which has seen the unchallenged triumph of globalization, neo-liberalism, and new means of communication, now offers many topics for film.

Animation is a particularly effective medium to gauge the pulse of these metamorphoses, because it brings different eras to life without the burden of historical reconstruction.

Its striking flexibility is able to stage the past in the prism of the contemporary glance. When Isao Takahata directed *Grave of the Fireflies* in 1988, he wondered "what would happen if a child of today was suddenly plunged into that era by a time machine?" (*Animage*, January 1991). This is why he sends his ghostly children of war in front of impersonal and amnesiac skyscrapers. A temporal conflagration found at the end of *Miss Hokusai* (2015), which is vaguely reminiscent of the conclusion of *Gangs of New York* (Martin Scorsese, 2002), where the city's architectural metamorphosis is shown through the striking effect of historical acceleration by fading in and out. Keiichi Hara juxtaposes two views of the capital taken from the same angle: Edo, as it was called in the nineteenth century, and Tokyo in the twenty-first century. Cars have replaced boats and pedestrians; buildings have risen straight up to the sky, blocking part of the landscape. The director is fond of time jumps, already present in *Colorful* (2010), where two teenagers go back in time to an old tramway line, the Tamaden, closed in 1969 in order to build the Tokyo subway. Drawn reproductions of black-and-white photographs from the period punctuate the story of the old means of transportation, which eventually revives its colors and starts moving again in an animated sequence, edited parallel to the boys' memorial journey. Animation sometimes seeks to refresh the viewer's memory, after upheavals that have affected the traditional structures, be they society, family, or individual.

From Up on Poppy Hill, Goro Miyazaki

There are certain contemporary movies that look back on the pivotal moments of post-World War II Japan. Rich in conflict, these times of transition allow for friction between the old world and the new world. They give way to a time of uncertain but creative latency.

It is 1955, in the postwar countryside. Children play bandits in an old air raid shelter, a discreet sign of the barely healed trauma. Life has resumed its course to the rhythm of the seasons. For this reason, Sunao Katabuchi's *Mai Mai Miracle* weaves a historical continuity between this rural life and the past of a thousand years ago, during the Edo era. However, modernity is up and running, and the country is opening up to outside influences. In this place on the fringe of history, progress emerges through the city girl Kiiko. Her classmates are amazed by her outfits from abroad and her rainbow-colored pencils. A sign of her social level, her house already contains such new goods as a refrigerator, while Shinko's family still resorts to ephemeral ice blocks. Shinko asks Kiiko a lot of questions regarding another unknown device: a television. Two symbols of the household revolution that is to come and that will forever change the comfort of homes and consumption patterns.

The wind of progress carried by the economic boom blows in Gôro Miyazaki's *From Up on Poppy Hill* (2011). Between historical anchoring and nostalgic reconstruction, the movie depicts the Japan of the 1960s—euphoric about the future Tokyo Olympic Games. In 1963, it was a time of hope, although the consequences of the war were still palpable in the broken fabric of families. Umi and Shun, children born during or just after the conflict, live their lives quietly as high school students in the port city of Yokohama. The first lost her sailor father during the Korean War (1950–1953) and raises the maritime flag in his memory every day. The second is an orphan after his family was irradiated in Hiroshima—a story of which he knows only bits and pieces. Several entanglements around their filiation hinder their budding romance. The tensions between tradition and modernity crystallize around the preservation of their "Latin Quarter," an old building that hosts all kinds of high school clubs and dusty bric-a-brac. This Ali Baba's cave, full of cobwebs, is at the center of their high school, but it is also the cause of political debate experienced by the youth. Foreshadowing the student protests of the end of the decade, fiery speeches question the essence of democracy and castigate the school board for wanting to tear down the building. "To destroy what is old is to destroy the memory of the past, to ignore the memory of those who lived before us. You will not have a future if you advocate the new and deny the past."

THE ANCIENTS VERSUS THE MODERNS

Two eras, 1982 and 1966, are balanced in Isao Takahata's *Only Yesterday* (1991) to measure the profound upheavals experienced by Japanese culture. Somewhat lost at the dawn of her thirties, Taeko leaves the urban concrete jungle for a stay in the countryside, which triggers her childhood memories. In particular, she remembers her sisters, teenagers in the 1960s, discovering "Michelle" by the Beatles, the miniskirt, fine arts, and American culture. Her family was under the authority of an old-fashioned, conservative father, who forbade her to do theater. Away from the city, Taeko questions her life choices as her mother pressures her to get her head out of the clouds and get married. She is a young woman at the crossroads of her life, like Japan over the decades, between the liberation of morals and the weakening of social ties. Between the pursuit of tradition and a shift to contemporary individualism.

During the High Growth period, the Japanese landscape underwent deep cuts. The massive rural exodus and accelerated urbanization caused apartment buildings and suburbs to spring up profusely, absorbing the swelling of the middle class.

Behind the tragic-comic fable of *Pom Poko*, Isao Takahata takes an uncompromising look at the growth of the new city of Tama in 1966–1967, which cut down 7,400 acres of nature to relieve Tokyo's overcrowding. Striking metaphorical shots, enhanced by a documentary voice-over, denounce the "creation of a new space totally remodeled to build a dormitory town." Visual translation: Mocking Buddhist gods play architects. Further on, a video game shot reveals *tanuki* (a mythological raccoon dog) cornered by deforestation, decimated by buildings that grow like mushrooms. To emphasize this anarchic urbanism, Takahata shows the disfigurement of natural spaces in rapid succession: a hill planed in two strokes of a crane, a giant leaf nibbled away at lightning speed by shovels likened to worms. In the end, only concrete remains.

The childhood home featured in the opening credits of *Only Yesterday*—an old-fashioned mansion in watercolor—is replaced by a glass skyscraper that reflects other sprawling apartment buildings. The urban claustrophobia is heightened by the cramped apartments, the crowded transportation, and the succession of office tasks—painted in a few shots that scroll at a Stakhanovite rhythm. In order to take a break, Taeko seeks refuge in the countryside. In contact with an invigorating nature, the Tokyoite wonders about the meaning of her life and aspires to reinvent herself. The abandonment of her city clothes for a peasant's outfit begins her transformation. At dawn, she takes part in the harvest of the safflower flowers following an ancestral method. Her horizons broaden through her conversations with Toshio, who has resigned from his job in a large corporation to return to the culture of the land—his birthplace. He describes the deep crisis facing agriculture, threatened by the erosion of spaces, machines, and fertilizers, all of which are in total contradiction with the cyclic rhythm of the seasons. Created by the hand of man, the countryside is born of a struggle and a fragile balance with nature. It reminds us of the essential truths, masked by the corrupting urbanization that cuts the roots of individuals.

What about cities and the countryside in contemporary times? Makoto Shinkai's *Your Name* tackles this opposition with an innovative sleight of hand. Since Mitsuha and Taki swap bodies from time to time, they become immersed in a way of life that is the opposite of their own. The boy is not only amazed to have breasts, but also discovers the languorous rhythm of a provincial village surrounded by untamed nature. He no longer lives in a small apartment in Tokyo but experiences the monastic life of a Shinto shrine as a protector of the traditions. Mitsuha is amazed by the excessiveness of the buildings and the price of drinks at the trendy cafes. She happily embraces this hectic life. She and her friends long to leave Itomori, where the local bar is nothing more than a vending machine and time passes in an immutable way. Rural teenagers fantasize about the thousand experiences of the big city, such as Hodaka from *Weathering With You* when he leaves his native island. In contrast, some adults return to their roots after a divorce or while in mourning (*A Letter to Momo*, Hiroyuki Okiura) to the great displeasure of their children (*Lu* Over the Wall, Masaaki Yuasa) or to their great joy (*Wolf Children*, Mamoru Hosoda).

HOW URBAN IS TOO URBAN?

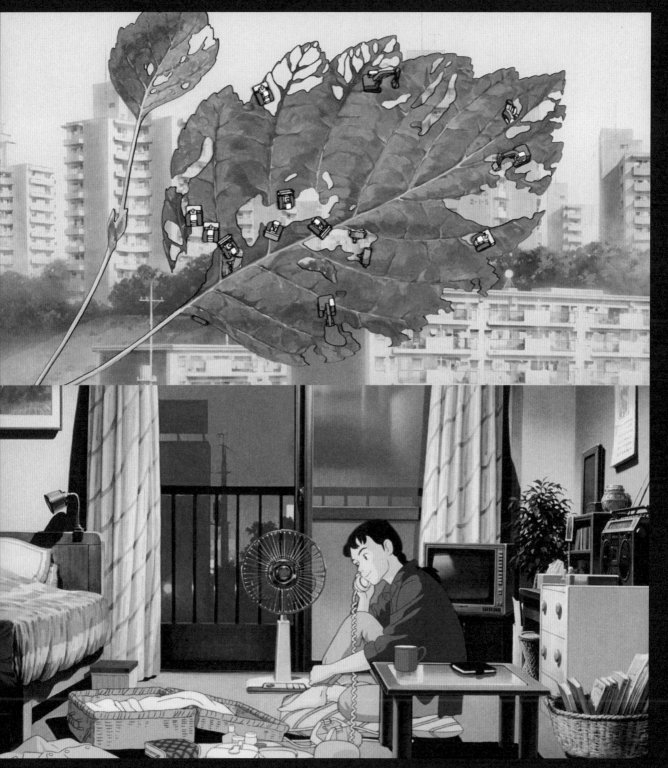

TOKYO SONATA

A memorial melting pot of Europe and Japan, Hayao Miyazaki's cities distill an anachronistic flavor and stand on the crest of realism, as in *Kiki's Delivery Service*. The master of Japanese animation has almost removed painting from the contemporary era, with the exception of the initial views of *Spirited Away*, which are quickly replaced by the phantasmagorical city of the baths. Other filmmakers claim an overt antinaturalism, as in Masaaki Yuasa's *Night Is Short, Walk On Girl* (2017), where Kyoto is completely distorted by the characters' crazy psyche: the asphalt and trees are lined with stylized flowers and the city transforms into shifting geometric creations as they wander.

But most contemporary filmmakers have realism written all over them. Their desire to transcribe the state of society in Japan's megacities—Tokyo in the lead, or Osaka at times, the country's third largest city—is palpable in their attention to detail. Certain buildings are reproduced with almost photographic fidelity, capturing the atmosphere of the various districts. *Your Name* sweeps through some of the capital's iconic locations, from the crowded intersection of Shinjuku to the National Art Center in Roppongi to Tokyo's "Eiffel Tower," and more. The ethereal love story of *The Garden of Words* (2013, Makoto Shinkai) could only bloom in Shinjuku's Imperial Garden, a pastoral bubble in the heart of the city. Animation thus came up with Tokyo's leitmotifs: skyscrapers as far as the eye can see, electric pylons, level crossings, neon signs, and stores open twenty-four hours a day. The sprawling transportation network—including the famous Shinkansen—fascinates filmmakers with its stations and trains that carry millions of passengers from home to school or work every day. The impression of authenticity comes from the credibility of the space inhabited by the characters, which traces a certain vision of city life. Set in the 1990s, Yoshifumi Kondō's *Whisper of the Heart* begins with snapshots of everyday urban life, right down to Shizuku's microscopic and overcrowded apartment. Weightless dives show the dense mesh of the new town of Tama, to a cover of the song "Country Road," originally dedicated to the nostalgia of deep America. A hit that the young girl ironically rewrites to describe the panorama in which she evolves: "Concrete roads, wherever I go the forests are decimated, the valleys are buried. Western Tokyo, Tama Mountain, my hometown, concrete roads." Questioned by the peasant women who have rarely ever been to the capital, Taeko of *Only Yesterday* answers: "Tokyo is dirty. Buildings, cars…It is really not a livable place. Here, it's another world!"

If overpopulated megacities are the home of possibilities, where you can meet your soulmate at any crossroads (as in *Your Name*), they are also characterized by their anonymity and many tragic stories. The destruction of social ties, broken families, and economic insecurity are the other side of the glittering city devoted to entertainment and consumption. Uniformity, as in "the only way to live in this great Tokyo," is theorized by the transformist foxes of *Pom Poko*. They have embraced the capitalist creed, which they parody in song while shaking an abacus: "To live as a human, you need money. How do you earn that money? You just need to have a specialty." Faced with the distress of his interlocutor, who wants to save his fellow creatures, there is only talk of bonuses and big salaries, provided that he enters the market and turns the magic art of the *tanuki* (mythical raccoon dogs) into the Wonderland theme park.

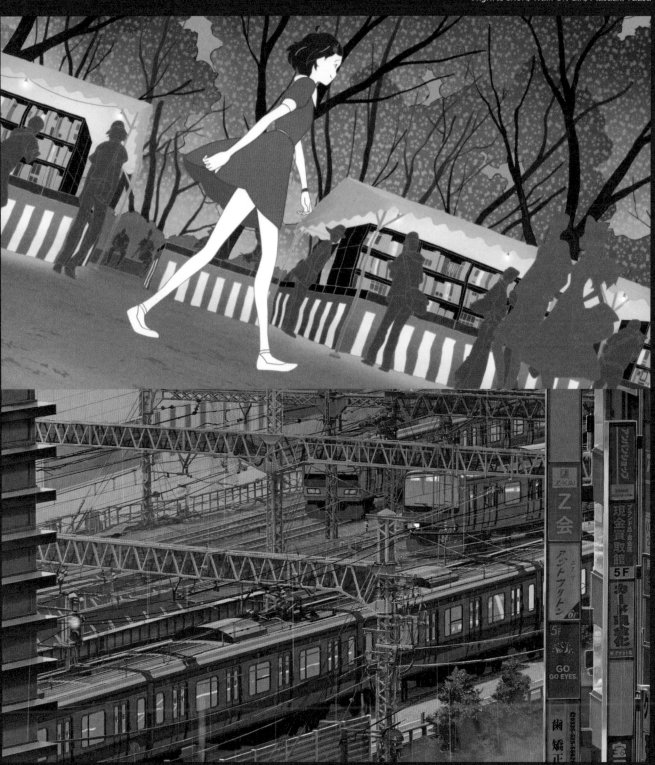

Night Is Short, Walk On Girl, Masaaki Yuasa

133

The Garden of Words, Makoto Shinkai

THE DAMNED OF THE EARTH

The highlight of Japanese animation is its willingness to embrace all subjects, even the darkest ones, as opposed to the sweet fables for children. It is unfailingly sharp when it comes to exposing the suffering of orphans and the disenfranchised. After running away, Ren from *The Boy and the Beast* (Mamoru Hosoda) and Hodaka from *Weathering With You* (Makoto Shinkai) wander around the capital, drowned in the crowd. Alone, without money, they hang out next to garbage cans, their stomachs empty, sharing their meager pittance with abandoned animals.

Some incisive works hide nothing of the misery of the underworld. They show the other side of a postcard Tokyo. Written by Michael Arias, an American who has been living in Japan for many years, *Tekkonkinkreet* (2006) is an adaptation of a popular manga by Taiyô Matsumoto. His antiheroes are street kids. Using powerful symbolism, the film explores the visceral bond between two "wild cats." As a rebellious teenager, Black has sworn to protect White, a pure-hearted boy who dreams as a means to escape his harsh conditions. They fight against yakuzas (Japanese gangsters) led by "the Rat" who works for the greedy property developer "Snake", ready to eliminate them to monopolize Treasure Town, the district of the underprivileged, which they want to transform into a theme park. Hence, a surreal architecture, between urban wastelands and colored cardboard decorations. The city is playful and chaotic, captured through distorted perspectives and odd angles. Facial features are increasingly sharp, even crumpled, as Black's descent into hell continues. The title of the movie is inspired by Taiyô Matsumoto linguistic confusion as a child and a play on the Japanese words for iron, muscle, and concrete. The city corrupts the frozen hearts of men, but that does not stop the kids from fighting for their survival and defending their territory. Because even if it is a disused basement made of bricks and mortar—dented car and broken toys—they have made a home. And the old beggar on the corner has become their surrogate grandfather.

The solidarity between the homeless is one of the rare glimmers in this urban hell. In breaking with his usual films that mix dreams and reality, with *Tokyo Godfathers* (2003) Satoshi Kon proposes a Christmas tale inspired by John Ford's *3 Godfathers* (1948), in which three outlaws become the devoted godparents of a baby at the request of his dying mother. By taking up this thread, Kon draws a vitriolic portrait of Japanese society, castigating its indifference to the fate of those forgotten by the economic boom. His acerbic depiction of the conditions of life on the street is not, however, without touches of humor among the grotesque. It shows great empathy for the three outcasts: a man ruined by gambling, a colorful transsexual, and a defensive teenage runaway. These lost souls discover a baby abandoned in the garbage on Christmas Eve. This leads to a journey through the capital to find the infant's parents, in which the realism of urban spaces is mixed with theatrical touches. In the course of these pilgrimages, we see hunger, beatings, alcoholism, and suicide. Nothing is hidden. As in Frank Capra's *It's a Wonderful Life* (1946), both a social movie and a Christmas tale, the providential ending offers redemption to the people who have been broken by life, but who are endowed with greatness of spirit. Nevertheless, latent violence can explode at any moment, as in Masaaki Yuasa's *Mind Game* (2004), where the main character dies from a bullet in the backside during an impromptu bar brawl with a yakuza. He is later reborn to experience incredible adventures and to reverse his destiny.

Tekkonkinkreet, Michael Arias

Tokyo Godfathers, Satoshi Kon

Belle, Mamoru Hosoda

espite the crises and social inequalities, affluent society perpetuates consumption and entertainment at all costs. The digital revolution and postmodern imagination have replaced traditional culture and further mediatized our connections to others through countless screens.

The great visionary of these upheavals is Satoshi Kon, who died too soon after just four movies and one series. Yet he left an indelible mark with his disturbing and ambitious films. *Perfect Blue* (1997) tackles the phenomenon of disposable idols (*aidoru*) that flourished in the 1990s. Hired by the entertainment industry, these interchangeable starlets perform in order to sell syrupy-sweet music. To deal with the festive commodification of the world, the filmmaker adopts the feel of slasher movies. Mima is suffocating under these shoddy spotlights. Aspiring for a career as a TV actress, the singer triggers the wrath of a serial killer who leaves corpses in his path. Vampirized by psychopaths, she descends into schizophrenia. Her brilliant image shatters into evanescent or bloody reflections, into pixelated views on multiple screens, until her pop star double tries to eliminate her. The film blurs the lines of reality, nightmare, and hallucination, compounding the story within a story. Before the Internet invaded our homes, Satoshi Kon anticipated the excesses of this lawless zone where image capture and identity theft are just two clicks away. From his apartment covered with photographs of the young woman, the monstrous stalker creates a fraudulent Website in Mima's name, where he steals her voice, publishes fragments of her private diary, and claims that she is being manipulated by her producers.

Twenty-five years later, Mamoru Hosoda's *Belle* tackles online harassment, where anything goes: ostracism, rumor mongering, and false identities. While Belle is adulated as the new princess of J-pop, Dragon is treated like a plague by a virtue league, supported by a gang of users. The pseudo-avengers of the virtual platform take advantage of their status to enforce their limited power and carry out their sponsors' product placements. Digital condemnation is used as a "warfare" technique in Yûta Murano's *Seven Days War* (2019), which is primarily about illegal immigration. A group of high school students invade an unused factory, where a young undocumented Thai man is hiding. A battle ensues with immigration services, led by the nerd of the band who is passionate about military strategies. To put an end to the scandal, a politician instructs his henchmen to break up the solidarity of the group by posting their photos all over the Internet. Their classmates jump at the chance to reveal their secrets or spill insanities.

SMOKE AND MIRRORS

Kyôhei Ishiguro's *Words Bubble Up Like Soda Pop* (2021) delves into the daily life of the millennial generation that cannot live without a cell phone. Yuki, known as "Smile," spends her free time wandering around the mall to photograph the latest trends. The influencer looks for anything *kawai* (cute) to share with her social media community. Her unexpected encounter with "Cherry," a haiku enthusiast, leads her on a memorable quest alongside an old man desperately searching for a lost record. Before becoming a temple of consumption, the mall was home to a vinyl press factory, which can still be found in an old secondhand store that is about to close, because it is considered too old-fashioned. This past world comes back through music and poetry to widen the horizon of the teenagers, beyond just appearances. In short, it is about the emotion of memories versus disposable consumption.

スタジオジ

STUDIO

SMALL ARCHIPELAGO, BIG STUDIOS

ブリ作品
GHIBLI

The evolution of the studios—which have shaped the history of animation—is a sounding board for the archipelago's economic mutations. A postwar lighthouse, Toei Dôga (a subsidiary of Toei created in 1956) gave Isao Takahata and Hayao Miyazaki a foothold in the industry, later joining a union to try to improve working conditions at the time. From the outset, the studio aspires to export its fictions internationally. During its golden age (1956–1962), it tried to compete with Disney by producing one feature film per year (adapted from fairy tales and children's classics), but the rise of television cartoons over the following decade quickly changed the situation. Founded by Osamu Tezuka, Mushi Production—Toei's official competitor—offers experimental works, but it has also developed the series format since 1963 with *Astro Boy* and then *Leo the Lion: King of the Jungle* in 1966, while also reducing its production costs, thanks to image banks and limited animation (drastically reducing the number of images per second). Toei striked back with *Wolf Boy Ken* (1963–1965), but the rapidly accelerating pace degraded the status of the animators, leading to strikes (notably in 1963 and 1971). *Horus, Prince of the*

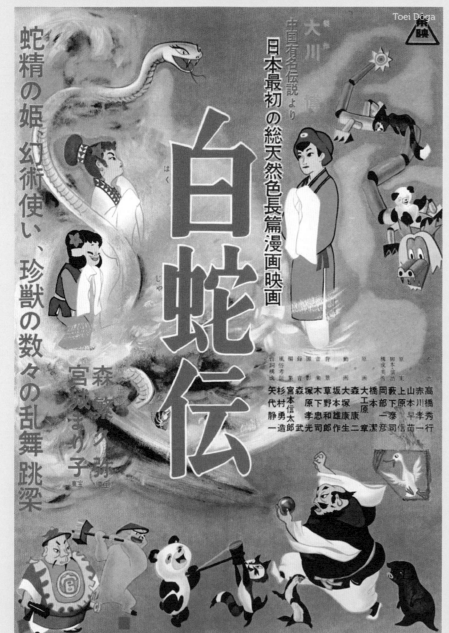

Sun (1968, Isao Takahata) was born in this complicated context. Exceeding scheduling and budget plans, the team was forced to cut some scenes to shorten the length of the film and to resort to a series of short, fixed shots (such as the attack on the village by wolves or rats). However, the fluidity of the other sequences, the depth of field, and the amplitude of the movements (vertical, from front to back or vice versa, and not only horizontal like in Disney) make *Horus* a major animation milestone.

In the 1970s, Toei's feature-film policy suffered a blow in favor of its series: here came the glory days of franchises, especially science-fiction *mecha* (*Mazinger Z*, 1972–1973; *Grendizer*, 1975–1977). With the Japanese wave—strange, subversive, full of originality—invading the world market, anime reveals its economic potential, with its unbeatable production costs and its multimedia variations (from manga to derivative products, including all film formats)—repeating, sometimes, some of the same formulas.

A second wind was born with Ghibli. This hot wind of the Sahara (the Arabic version of sirocco), which inspired the name of a boat and then of an airplane pertaining to the Italian army during World War II, ends up immortalizing the author's animation throughout the world. In 1984, despite the success of *Nausicaä*, coproduced by Tokuma Shoten (the manga publisher) and Topcraft (that went bankrupt on this

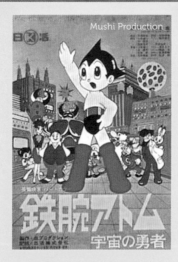

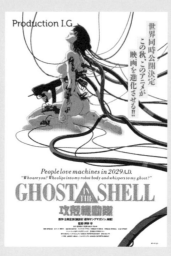

occasion), Miyazaki and Takahata had difficulties finding production companies willing to take risks on their works, because they were off the beaten track at a time when TV series guaranteed profits. With the help of his unwavering companion Toshio Suzuki and supported by Tokuma Shoten (until 2005), the two partners founded Ghibli in 1985 (although Takahata never wanted to sign the contracts, considering himself an "in-house playwright" within the studio). Their objective, with every fiber of their being, was to "make good films" for theaters, in which quality and originality are paramount. After the promising start of *Castle in the Sky* (1986) and the relative indifference caused by *My Neighbor Totoro* and *Grave of the Fireflies* (1988), *Kiki's Delivery Service* (1989) began a chain of continuous hits until the consecration of *Princess Mononoke* (1997) and, in particular, *Spirited Away* (2001), which sold over twenty-four million tickets. Refusing to skimp on the investment (time, money, artist involvement), Ghibli is totally atypical in its functioning. The "small business" has employed full-time cartoonists and places a high emphasis on training young recruits—a subtle balance between creativity and commercial success, although the question of succession is now cruelly felt.

Alongside this jewel, other studios were born and made their mark by focusing on a marked aesthetic identity with ambitious cinematographic works, attracting big names or propelling new talents to the forefront. Created by former Mushi Production employees in 1972, Madhouse turned to creating demanding animated films in the 1980s, which did not take long to reopen the wounds of the past (*Barefoot Gen* by Mori Masaki, 1983) and tackle a possible future (*Harmagedon* by Rintaro, 1983). From *The Dagger of Kamui* (1985) to *Metropolis* (2001), Rintaro was the spearhead, before the studio launched the career of Satoshi Kon (producing all his films since *Perfect Blue*, 1997) and Mamoru Hosoda (*Crossing Time*, 2006; *Summer Wars*, 2009). Founded in 1987, Production I.G. brought Mamoru Oshii's masterpieces (from *Patlabor 2: The Movie,* 1993) and initially specialized in tormented science fiction for adults, with clear narrative ambitions, which did not shy away from technological innovations in 3D. Although the Gainax studio (1984) has a more limited filmography, it has delivered several original works since its first production, *Royal Space Force: The Wings of Honnêamise* (1987), by Hiroyuki Yamaga. One of its creators, Hideaki Anno, has signed important series, such as *Nadia: The Secret of Blue Water* (1990–1991) and *Neon Genesis Evangelion* (1995–1996). As for Studio4°C (1986), whose name refers to the temperature at which water is the densest, it is an apostle of formal and narrative experiments. It has given us the eccentric *Mind Game* (2001) by Masaaki Yuasa, the committed tale *Princess Arete* (2001) by Sunao Katabuchi (one of its cofounders), and the urban fable *Tekkonkinkreet* (2006) by Michael Arias. Meanwhile, Mamoru Hosoda launched his own company, Chizu, in 2011, when former Ghibli animators—including Hiromasa Yonebayashi—created Studios Ponoc in 2015. In short, one studio can always lead to another.

141

THE ENFANTS TERRIBLES

W hether it's about capturing the changes in Japan or dealing with current social problems, a whole section of Japanese animation longs for realism. This love of reality is part of a fruitful tension with the stylization specific to cartoons that can condense impalpable emotions or fleeting sensations into just a few strokes. Author of several theoretical texts, Isao Takahata made realism his secret weapon to touch the hearts of viewers from the appropriate distance and to send them a recomposed reflection of their relationship to the world. He is, thus, intimately "convinced that animation is the best way to depict reality," even more so than traditional cinema, which is condemned to reenacting it with actors. Herein lies the paradox: "The cartoon that does not attempt to hide the fact that it is an artistic interpretation can, therefore, commit itself to depicting reality." This is because there is a realism in the subjects regarding societal concerns, which lends itself to the objective retranscription of everyday life. This realism also applies to strokes and movement that are able to inscribe the character in a credible space-time and to draw the public deeper into the fiction. So, Takahata's original advice to all his colleagues, during the formative years at the Toei studio: "Learn to observe reality as closely as possible, to reflect the hearts of children, the reactions of loved ones, etc." (*Positif*, July–August 1996).

Animation has never been without deep reflections on human nature. As a form of popular art, it seizes the dramas and passions that make up the spice of life, as well as the ordinary aspects that are more likely to resonate with each viewer, be they parent or child. It sometimes embraces a sociological aspect through its exploration of various microcosms: school, sport, work, etc. Close to reality, it offers a magnifying-glass effect on the issues that shake society, whose well-oiled mechanisms it scrutinizes. Often adapted from a manga intended for girls (*shōjo*), boys (*shōnen*), students (*gakuen*), or young teenagers (*seinen*), anime looks at the tender age of formative years, this pivotal period rich in experimentation where the characters discover the love or aspirations that torment them. These initiation stories, punctuated by rites of passage, capture the incandescence of youth, as well as the torments of adolescence, dysfunctional families, and even school bullying and suicide.

The Case of Hana & Alice, Shunji Iwai

143

鏡の國のアニメ

144

PARENTING, A COMBAT SPORT

Family is the first environment that developing individuals are exposed to—a timeless and universal subject, for better or for worse. Between scenes of everyday life and homes on the verge of a nervous breakdown, families have been examined from every angle. In both funny and tragic sketches. Isao Takahata's *Chie the Brat* (1981) follows the life of a strong-willed little girl who struggles to patch up the cracks in her broken family. To do this, she runs the family restaurant in a working-class area of Osaka. She even tries to set her lazy father straight in the hope that her mother will return. As Chie sums up in a few disarming words, typical of Takahata's extremely detailed realism: "It's hard to live with men."

My Neighbors the Yamadas (1999) is truly original: For the first time, Takahata uses digital computer graphics to give shape to his most artistic ideas. The movie facetiously paints the life of a traditional Japanese family, launched onto the big wheel of life, capturing the joys and sorrows of a couple, two children, and a grandmother in a few pure and naive strokes upon a watercolor background. Inspired by a manga consisting of four panels by Ishii Hisaichi (in the tradition of humorous *yonkoma*, found frequently in the press), it is composed of burlesque or poetic sketches. So many archetypal situations, highlighted by intertitles: "Danger in the Home," "The Father-Son Dialogue," "Yamada Family Almanac." Some moments are rightly hilarious. After pronouncing their vows, the newlyweds are thrown into their gigantic wedding cake and begin an eventful bobsled ride, a parable representing the hazards that await them. Depending on the scene, the drawing can vary dramatically: for example, the sequence that borrows from gangster movies to evoke a banal neighborhood conflict involving bikers, or the haikus that intermingle with the drawing to evoke the regrets of the head of the family, the housewife's boredom, or the son's need for love.

In spite of a failed passage at Ghibli for the direction of *Howl's Moving Castle* (taken over by Miyazaki), Mamoru Hosoda remained marked by his meeting with Isao Takahata. Like him, he transcribes the minute details of everyday life, although his fables mix the real and the imaginary. The filmmaker is fascinated by the complexity of family ties, which he constantly unravels. *Summer Wars* brings together all generations under one roof, from the connected youth to the imposing grandmother. This living memory precipitates an extended family on the verge of tearing itself apart after the return of the prodigal son, which jeopardizes the cohesion of the group, already entangled in a worldwide digital crisis. *Wolf Children* portrays a courageous mother who raises her son and daughter—Ame and Yuki—alone after the death of her husband. She fully accepts the phenomena to which she has given birth, despite her inevitable separation from the youngest, who wants to live in the forest. *The Boy and the Beast* explores the pitfalls of fatherhood, nowadays and in the past, as well as childhood confronted with family and social breakdown. In *Mirai*, the relationship between brother and sister and the joyful chaos of a newborn's arrival are the focus of the story. Between bouts of jealousy, domestic scenes, and the reversal of traditional roles (the father, who is an architect, is now the homemaker and prepares the meals), the movie paints a picturesque depiction of a modern family. And *Belle* ponders about the separation of adolescence at risk of social networks. Mamoru Hosoda sharpened this passionate observation when he became a father, drawing inspiration for his characters from his own mother or his offspring. Because there is no better inspiration than one's own lived experience.

The Boy and the Beast, Mamoru Hosoda

Neon Genesis Evangelion, Hideaki Anno

This famous anathema by André Gide concentrates all the venom that contaminates dysfunctional families—with devastating consequences on the psyche of teenagers who suffer from parental selfishness, the breakup of the home, and even outright rejection. In *Neon Genesis Evangelion*, Shinji's father has no qualms about making his son a child soldier. He is ready to sacrifice him to carry out his deadly fight against the Angels. Their relationship is truly toxic: indifference from one, resentment from the other. A concrete wall separates them, throwing the boy into an abyss of misery. Shinji is a crushed being who puts on his robotic shell to try to exist in the eyes of his father.

Many anime narrate chaotic starts to life. In *The Boy and the Beast*, Ren loses his mother, divorced from a father who left no forwarding address and who does not come back for him. He runs away from his stone-cold guardians before finding a substitute family in an imaginary world. A flashback from Hiromasa Yonebayashi's *When Marnie Was There* shows Anna's distress following her parents' death. Hunched in a corner, she witnesses the quarrels of adults who tear each other apart to avoid having custody of her. When she discovers that her adoptive mother is receiving child support for her education, she comes to the conclusion that no one wants her. Her perception of the world is tinged with hostility. She needs to go through the dream—the fantasized friendship with the ghost of her grandmother as a young girl—to make peace with her history in memory lagoons.

Too often, infidelity and divorce shatter children's dreams at the altar of sordid reality. In Tatsuyuki Nagai's *The Anthem of the Heart* (2015), Jun is just a child making up tales when she tells her mother that she saw her father leave the "castle"—in reality, a "love hotel"—with another woman. As cruel as he is selfish, he holds her responsible for the divorce and blames her for having a loose tongue. As a result, Jun chooses silence, unable to utter a single word without experiencing violent stomach cramps. Years pass and, unable to grasp her teenager's difficulties, her mother feels ashamed and wears her resentment on her face for all to see: a real cold fish. *Colorful* by Keiichi Hara narrates the slow ascent from the underworld of a wandering soul. Stuck in limbo, the being in transit is offered a second chance to repair the terrible mistake linked to his death—of which he is unaware. He is reincarnated in the body of Makoto, a schoolboy who commits suicide after seeing his mother with her lover, as well as the girl he loves prostituting herself. Guided by an angel, the soul investigates, wanting to understand the causes behind such a desperate gesture, before realizing that he is, in fact, one with the teenager.

In Mamoru Hosoda's *Belle*, aggression is unleashed on social networks and in the daily life of "the Beast." This scarred dragon absorbs the blows of others into his flesh, whether they be virtual lynchings or physical brutality—because in real life, the boy is mistreated by a violent father. Without pushing the cursor so far, teenage torments are dissected, whether they are born of mourning (*Okko's Inn*), divorce (*Lu Over the Wall*), infidelity (*Colorful*), absence (*Night on the Galactic Railroad*), a father's irresponsibility (*Chie the Brat*), or the search for one's filiation (*When Marnie Was There*).

"FAMILIES, I HATE YOU!"

147

The Anthem of the Heart, Tatsuyuki Nagai

FIND A VOICE

ack of communication is at the heart of the teenage crises painted on the screen. Faced with a whirlwind of emotions and unspeakable trauma, they retreat into their shells, building a wall with their parents or peers. Symbols of this phenomenon are seen in *Words Bubble Up Like Soda Pop*: the mask worn by Smile to hide her protruding teeth corrected by braces and the helmet by which Cherry protects herself from the hubbub of the world.

In *Colorful*, the amnesiac soul eagerly seeks to inhabit the tortured psyche of Makoto, ill at ease at school and at home. The teenager who tried to commit suicide has no friends, feels betrayed by his mother's infidelity, and has nothing but contempt for his father, a simple employee who never received a promotion. At the beginning, the soul is hostile toward the mother of the family, who walks on eggshells. The meal scenes are chilling, between empty words and heated discussions about the choice of high school. As time goes by, the daily life of the soul-Makoto recovers its colors, thanks to painting and friendship. His view of the world softens when he chooses to live with the ups and downs of life—a simple message for young viewers.

The inability to express emotions is metaphorized by the "curse of the egg"—a tale invented by the character of *The Anthem of the Heart*. Scarred by her father's accusatory words, the young girl is convinced that poison comes out of her mouth. Since her words hurt others, she closes in on herself. Only able to articulate grumbling sounds, she has no friends and feels rejected. That is, until a teacher brings together several quiet people in order to form a committee to organize the school fair. When Takumi discovers Jun's talent for transcending her innermost wounds through song and fiction, he brings the group together to put on a musical. The torrent of suppressed emotions explodes on stage, binding all the protagonists together.

It is also through singing that Belle expresses her melancholy in the movie of the same name. Shy and withdrawn, at first she is incapable of vocalizing—a passion shared with her deceased mother. The wound is so intense that she vomits in pain as she tries to regain her voice. But the algorithm of the U virtual network detects her secret gift. Hidden beneath the features of her avatar, another metaphor for the mask that teenagers wear, she lets her sensitivity shine through, delighting her fans. In A *Letter to Momo*, Hiroyuki Okiura dissects the weight of the final words exchanged between a father and his daughter: "I hate you, Dad. Don't bother coming back..." However, he dies suddenly during an expedition at sea, leaving behind an unfinished letter: "Dear Momo..." Terrible suspension points that will never be filled. Momo is plagued by guilt, while her mother endures her ailments in silence, until she becomes ill, overcome by asthma attacks.

Mutism is doubly at the heart of Naoko Yamada's A *Silent Voice* (2016), which centers on the rejection experienced by a deaf-mute at school. Guilty of bullying the schoolgirl, the turbulent Shōya is treated like an outcast. Ashamed, he considers suicide, withdraws into an impenetrable bubble, and sees only faces through the cross covering his own. To illustrate this incommunicability, the filmmakers occasionally break the realistic framework of high school life with stylized and metaphorical shots, from the venomous mouth of Jun's invented tale to Shōya's perceived facelessness. In the worst situations, teenagers become *hikikomori* (a term first used in Japan in the late 1990s), entrenched in their homes and without any social life, like the girl in Shunji Iwai's *The Case of Hana & Alice* (2015).

鏡の國のアニメ

Josee, the Tiger and the Fish, Kotaro Tamura

TEENAGE

I he craze for Japanese animation is partly due to its contemporary look at the harshness of social relationships and existential problems affecting teenagers. *Colorful* deals with suicide, the violence and reality that Makoto suffers, and even a teenage girl who prostitutes herself to be able to afford nice clothes. *A Silent Voice* is as good as any prevention advertisement against school inequality: it focuses on disability, features two failed suicides, and goes into great detail about the harassment of Shôko, who tries to complete normal schooling despite her deafness. Shôya persecutes her, tears off her hearing aids, and beats her before consequently suffering the ostracism of his classmates. The tables have turned. Aware of the seriousness of his act, the boy does everything he can to make amends. He learns sign language, forms a deep friendship with Shôko, and tries to renew the links he has broken.

Disability as a barrier between oneself and others is at the heart of *Josee, the Tiger and the Fish* (2020) by Kotaro Tamura. Paraplegic and overprotected by her grandmother, Josee knows only the oppressive outlines of her apartment. In her drawings, she depicts the outside world with the help of her fertile imagination—where she recovers her motor skills like a mermaid floating through the city. Her meeting with Tsuneo, a student in marine biology, widens her horizons, although the beginning of their relationship is stormy. He relentlessly pushes her to overcome her frustrations and takes her to see the sea that she has so often fantasized about. There are so many first times that seem to be self-evident, but that upset the characters. Kotaro Tamura takes the opportunity to dissect the contempt and rejection of people with disabilities in Japanese society.

*The Case of Hana & Alice i*s a quirky teenage chronicle with touches of humor and poetry. Alice is an original person who does not let herself be fooled. Yet the movie evokes brutal teenage relationships. After a divorce and a house move, the young girl experiences a strange atmosphere in her new class, haunted by the alleged murder of a former classmate, Judas. Initially disliked because she occupied his vacant seat, she is taken to an exorcism session. This pseudo-satanist ceremony is nothing but a ploy by another student to stop being persecuted. To clear her conscience, Alice investigates with Hana, a recluse who believes she killed Judas. During a confession scene under a car, she reveals the facts to Alice. Betrayed by the high school student, who made no less than four promises of marriage at the same time, Hana slips a bee into his collar as revenge. Allergic, he will never return to class: thus, the legend of his death is born. Since then, the teenager has turned into a *hikikomori*, unable to leave her home. The ninety-degree tilted shots, the sharp facial features, and the flickering of the bodies accompany the fluctuating vision of the world and the metamorphoses of youth.

With a title that is both a declaration of love and an epitaph, Shin'ichirō Ushijima's *I Want to Eat Your Pancreas* (2018) has no taboos. The film tells the story of an unlikely friendship between a bright teenage girl and an antisocial bookworm. However, Sakura is suffering from an incurable disease in its terminal phase. She knowingly chooses to bond with Haruki, because he shows no empathy for others. Deciding to seize the day, she teaches him the joy of savoring the little things in life. The ultimate irony is that she dies not because of her failing pancreas, but because of a killer lurking in the neighborhood. Basically, it tackles violence on all levels, but also the strength to face setbacks with courage.

CRISES

Seven Days War, Yūta Murano

SENTIMENTAL EDUCATION

The schoolyard, the classroom, and the playing field are fertile grounds for "first times" and have given rise to more than one love story. Just as gender relations were liberated in the 1980s, the codes of romantic *shōjo* became popular, before being adapted for the screen en masse. The *shōnen* focused on high school and sports are no less. In the midst of hard training and prestigious championships, the quest for the top step of the podium is gladly accompanied by an initiation to love. The champion is often the trophy for swooning high school girls. In *Attacker You!* (1984–1985), the beautiful volleyball player confuses her mad passion for the game with her passion for the eyes of the captain of the boys' team. Mixing romance and baseball, *Touch* (1986) by Gisaburô Sugii is a film based on an animated series, an adaptation of a manga beloved in Japan. Despite their opposite characters, two twin brothers are in love with their childhood friend, Minami. Driven by this impulse, Kazuya does everything to bring his team to the top in the Kôshien (a high school baseball tournament loved by the Japanese). Between sporting twists and turns, intermittence of the heart, and intrusion of the tragic, *Touch* finely handles the *topoi of* the learning story.

Hooked on the games of love, romantic comedies have their obligatory passages, their initiatory rites: from the embarrassed revelation to the fear of the other sex or of mockery, not to mention the inevitable love triangle, the broken heart, or the first kiss. These three ingredients are at the center of *Kimagure Orange Road: I Want to Return to That Day* (1988) by Tomomi Mochizuki, after a manga adapted into an anime. Trapped by his memories, the movie traces

a pivotal moment in Kyôsuke's young life. While anxiously waiting for his college entrance exam results, like a sword of Damocles in view of the academic competition, he remembers the heartbreaking choice he had to make between the naive Hikaru—a caricature of the young girl in love whose heart he breaks—and Madoka, his more mature and tormented friend. A sign that the formula of the sentimental crossroads remains prolific, *The Anthem of the Heart* is an entanglement between teenagers who hide their feelings. Daiki falls in love with Jun, who is in love with Takumi, who has been in love with Natsuki since middle school, although the fear of rejection has kept them apart. They need to go through fictitious musical characters to be able to declare their love.

Some works have innovated in relation to these immutable frameworks, either by making the registers more complex or by tackling societal problems. In Mamoru Hosoda's *Crossing Time*, Makoto comically uses her time machine to prevent her best friend's declaration of love, which makes her uncomfortable. As a result, he gets closer to her girlfriend, which does not suit her either. The heart has its reasons... *Penguin Highway* tells the story of a precocious child's sexual attraction to a dental assistant. He is fascinated by her breasts and is deeply saddened when she leaves. *A Silent Voice*, like *Josee, the Tiger and the Fish*, is about love beyond disability. *Seven Days War* by Yûta Murano evokes female homosexuality. When young Mamoru finally has the guts to confess his feelings to Aya, she reveals hers to her best friend Kaori, who shares them. The two girls fall into each other's arms, under the tender gaze of their classmates.

THE HARVEST OF THE HEART

The advantage of reality in animation goes hand in hand with a cinematographic poetry, at the service of faces, landscapes, and emotions. Through its thousand-and-one nuances, the cartoon is able to capture the oscillations of consciousness. It is able to reproduce reality in great detail, and it can also stylize and use it as a counterpoint to embody its sensitive relationship to the world. Animation occasionally frees itself from the tangible universe to veer toward varying moods. It glides with unsettling ease from the objective to the subjective, from realism to lyricism, from the full to the empty. Between the palette of registers, the stylistic breaks and the shots that intermingle on various levels of perception, it sometimes orchestrates the superimposition of the real and the imaginary, of the past and the present. Isao Takahata is the undisputed master of this type of shift, from the concrete painting of everyday life—striking in the collective scenes—to the poetic, intimate, and memorial flights of fancy that reveal the characters' affects. These graphic metamorphoses capture the flashes of reality according to the events as they are experienced in the deepest parts of our souls.

This is why animation lends itself readily to the exploration of feelings of love connected to spiritual landscapes. The flexibility of drawing transcribes the subject's moving interiority, from the psychic meanderings to the intermittences of the heart. Crazy love or the loss of a loved one become a lyricism of nature, conveying the awareness of the passing of time or the gushing of memories. In this poetic cinema, the natural elements carry elegiac reveries and are metaphors for the ephemeral. They testify to a sensitivity just below the surface and raise the intimate to the universal, as with Makoto Shinkai.

Another sensory incubator, which triggers an olfactory and tactile imagination as much as a gustatory one, is cooking. With its plethora of ingredients, colors, and textures, it instills gluttony in animation, from typical Japanese recipes to the reinterpretation of universal ones. Just like the art of cutting and plating dishes, the kitchen becomes a metaphor for the cinema, which chisels each element into the shot to make the viewer salivate. Because food essentially reflects an aesthetic relationship to the world.

To seize the being in all its dimensions requires us to overcome the most impalpable realm, which is the unconscious drowned in its labyrinths. This formidable machine for producing surreal images and absurd narratives metabolizes the subject's intimate questionings in a fantastical mode. It has a lot to do with artistic creation, which was embodied by one of animation's crazy geniuses: Masaaki Yuasa.

5 Centimeters Per Second, Makoto Shinkai

155

鏡の國のアニメ

156

ANIME THROUGH THE LOOKING GLASS

5 Centimeters Per Second, Makoto Shinkai

BIG EVERYTHING AND LITTLE THINGS

Isao Takahata always starts with reality—with everyday life and its magic, but without privileging the fantastic like Hayao Miyazaki does. Not being a drawing artist himself (except for the storyboard), he surrounds himself with the best cartoonists and does not hesitate to change his style according to his artistic wishes. Each time, he describes the ordinary life of young people with infinite precision. When he took part in Nippon Animation's *World Masterpiece Theater* program, dedicated to adapting Western classics for young people (and even "girls' literature"), he shook up the quality of television animation. Despite the production constraints, he described in detail Heidi's life on the farm in the series of the same name (1974). With her gruff but loving grandfather, the little girl marvels at taking the sheep up the mountain to graze and resonates to the rhythm of the seasons. She learns the names of the flowers and participates in milking cows and making cheese until she becomes a real farmer. The same is true for the coming-of-age story *Anne of Green Gables* (1979), in which the orphan girl, taken in by the Cuthberts, discovers the customs of a town on Prince Edward Island, in eastern Canada, in the late nineteenth century.

Takahata is particularly fond of collective scenes that anchor his characters to a specific microcosm: the life of villagers fishing for pike or forging iron in *Horus, Prince of the Sun*, the peaceful existence of kids in the woods as opposed to the etiquette of the court in *The Tale of Princess Kaguya*. This quest for objectivity allows the viewer to accompany the protagonists and perceive the experience through their eyes. The director will seek the appropriate balance between this neutral approach and the deepening of subjectivities to broaden the spectrum of perceptions and embrace the minute variations of being in the world.

In order to accurately reproduce the settings, landscapes, and techniques, he will carry out an exhaustive documentation and tracking process. In short, Takahata is fanatical about detail. In *Grave of the Fireflies*, he pondered which side of the sky the Allied planes will come from before bombing the city of Kobe. For *Only Yesterday*, he spent a long time in the Yamagata region with his collaborators, read dozens of books, and met with farmers to accurately reflect the traditional process of transforming safflower flowers into dye. The authenticity that is imprinted on the faces and gestures comes from observing the farmers and the fields of flowers. From the floral colors to the twirling leaves, to the backgrounds of forests and mountains, Takahata focuses on the textures of light and shadow that vary from dawn to dusk. Attentive to the "thousand-and-one tiny elements that make up an image" (*Positif*, July–August 1996), he pays homage to the beauty of the world, creating a sensation of symbiosis with nature. A meticulous capture of reality—at the heart of the creative process—that he passed on to Miyazaki during his apprenticeship. To bring the Japanese countryside of *My Neighbor Totoro* to life, he tried to include flowers of each variety, their hues changing according to the hours of the day and the months, just as he attempted to replicate the sound of old buses from the 1950s.

The succession of seasons, the rustling of the elements, the labile matter of the petals, and the changes in temperature all come together to create a lively representation of the passage of time as the characters mature. They provide the fiction with a specific duration, proper to the blossoming and oscillations of various moods. Japanese animation as a whole is sensitive to the cyclical rhythm of the elements, to the poetry of nature, to the grace of a summer lilac, from Makoto Shinkai (*5 Centimeters per Second*, 2007) to Mamoru Hosoda (*Wolf Children*) and Keiichi Hara (*Miss Hokusai*).

The Wind Rises, Hayao Miyazaki

24 BEATS PER SECOND

From *Heidi* and *Anne* of *Green Gables* onward, Isao Takahata has known how to magnify the predisposition of orphaned girls who have been tossed about by life to enrich the smallest aspects of their existence through the beautiful way in which they look at the world. As she discovers family love and educational rites, Anne is dazzled by the shimmering colors of the seasons. Each tree, each encounter arouses in her communicative lyrical impulses. Through her capacity to poetize the moment, the wild child enters into communion with nature. On this occasion, Takahata experiments with the shift from a realistic shot to a subjective view, which materializes evanescent feelings in the heart of the drawing. These poetic departures embody the metamorphosis of reality under the pressure of an emotion that colors it with a particular hue.

From the city to the countryside, Taeko from *Only Yesterday* takes a journey through her memories. In contact with the elements, the young woman lets herself be invaded by buried emotions, until the little girl of yesteryear reappears. Inspired by a manga about childhood memories, the film differs from it by intertwining the past and the present, characterized by opposite styles. Overloaded when it comes to the urban context, the shots devoted to the daily life of the peasants are of documentary precision. In counterpoint, the flashbacks sketch round and refined figures on a pastel background, which conceal the sweetness of memories half-faded by time. The filmmaker creates striking moments, so many little things that come out of the mists of memory: the boredom of a long vacation spent in the deserted capital instead of a stay in the country, the joy of tasting an exotic pineapple despite its disappointing taste. Metaphorical shots are still in the fictional frame, such as when Taeko literally floats in the air when she happily experiences her first feelings toward a boy. To give substance to the young woman's inner journey, a touching conjunction sometimes brings together the little girl and the adult in the same shot. At the end, they are even accompanied by schoolmates, as if the past, reconciled with the present, was supporting Taeko at the moment of making a choice—as yet undecided—between two different ways of life.

Gauche the Cellist (1981), in kudos to Beethoven's *Sixth Symphony*, has stylistic shifts that embody the transcendence of music. They match the sensations provoked by the surge of the *Pastoral*. By fading in and out, the indoor rehearsal scenes suddenly give way to a play that is sometimes sensitive and sometimes wild, under a romantic or stormy sky. The characters' features are martial and idealized, but the watercolor landscapes intertwine with the tessitura of the cello, giving strength to the artistic emotion. From these ruptures springs a strange, unresolved duality, full of charm.

A fantasy biopic, *The Wind Rises* is Hayao Miyazaki's most realistic movie, which nevertheless has some dreamlike escapes. Jiro is a scientist who multiplies calculations and plans. As he draws his airplane wings, a superimposition makes the machine spring out of his head in a kind of a mental flash-forward. Abstract formulas take on the palpable and sensual form of the engineer's dream plane. His creative trance brings about the fusion of the sky with a camera—before the latter falls apart like a sheet of paper under the pressure of the wind, causing the sketches on the work table to scatter. When a colleague calls him back to reality, the celestial background becomes consistent with his professional environment. As for Naoko's umbrella, it flies away and rushes on Jiro during their meeting like a tornado of destiny. The object returns in the ending as a sign of the presence-absence of the young woman who died of tuberculosis and who visits Jiro in his dreams, imploring him to live his best life in spite of everything. *The Wind Rises* is a melancholic film reflecting mad passion for the air and a muted gush of the cruelty of the world.

Kiki's Delivery Service, Hayao Miyazaki

GHIBLI'S GRAMOPHONE

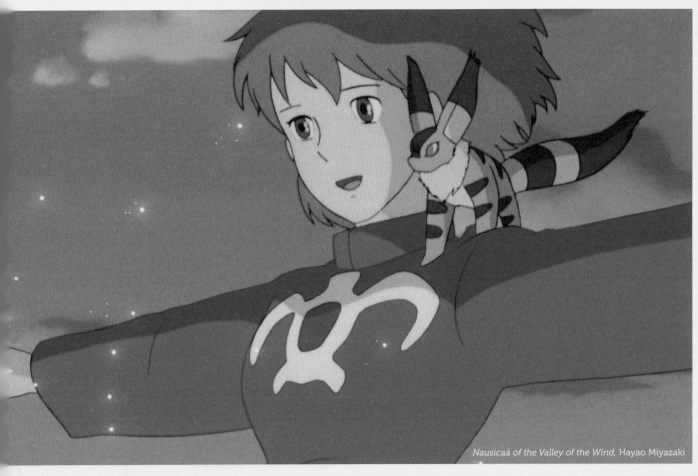

Nausicaä of the Valley of the Wind, Hayao Miyazaki

Sonatine, Takeshi Kitano

For the past twenty years, the soundtracks used in Studio Ghibli's anime movies have become part of Western moviegoers' collective memory. This is thanks to the genius of one man in particular, who was the conductor for Hayao Miyazaki's films: Joe Hisaishi. Hisaishi, whose real name is Mamoru Fujisawa, has been using this pseudonym since the 1970s as a discreet tribute to the trumpeter and producer Quincy Jones. He has become the studio's musical ambassador, to the point where no one would consider a new Miyazaki without his long-time sidekick at the helm. Here is an artist who has become so famous that he now gives concerts all over the world, in which he conducts symphonic suites from his creations for the movies—all enhanced with original pieces of his own. More than just a film composer—a "wallpaper maker," to use John Carpenter's modest phrase about his own work—Joe Hisaishi has established himself as one of the most popular figures in contemporary music. It is a name that turns heads when mentioned.

As is often the case in Japan, everything begins with images. In 1982, Hayao Miyazaki published his manga *Nausicaä of the Valley of the Wind* in the Japanese magazine *Animage Monthly*. It was a project that he has wanted, from the first sketches, to bring to the screen himself. Through his colleague Isao Takahata—whom he has known since the mid–1960s and the shooting of *Horus, Prince of the Sun* (1968)—Miyazaki met Hisaishi, whom he asked to shape the musical soundtrack for his feature movie. At that time, the young Hisaishi was a talent of the Japanese electro scene, having become an assistant to Masaru Satô, one of Akira Kurosawa's regular composers. Born in 1950, he has been a violinist since childhood, an accomplished pianist, a writer in his spare time—he has published two novels—and a feature film director (*Quartet*, 2001), Hisaishi is known to the initiated for his many creations for television. From 1974 onward, he set music for animated series, advertisements, and documentaries, where one can sometimes feel the influence of the minimalist movement supported by

The Tale of Princess Kaguya, Isao Takahata

The Secret World of Arrietty, Hiromasa Yonebayashi

Fireworks, Takeshi Kitano

Steve Reich and Philip Glass. He has experimented with symphonic writing, demonstrating his mastery of the synthesizer, but is most noted for his melodic brilliance and clarity. Although the relief of his compositions is still somewhat limited, probably due to the conditions of television production, his sense of clear lines is already emerging. The same one that will subsequently allow him to figure in a few notes, with force, such as for the botanical paradise of *My Neighbor Totoro* (1988) and the tragic decay of *Princess Mononoke* (1997).

In any case, the triumph of *Nausicaä* (1984) at the Japanese box office would suddenly change everything. Hisaishi, who was put to the test by Miyazaki on this occasion, became his regular composer. He composes ever-increasing powerful and melancholic themes, often supported by strings, as in his score for *Castle in the Sky* (1986)—Studio Ghibli's first official feature movie. He shapes melodic lines that are immediately recognizable, such as the leitmotif that informs and structures *Howl's Moving Castle* (2004). Although he rarely overemphasizes, he also knows how to show a disarming simplicity, completely fitting with Miyazaki's work, such as in the childish theme composed for the pastel masterpiece *Ponyo on the Cliff by the Sea* (2008). While it can be said that, sometimes, some of his melodies sound the same—as his rare detractors like to point out—they mostly show a striking organic quality and coherence that give his compositions for animation a truly unrivaled signature. However, his fame is not only due to his work for Miyazaki and, later, for Takahata (*The Tale of Princess Kaguya*, 2013). His scores for Takeshi Kitano, with whom he collaborated until *Dolls* (2002), have redesigned the musical universe of the yakuza film. In *Sonatine* (1993), a simple piano ritornello in

A minor is enough to illustrate all the depth of a story in which criminals return to childhood, and where their bullets are mixed with absurd and nostalgic beach games. In *Fireworks* (1997), probably the pinnacle of the iconoclast Kitano's career, Hisaishi delivers a heartbreaking score, which highlights the paintings of the filmmaker (a naive painter) that surreptitiously punctuate the film, reinforcing the emotional charge of the final suicide, left off-screen. The cutter falls before the strings resume their funeral wake during the credits. In short, beyond his work for Miyazaki, Joe Hisaishi has well and truly left his mark on contemporary Japanese cinema.

Here's an interesting additional fact: in 2010, Ghibli entrusted the soundtrack of *The Secret World of Arrietty* to Cécile Corbel, a harpist from Brittany, France. A year earlier, as a simple fan of the studio that made her dream throughout her adolescence, the young singer sent one of her records to the Japanese company. It landed on the desk of Toshio Suzuki, the studio's chief producer and former president, who played it for director Hiromasa Yonebayashi. As a result, a little touch of France accompanies this story, which narrates the meeting between a Borrower, a young Lilliputian living under the floor of an old house, and an unhappy, lonely boy. That magical package led to the Frenchwoman joining the Ghibli family.

5 Centimeters Per Second, Makoto Shinkai

WEATHER OF THE SOUL

Throughout his works, which honor both silence and poetry, Makoto Shinkai has woven leitmotifs: love hindered by distance, poverty, and absence, by fleeting or aborted reunions. It gives pride of place to the bursts of inner voices from separate characters that end up intertwining, even from light-years away. This sweet sadness, however, is transfigured by odes to the rain, the sky, the sun, and even the cycles of the cosmos, which express a subtle meteorology of the soul. With its enigmatic title, *5 Centimeters per Second* refers to "the speed at which cherry blossoms fall" (2 inches a second). It is under these auspices that the feelings of two college students, separated by a move, crystallize. Their snowy reunion after an endless train journey seals both their first kiss and their inevitable separation. The years pass, the memory remains, hindering the blossoming of new loves. In the last segment of this story, structured in three elliptical beats, Takaki (whos life has lost its meaning) and Akari (about to be married) meet by chance at a railroad crossing, struck by an uncertain reminiscence. A train passes by, obstructing their vision...and the young woman has disappeared. A lyrical medium-length film, *The Garden of Words* sketches the possibility of a love that will not materialize between a high school student who skips school on rainy days and an older, drifting stranger. In the Imperial Garden of Shinjuku, where they usually meet, they contemplate the reflections of the splashing drops. Based on the cyclical rhythm of the seasons, punctuated by fades to black, the work magnifies the five senses and pays extreme attention to fleeting sensations. In this subdued atmosphere, the fifteen-year-old teenager falls in love with this woman who holds "all the secrets of the universe" for him. Melancholic, she relearns to walk with him until she eventually reveals her identity (a high school teacher harassed by students). In this haven of peace among skyscrapers, time is suspended, far from the social constraints and the banality of the day, rendered by recurring shots of the subway, courtyards, and family meals. Snippets of inner monologues attempt to express the fragile bonds between these weightless beings.

Through an inventive weaving of genres, Makoto Shinkai's distance between lovers is sometimes played out on a cosmic level, on the scale of galaxies or parallel worlds. A tinge of fantasy or science fiction colors the realistic depictions of feelings, especially when soulmates do not inhabit the same space-time. *Voices of a Distant Star* (2002) is a short film that interweaves a love story with an intergalactic odyssey, with characters torn between Earth and space. Plunged into abysmal solitude beyond the solar system, Mikako's emails take longer and longer—up to eight years—to reach Noboru. *The Place Promised in Our Early Days* (2004) is a fictional rewriting of history that imagines a Japan cut in two after World War II, where governments (a Japanese–American state and a power called "the Union") seek to manipulate parallel universes. Three teenagers are fascinated by a mysterious tower related to the deep three-year sleep Sayuri is in. Hiroki, who has always loved her, cannot accept the fact that she is locked up in the world of dreams, impervious to his calls. With its open-ended conclusion, *Your Name* leaves more hope for Taki and Mitsuha than the end of *5 Centimeters Per Second*. Connected by a mysterious invisible thread, the young couple manage to connect their parallel universes and overcome death before meeting in the flesh in the middle of a staircase. The story ends, brimming with possibilities.

165

Howl's Moving Castle, Hayao Miyazaki

THE FLAVOR OF RAMEN

Alliance of body and spirit, food fulfills the physiological needs of the body, but it also encourages sharing with others. A true barometer of relationships, meals function as rituals, which sometimes turn sour. In Keiichi Hara's *Colorful*, the family table reverberates with repressed tensions between a mother and her son. In contrast, the young Umi shows the loving way she treats her borders in Goro Miyazaki's *From Up On Poppy Hill*. Every morning, she carefully assembles breakfast and bentos (Japanese lunch boxes) for her guests. The apprentice innkeeper of *Okko's Inn* (Kitaro Kossaka) forgets her own sadness by preparing a spring cake for a boy who is grief-stricken like herself. This gesture creates a link between the dead and the living, beyond loss. This sensitive relationship with food is sometimes broken in the form of an existential anorexia. The drifting young woman in *The Garden of Words* has lost her taste since having to quit high school—a sign of her vital energy loss. The only taste she can still distinguish is that of the bitter beer she sips in the park every morning. Only her meeting with Takao allows her to, once again, enjoy the small pleasures of everyday life.

In *Empire of Signs*, dedicated to Japan, Roland Barthes underlines the delicacy of chopsticks that gracefully grasp each element, refusing "to cut, grip, mutilate, or pierce" like the fork and the knife do. Cooking as an art of living is a sensory aesthetic that is truly revealing of the characters' vision of the world. As a testimony of its progressive molt, Ponyo springs from her bucket to devour Sosûke's sandwich: this fish "likes ham!" Her appetite is a sign of her joy for life and desire for new experiences. Sitting eagerly at the table, the little girl is fascinated by the transformation of the instant noodles in the steaming bowl, which after a few minutes reveals a tasty ramen with eggs, ham, and small onions (*Ponyo on the Cliff*, Hayao Miyazaki). To be accepted into her new family, Grandma Sophie of *Howl's Moving Castle* must tame the fire Calcifer who only obeys Hauru. Next to the dirty dishes, she scoops out ingredients to make a generous bacon omelet on a table overflowing with products: cheese, loaves of bread, kouglof—a nod to Miyazaki's memories of Alsace in France and of Europe. Calcifer dubs Sophie "Yum yum!" The home that was falling apart is warmed up by the magic of a rustic recipe, which anticipates the spring cleaning of this eccentric home.

While the relationship to food refers to our many ways of inhabiting the world, it also signals the state of society, between scarcity (if not famine) and bulimia. Even in the midst of war, Suzu lovingly cooks the meager rations she has (*In This Corner of the World*, Sunao Katabuchi). Thanks to a samurai's book on survival cooking, she manages to increase the swelling of the rice grains—and it's a feast! What can we say about the joy of little Setsuko when she feasts on some sour candy in Isao Takahata's *Grave of the Fireflies*? And the heartbreak felt by viewers when, hungry and delirious, she swallows rocks? At the other end of the spectrum, the abundance of consumer society breeds gluttony. Under her dejected gaze, Chihiro's parents literally gorge themselves like pigs, which is the source of their curse (*Spirited Away*, Hayao Miyazaki). Between the sucking sounds and sauce dripping from their mouths, they devour mountains of chicken, sausages, and fish heads. As for the employees of the baths, they are as hungry for gold coins as the Faceless God in front of the gargantuan dishes, paraded before him in temptation. From traditional dishes to junk food, cuisine reflects moods, character traits, relationships to tradition, and social status. Tell me what you eat and I'll tell you who you are.

lusionist filmmakers have embodied the meanders of the unconscious, which is essentially intangible, with leaps and bounds. Under the pressure of psychedelic visions, everyday life goes haywire in a deluge of shapes, colors, and surrealist fables. The characters are absorbed in stories within stories or stuck at the edge of several dimensions: between dream and reality; nightmare and fiction; life and death. In *Perfect Blue*, Satoshi Kon stages the hallucinations that shatter Mima's perception, a pop star who is harassed by psychopaths wanting to colonize her brain. *Millennium Actress* (2001) explores the memory of an elderly actress, interviewed by a filmmaker fan who finds himself transported with her to the movie sets of her time. The actress's memories merge with the history of cinema—which is also the history of Japan—in a dizzying array of realistic, mental, and filmic images that merge into one. As for *Paprika*'s psychoanalytical therapy, it turns into a big mess when a mad demiurge penetrates the dreams of others and puts them into collective trances in a manipulation of the imaginary in which the tangible world is dismantled.

Although he has delivered more affordable works, such as *Lu Over the Wall* (2017) and the postapocalyptic series *Japan Sinks* (2020), Masaaki Yuasa loves experimentation. He is an apostle of "bizarre scenes" (in his words) and of great stylistic deviations. As its title suggests, *Mind Game* (2004), based on an autofictional manga by Robin Nishi, plunges into the fertile subconscious of a young man who wastes his life through lack of courage. The character would like to be a famous mangaka and win back his high school sweetheart, but he is unable to muster up the courage. Crossing the path of yakuzas, he is pierced by a bullet that sends him to heaven. In limbo, a protean demon-god mocks his whining before granting him a video game reset. Back at the bar, where Nishi turns the tables by killing the thug, "A hero is born." Later, involved in a car chase, Nishi and his friends fall into the water and are swallowed up by a mythological whale. A hallucinogenic odyssey, *Mind Game* amplifies the crazy micro-narratives and recycles all the genres: gangster movie, biblical story, science-fiction anime, wacky dystopia about an intergalactic turd, etc. His graphics jump from one style to another mixing image types—2D, paper animation, inlay of real views—creating a type of sensory fireworks.

Following on from his series *The Tatami Galaxy* (2010), Masaaki Yuasa brings another novel by Tomihiko Morimi to the screen: *Night Is Short, Walk On Girl* (2017). In the line of surrealist authors, this movie is "as beautiful as a chance meeting between an umbrella and a sewing machine on a dissection table" (Lautréamont). This pseudo-romantic comedy mocks the codes of the genre as the "plot" advances in a zigzag fashion, just like the characters who wander through a nocturnal Kyoto tinged with unreality. Determined to provoke fate after a case of love at first sight, a student pursues a dark-haired girl who appears to be living life to the fullest. From one adventure to the next, the story includes barhopping, a reptilian dance, a loss of underwear, a drinking contest, a contest to eat hellish chili peppers, a search for erotic engravings or childhood books, guerrilla theater, etc. The graphic metamorphoses are perpetual: from exaggerated features to deformed bodies, from oblique perspectives to epileptic movements, not to mention refined subjective shots or unexpected chromatic transfigurations. Masaaki Yuasa disregards all narrative and aesthetic conventions in favor of an illogical sensation, which gives way to the delirium of the imagination and creativity.

THE DARK SIDE OF THE MOON

"I AM ANOTHER"

"The wind is rising!...We must try to live!" By choosing this line from Paul Valéry's *The Graveyard by the Sea* (1920) as the title of his film-testament, Hayao Miyazaki offers his viewers a poetic and philosophical farewell—in other words, praise for the vital spark and creative breath, despite the vicissitudes of history. Although some people use his inventions for warlike purposes, Jiro keeps on drawing the lightest possible airplane plans to pursue his dream of flying in the sky like the birds.

Animation could not exclude from its field of vision a fundamental dimension of existence that transcends it: artistic creation. Represented in all its variations. In all its forms. Whether it allows us to seize a fragment of reality, to put balm on the heart, or to exalt beauty, it deploys all its powers and never ceases to be honored by the heady presence of artists at work. Whether they fear the blank page, are striving to make progress, or are fueled by inspiration, painters, mangakas, musicians, poets, and novelists invite us to think about the different modes of artistic expression. In other words, the multiple ways of transfiguring the world through lines, colors, movement, notes, and words. Placed at the center of certain stories, these figures are the pretext for many formal experiments. They reveal themselves as fictional doubles of the animation filmmaker, related in the first place to craftspeople and magicians, who breathe life into objects and situations. Moreover, this self-reflective aspect reverberates the singularities of the cartoon in the mirror of other practices.

This is how animation has sometimes questioned its differences with live-action cinema, through homage, pastiche, or reinterpretation of classics; by inventing film-loving characters and directors; by showing the behind-the-scenes of how a film is made. Because the dialogue is incessant, animation has also highlighted its visceral link to Japanese pictorial arts, from whom it has inherited a long tradition in the same way as manga. The music still intertwines with the cartoon, sublimating it or exacerbating the intimate feelings of the protagonists. Literature and poetry made dazzling breakthroughs, especially haiku. Above all, this cinema intrinsically thinks about the dynamic relationship between words, sounds, and drawings, with interrelationships at the heart of Japanese writing (a mixture of *kanji* derived from Chinese ideograms and several syllabic *kana* systems). Able to embody sensitive emotions, the artistic work reveals a vital existential part, often invisible at first sight. It offers a striking capture of reality, which takes on other colors in the prism of these multiple aesthetic re-creations.

171

鏡の國のアニメ

172

ANIME THROUGH THE LOOKING GLASS

The Cat Returns, Hiroyuki Morita

PORTRAIT OF THE ARTIST AS A MAGICIAN

" Witch's blood, painter's blood, baker's blood...It's a power given to us by a god or who knows...Even if it leads to trouble" (*Kiki's Delivery Service*, Hayao Miyazaki). For Kiki's painter friend, the magician, the craftsperson, and the artist are made of the same stuff. They tirelessly work to produce authentic work that resonates with the world. Faced with Kiki who laments having lost her powers, unable to move her broom, the young woman qualifies this crisis of inspiration as inherent to any creative process. Through one of his multiple fictional doubles, Hayao Miyazaki offers vibrant praise of learning and perseverance, which sometimes requires letting go: "You have to fight with all your strength. Draw, draw nonstop." What if we can't do it anymore? "You stop drawing. You walk, you look around at the landscape, you take a nap, you do nothing. And suddenly, you feel like drawing again." To reignite desire, you have to stop imitating, create your own way, and forge your own inner style. Kiki then understands that magic—like any other art form—does not consist in repeating ready-made formulas, but in nourishing each gesture with your own sensitivity.

Thus, the figures of the artisans are self-portraits of the animator: all of them practice a form of "witchcraft" that breathe life into the objects they shape with their own hands. The grandpa who is a junk dealer in *Whisper of the Heart* fascinates Shizuku by repairing an old broken clock. After three years of work, he inserts the missing part, reassembles the mechanism, and reactivates it. Then, the miner elves discover precious stones, the fairy discards her sheep's appearance to meet her prince at noon sharp. But to achieve this alchemical transmutation, "you have to find the precious stone in yourself and take the time to polish it. It takes work." This is the grandfather's lesson to the apprentice novelist, so that she develops her talent from within. Shizuku is also inspired by Seiji, the aspiring violin maker who makes his violins with infinite patience. He trains himself to practice his craft according to the rules of the art. For his first and only film, Yoshifumi Kondō illustrates his relationship with animation and the sacred monsters of Studio Ghibli with great humility.

Artisanal—and artistic—creation is an animism that offers moments of grace, enchantment, and fiction. The eyes of the Baron's statuette reflect kaleidoscopic shapes in the sun, imperceptible at first glance. These glimmers triggered Shizuku's desire to write, and she noted in her story that "the craftspeople were descendants of witches, their workshops adjacent to each other." There is magic in bringing things to life, the quintessence of animation. This is why the Baron—frozen object, then literary hero—wakes up in the film sequences that put the novel into images, before being at the center of a film by Hiroyuki Morita a few years later (*The Cat Returns*).

Between craftsmanship and engineering, between science and magic, the aircraft designer of *The Wind Rises* frantically draws his plans, calculates the ergonomics of the shapes, and anticipates the movement of his metal carcasses when propelled into the air. These different stages of manufacturing are reminiscent of Miyazaki's countless sketches before his machines take flight in his fictions. The filmmaker has often paid homage to the craftspeople he captures in the midst of their work. He praises the collective work, from the miners in *Castle in the Sky* to the female iron workers in *Princess Mononoke*, to the workshop of the female airplane builders in *Porco Rosso*. These small hands reflect the hard work and collaboration that preside over the slow gestation of films at studio Ghibli.

The animation world is full of painters and cartoonists who love to capture the world in a few brushstrokes. This passion allows some to transfigure their daily life: the brutal reality of war (*In This Corner of the World*, Sunao Katabuchi) or teenage malaise (*Colorful*, Keiichi Hara).

These fictional artists are primarily avatars of the director and graphic designers in charge of the characters and backgrounds. In a playful way, they offer a story within a story of this work, before the actual animation itself. By attempting to represent a face or a landscape, they recall the original gestures of the filmmaker and his team. A nod is made to the painter who draws Kiki on her notebook within the storyboard—an essential phase of the future feature film, which requires countless preparatory sketches. The copies—pictorial and on film—of the young girl are inserted here in the same shot. The same goes for the country scene painted by Naoko, during her second meeting with Jiro in *The Wind Rises*. The young girl strives to put to canvas the colorful field of flowers that surrounds her. To emphasize just how much movement is at the heart of his practice, Miyazaki blows a violent gust of wind across the landscape, which suddenly transforms the realistic framework into an impressionist and then pointillist one. A sequence in *Castle in the Sky* explicitly switches from drawing to cartoon. In Pazu's workshop, there is a model of a bird plane and the wooden frame of an unfinished aircraft, as well as a sketch of an airship and a photograph of Laputa taken by his father before his death. This pencil drawing, hung on the wall, triggers a flashback that retraces the discovery of the flying island and its immortalization by his father's camera. This reverberation of painted and animated settings can be found again in Hiromasa Yonebayashi's *When Marnie Was There*, where an old woman keeps sketching the swamp house that holds the key to Anna's family puzzle.

In contrast, *The Tale of Princess Kaguya* establishes bridges between animation and Japanese pictorial arts—a subject that Isao Takahata tackled in one of his theoretical works, *12th Century Animation* (1999). The *emaki* from this period are painted scrolls that reveal their vast narratives, sequence by sequence. Kaguya's teacher brings one to the girl so that she can perceive how "the story flows by itself." Impatiently, the princess unrolls it in one go along the entire depth of field. Later, instead of practicing calligraphy, she draws a rabbit, a nod to the animal caricatures found in an *emaki* by Toba Sôjô, although her sketch also makes reference to cartoons. Takahata still draws inspiration from medieval scrolls to compose shots in the film, from the credits referring to the calligraphic style of the Heian period to the descent of the Buddhist procession and his representations of the Court.

Miss Hokusai weaves a parallel in her own way. The work is an oblique biography of the great Hokusai, who marked Japanese painting in the nineteenth century with his *Thirty-Six Views of Mount Fuji* (1831–1833), among others. This taciturn and eccentric artist is captured through the eyes of his daughter, O-Ei, who in turn catches the interest of director Keiichi Hara. A woman of character and an accomplished painter, she shares her father's visceral passion for this art, a pretext for a parade of styles and genres: prints, erotic engravings, caricatures, paintings of monsters and hell. On many occasions, the representations on the canvas come to life and contaminate the aesthetics of the film, underlining the extent to which the painting rubs shoulders with the fantastic and the invisible forces that the artist immortalizes in a just few strokes. By switching between the historical environment, the painted canvases, and the dreamlike and subjective detachments, *Miss Hokusai* reveals the artistic transfiguration of reality at the heart of the pictorial work.

MAGIC BRUSHES

PLATO'S CAVE

Animation directors have captured the art of filmmaking in their nets, setting it up as a subject of fiction—a way of questioning the world in its multiple representations.

A master of the story within a story, Satoshi Kon constantly sets up decoys for his viewers: he is adept at connecting shots that do not have the same status, jumping from the real to the imaginary. Full-frame scenes that seem to be lived by the character at first reveal their true nature afterward: lines exchange on a film set, snippets of shows, dreams or films projected onto a television screen. A luminous counterpart to *Perfect Blue*, *Millennium Actress* is an ode to cinema that works as a trompe-l'oeil. This narrative and aesthetic puzzle blurs all markers between fiction and reality, past and present, stories and history. At the request of a documentary filmmaker who has come to interview her, an old actress who has retired from public life revisits her filmography, which is intimately intertwined with her memories, themselves distorted by recollections and fiction. The star, the director, and his cameraman are even projected in the past or the middle of film sequences, shamelessly transgressing the space-time continuum. There is a common thread in this labyrinth: Chiyoko's desperate race to find a shadow, a dissident painter she met during the Sino-Japanese war in Manchuria. She does not know his name, but she preciously holds onto a key, a relic of love that is constantly lost and found. From life to screen, each role she plays offers a variation on this framework, inspired by a trilogy of live-action films by Hideo Oba (*What Is Your Name?*, 1953–1954). Through its temporal and fictional leaps, *Millennium Actress* reviews one thousand years of Japanese history and one hundred years of cinema. This metafilm is a deluge of quotes, pastiches, and cinephile homages. The heroine is a composite of several Japanese stars, the posters imitate those of yesteryear, and the demolition of the Ginei studios recalls the golden age and decline of the big production houses. Film excerpts show how Chiyoko mimics the aesthetics of timeless signatures, from Akira Kurosawa to Yasujirō Ozu, along with some Western references. The various genres mobilized explore both ancient and contemporary times: propaganda film for the war effort, outer space science fiction, and *chambara* and samurais of the feudal era.

In an equally whimsical and reflective vein, *Paprika* uses the metaphor of cinema as a waking dream: according to the heroine, "night dreams are artistic shorts and morning dreams are entertainment features." Using an experimental device (which will be stolen), patients' dreams are recorded and reviewed like movies for analysis. Dr. Atsuko Chiba can even intervene directly through her avatar, Paprika, who has been compared to "an actress in dream films." Superintendent Konakawa Toshimi undergoes this revolutionary therapy in order to understand the unconscious meanings of a recurring nightmare connected to his murder investigation but also to a repressed memory. He finally discovers the reason for his anguish: he has forgotten his lifelong dream—to become a filmmaker—which he shared with his best friend, who has since passed away. In addition to allusions to key figures—such as James Bond and Tarzan—and movie quotes (*The Greatest Show on Earth*, 1952; The *City of Lost Children*, 1995, etc.), the different layers of the dream explicitly refer to coded genres—adventure, romance, thriller. Both viewers and actors, the characters go to the dark rooms, cross the screen, and discuss the technique of fittings and camera lenses. When they are not wandering in front of Satoshi Kon's movie posters: *Tokyo Godfathers*, *Millennium Actress*, and *Perfect Blue*. These stories within stories underline the extent to which cinema has reflected, since its origins, its relationship to its own images.

Paprika, Satoshi Kon

A nimation filmmakers have fun weaving intertextual echoes between their films. The young couple from *Kimagure Orange Road: I Want to Return to That Day* (1988, Tomomi Mochizuki) goes to the cinema to see *Touch* (1986, Gisaburo Sugii), an allusion to a pillar of anime fiction: a high school romance destroyed by a love triangle. The narrative crossovers between *Galaxy Express 999* (1979 film) and *Space Pirate Captain Harlock* (1978 series) underline, for their part, the vast ramifications that organize the universe of the mangaka Leiji Matsumoto beyond his works. They prolong the pleasure through this or that variation of protagonists who reappear in a world related to their own. In *Galaxy Express 999*, after receiving from Toshirô's mother the cosmo gun and her son's hat, Tetsurō ends up meeting the latter right at the point of death, before offering him a worthy burial. Afterward, Captain Harlock and Queen Emeraldas help Tetsurō and Maetel to destroy Andromeda and save humanity from mortal danger. In the same way, during the parade of monsters in *Pom Poko* (Isao Takahata, 1994), some of the most important figures of the Ghibli works reappear unexpectedly. In a sleight of hand, Totoro, Kiki, Porco Rosso, and the little Taeko from *Only Yesterday* (1991) take their place among the supernatural creatures. This playful nod underlines how much the powers of animation—and perhaps of cinema in general—lie in the transubstantiation of imaginary beings into effective traces in the memory of the viewers. Regardless of the aesthetics of the movies in question, between realism and wonder, these characters acquire an autonomous fictional life. In another shot of *Pom Poko,* two *yôkai* (Japanese sprites) spring from the drive-in screen to scare the public. Not only does cinema capture invisible spiritual entities in its web of lights and shadows, which take shape before our eyes, it is also capable of having concrete effects on the psyche: fear, wonder, laughter, etc.

Animation has sometimes questioned its differences with live-action cinema. Especially Satoshi Kon, who likes to play with cinematic illusion and blur the boundaries. In *Millennium Actress* (2001), he reinterprets some masterpieces of live cinema in a drawn and animated version. In places, there are explicit references to *Late Spring* (1949) and *Tokyo Story* (1953) by Yasujirō Ozu; *Godzilla* (1957) by Ishirô Honda; and *Throne of Blood* (1957) by

ANIME MAKES ITS CINEMA

Requiem for a Dream, Darren Aronofsky

Perfect Blue, Satoshi Kon

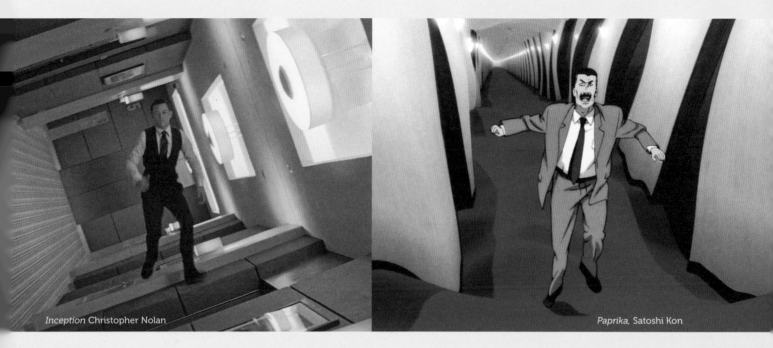

Inception Christopher Nolan

Paprika, Satoshi Kon

Akira Kurosawa. Thus, the admirer of the old actress finds himself immersed in feudal action scenes with her, wearing the samurai clothes and helmet once worn by the famous actor Toshiro Mifune. This formal translation questions the specificity of animation, which is not a genre but a particular technique, just as documentary is not fiction. In this way, the cartoon offers delicious graphic variations on anthology sequences, whether they are Japanese or Western.

Live-action cinema has also paid tribute to animation, a sign—if any were needed—of its artistic fertility. *Inception* (2010) by Christopher Nolan owes a certain debt to *Paprika* (2006), whether for the concept of interlocking dreams, shared by many, or for specific sequences, such as the chase of a mysterious enemy through a weightless corridor. As for Darren Aronofsky, his admiration for the author of *Perfect Blue* (1997) is no secret. He goes as far as to literally reference the shot of the heroine's back curled up in her bathtub in *Requiem for a Dream* (2000). And what is *Black Swan* (2010) if not a retelling of the character of Mima transposed into the world of dance? Played by Natalie Portman, Nina is exploited by jealous and frustrated people, until her reality shatters in distressing and hallucinatory visions.

And then, sometimes, films suddenly turn into cartoons. A case in point: *Kill Bill, Volume 1* (2003). To make the original

trauma of O-Ren Ishii (Lucy Liu) more poignant, who at the age of nine witnesses the savage murder of her parents by a terrible yakuza boss, Quentin Tarantino chose animation. This one was entrusted to Production I.G., whose work he admires, particularly *Ghost in the Shell* (1995) by Mamoru Oshii and *Blood: The Last Vampire* (2000) by Hiroyuki Kitakubo. The drawing's stylization magnifies the scene's violence, reinforcing its unimaginable dimension, as if the universe of childhood was brutally bloodied by gore and horror in its pure state, triggering the uninterrupted cycle of revenge. Thus was born this fearsome killing machine nicknamed "Cottonmouth." A member of the "Deadly Viper Assassination Squad" in Bill's pay, she participates in the fateful battle in the church in the middle of the desert, leaving the pregnant bride played by Uma Thurman for dead. Who, from that moment on, can only think of payback. Quentin Tarantino likes to represent this key sequence both in anime and in live action. It took a postmodernist like him to achieve such an organic interweaving of the two types of cinema. Within a film, itself, he creates a junction between East and West.

181

Kill Bill, Volume 1, Quentin Tarantino

Gauche the Cellist, Isao Takahata

鏡の國のアニメ

182

ANIME THROUGH THE LOOKING GLASS

The Piano Forest, Masayuki Kojima

"Music is the ultimate weapon to connect the hearts of men to one another," according to Isao Takahata's vision. Truly well-versed in this art, he practiced his musical direction in *Kiki's Delivery Service*. Inspired by the Europe of the Middle Ages and the Renaissance, the song of Hilda—bewitched by the sorcerer—is poignantly melancholic (*Horus, Prince of the Sun*). The songs of the villagers draw from the popular repertoire of Eastern Europe and accompany the dances that bind the community together. With its eloquent title, *Whisper of the Heart* by Yoshifumi Kondō offers a moment of improvised grace and communion between generations. Seiji accompanies Shizuku on the violin while she sings the rewritten lyrics of "Country Roads" by John Denver. They are unexpectedly joined by the old secondhand dealer and his friends, with a cello, tambourine, and zither. It is also the music—electronic this time—that seals the friendship between the teenagers and the mermaid in *Lu Over the Wall* by Masaaki Yuasa. The magical powers of sound provide the supernatural creature with legs that carry it in wriggling dances, but they are also the pretext for graphic excesses. Since music propels us into another dimension, everyday life takes on phantasmagorical colors and disregards all rules. In Masayuki Kojima's *The Piano Forest* (2007), social antagonisms are abolished by music. The magic that it distills is illustrated by the mysterious presence of a grand piano in the woods, from which only Kai manages to draw divine notes. A poor child raised by a prostitute mother, this mischievous boy has never taken lessons but reproduces the greatest pieces, from Beethoven's symphonies to Chopin's *Minute Waltz* and Mozart's *Piano Sonata No. 8 in A Minor* by ear. The opposite of Shūhei, son of a good family who trains hard to become a virtuoso and win a national competition. An ode to the classical repertoire, The *Piano Forest* has had a new series adaptation in 2019.

Beyond being a unifying force, music determines the structure of certain works. Adapted from a short story by Kenji Miyazawa, *Gauche the Cellist* is punctuated by the main themes of Beethoven's *Symphony No. 6*, already visited by Disney in *Fantasia* (1940). A hymn to nature—from the sun to the storm before the reconciliation of man and the world—the *Pastoral* gives rhythm to the "movements" and drawings of the feature film, sometimes bucolic, tormented, or cathartic. Under the bushy eye of Beethoven's portrait, Gauche experiences an eventful musical initiation, in keeping with his introverted character. The awkward cellist is chastised by the conductor during rehearsals for his lack of emotion, but he is visited at night by talking animals who help him feel the notes, the cadence and the tones, until he is finally inhabited by the score's intimate vibrations. The apotheosis of his subjective fusion with nature anticipates the ovations of his partners and the audience during the final concert, where he finally reveals the sensibility of his interpretation.

MOON- LIGHT

A unique sensory experience, *Interstella 5555* (2003) celebrates the marriage of two artistic universes: the electronic music of the French group Daft Punk combined with the graphic style of Leiji Matsumoto, creator of *Space Pirate Captain Harlock*, *Space Battleship Yamato*, and *Galaxy Express 999*. The hits from the album *Discovery* (2001) resound on clips animated by the famous mangaka and accompany a wordless science-fiction plot. As they unleash the crowd on "One More Time," a group of extraterrestrial musicians are abducted, lobotomized, and given makeovers for an unscrupulous record company that wants to make its new stars profitable at all costs. In this case, animation is akin to a symphony for the eyes and ears, mixed with a story within a story filled with adrenaline about the music industry.

Words Bubble Up Like Soda Pop, Kyōhei Ishiguro

ETERNAL LIGHTNING

Animation cinema draws from the plots of novels and mangas, transforming them through its own formal characteristics: from literary images to cinematic drawings, from comics to anime. *Whisper of the Heart* reflects on the adaptation process, as the Baron's statuette comes to life in Shizuku's story, before it is brought to life on the screen. A transfiguration is also present in *Mind Game*, where Masaaki Yuasa takes over a manga about a mangaka catapulted into the intricacies of his unconscious, populated with graphic, literary, and mythological memories.

Some books have left such a mark on generations of readers that they run through several anime like a common thread. *Night On the Galactic Railroad* (1927) by Kenji Miyazawa appears as an existential milestone for the teenagers of *Summer Days With Coo* (Keiichi Hara). Adapted into a feature film by Gisaburô Sugii in 1985, the short story infuses works as diverse as *Galaxy Express 999* and *Giovanni's Island* (Mizuho Nishikubo). A whole section of the surrealist night in Masaaki Yuasa's *Night Is Short, Walk On Girl* is devoted to the relentless search for old books in a second-hand book festival. The black-haired girl suddenly remembers her love for an illustrated story, which propels her back to childhood through stylized flashbacks. Seeking to obtain the only copy of *Ra Ta Ta Tam* (Peter Nickl, 1975) to seduce the mysterious stranger, the man who follows her confronts other bibliophiles ready to do anything to recover their "white whale"—a nod to Captain Ahab's obsessive and passionate hunt for Moby Dick in Hermann Melville's novel. Because books have the power to evoke strong memories and mark the psyche of literature lovers. The silhouette of the young man fleetingly takes the flat form of a blue page blackened with ink that mixes *kanji*, *kana*, alphabet, and equation. But he begs the god of books to give him, not wisdom, but grace and charm. *Night Is Short* goes as far as to offer a playful reflection on intertextuality, that is, the infinite ramifications that link novels together through clever quotations, pastiches, and repetitions. A re-creation extended by animation when it proposes its reinterpretation of novels. This was the case with Satoshi Kon's *Paprika*, based on the work of Yasutaka Tsutsui, which was considered unsuitable for the screen.

Some films explicitly invite poetry, such as Isao Takahata's *Gauche the Cellist* and Makoto Shinkai's *5 Centimeters per Second*. *My Neighbors the Yamadas* integrates haikus by Bashô (1644–1694) and Santôka (1882–1940) into the pure graphic compositions, which give pride of place to emptiness. If the first defended a structure established on the rhythm of five-seven-five syllables, the second preferred a freer form. The brevity of the haiku chisels reality into three lines to celebrate the evanescent beauty of the moment, of nature, or the fragility of an emotion. Close to the painting, this purely Japanese poem is based on the sensitive image, which is why it goes so well with the cartoon. Thus the haikus that dot the fragments of the Yamadas' lives sum up the poetic gesture of the film: "A fading silhouette / solitary from behind / in the rain." In other words, daily life transfigured in just a few lines, exhuming the small feelings that shake the soul like a wave. The originality of Kyôhei Ishiguro's *Words Bubble Up Like Soda Pop* is to merge this poetic tradition with contemporary pop art. The haikus that the shy Cherry writes to verbalize his emotions are displayed around the mall by one of his friends. The anachronistic teenager also offers Yuki the most original of declarations of love by revealing his love of haikus to the world, only to end up explaining the title of the movie: "Words bubble up / like soda pop."

INDEX OF WORKS

The numbers in bold refer to the works that are illustrated.

INDEX OF DIRECTORS

© PRESTEL VERLAG, MUNICH · LONDON · NEW YORK, 2023
A MEMBER OF PENGUIN RANDOM HOUSE VERLAGSGRUPPE GMBH
NEUMARKTER STRASSE 28 · 81673 MUNICH

THE ORIGINAL EDITION WAS FIRST PUBLISHED BY GALLIMARD, PARIS
UNDER THE TITLE *AU PAYS DES MERVEILLES. TRÉSORS DE
L'ANIMATION JAPONAISE*
© EDITIONS GALLIMARD, COLLECTION HOËBEKE 2022

EDITORIAL DIRECTION: CLAUDIA STÄUBLE
PROJECT MANAGEMENT: VERONIKA BRANDT
TRANSLATION: JACQUELINE MAURELOS FOR CILLERO & DE MOTTA
COPYEDITING: THERESA BEBBINGTON FOR CILLERO & DE MOTTA
TYPESETTING: VERÓNICA MORELLÓ FOR CILLERO & DE MOTTA
PRODUCTION MANAGEMENT: LUISA KLOSE
PRINTING AND BINDING: L.E.G.O. S.P.A, VICENZA

 PEFC/18-31-280

PRINTED IN ITALY

ISBN 978-3-7913-8014-8

www.prestel.com